Out of
My Father's
Shadow

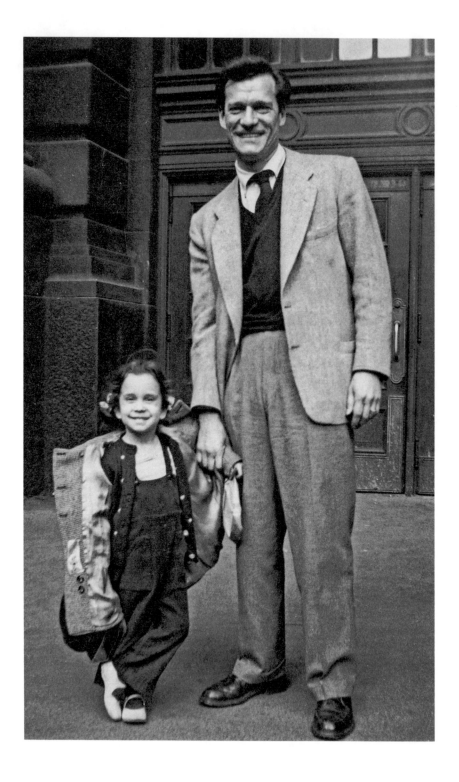

Out of My Father's Shadow

SINATRA OF THE SEINE, MY DAD, **EDDIE CONSTANTINE**

A MEMOIR BY **TANYA CONSTANTINE**

Introduction by TIM LUCAS

Contents

Eddie's headshot in 1969 RICHARD SASSO

Introduction

by TIM LUCAS

WHO WAS EDDIE CONSTANTINE?

In his day, he was known as the Humphrey Bogart of Paris, the Sinatra of the Seine. He sold millions of records abroad and was the only singer who could lay claim to having recorded with such greats as Édith Piaf, Juliette Gréco, and Frank Sinatra. He also made a hit recording with the author of this book, his daughter Tanya—"L'homme et l'enfant"— which sold millions of copies. As a young man, Eddie collaborated with most of the great stars of the day—among them James Stewart, Joan Crawford, Gene Kelly, and June Allyson—without ever getting noticed. After relocating to Europe in the late 1940s, he became one of the great action stars of French cinema, usually cast in the role of hard-drinking, two-fisted FBI man Lemmy Caution. He matured into an icon of the French and German New Wave cinema for a period spanning three decades, starring in pictures for the likes of Jean-Luc Godard, Rainer Werner Fassbinder, and Lars von Trier. His most famous role married these two career extremes, in Godard's legendary science-fiction classic *Alphaville* (1965), subtitled "A Strange Adventure of Lemmy Caution."

Eddie Constantine was born Israël Constantine in Los Angeles, California, on October 29, 1913—not 1917, as commonly cited. He

inherited the love of music that ran in the veins of his Russian immigrant family. In the early 1930s, his father sent him to Vienna to study singing for five years with Igor Gorin of the Vienna Conservatory, hoping that he might become the first professional in the family's long line of amateur opera singers—but this didn't happen. When Eddie returned home, he jerked sodas, washed cars, and, by his own admission, hung around the lot at Metro-Goldwyn-Mayer, hoping to get noticed. Eddie could pour on the charm when he wanted to, and he made friends easily. He befriended actor Franchot Tone (a man who, by all reports, did not befriend easily) and was soon after taking singing lessons with—or, more likely considering his past experience, giving them to Tone's wife, MGM star Joan Crawford. According to Eddie's family, he and Joan were also lovers; though they went their separate ways romantically, they remained close friends until her death in 1977. At her probable recommendation, Eddie was hired to join MGM's 60-member vocal chorus, in which capacity he remembered lending background voice to such Nelson Eddy/Jeanette MacDonald musicals as *Rose-Marie* (1936) and *Maytime* (1937). When the studio presented a live production of *A Midsummer Night's Dream* at the Hollywood Bowl, featuring contract players Mickey Rooney and Olivia de Havilland, Eddie was part of the show. He also landed an uncredited bit part as a singing sailor in the MGM musical *Born to Dance* (1936), starring James Stewart and Eleanor Powell—but his rugged, pockmarked face was not in the MGM tradition, and *Born To Dance* would be his last film role for 18 years.

Frustrated by his inability to advance, his outgoing personality hungry for the spotlight, Eddie relocated to New York City in 1938. He made his public singing debut in a Bayonne, New Jersey, theater as part of a trio, which soon added two members and became the short-lived "Five Musketeers." By 1940, he was dancing in Broadway chorus lines with the soon-to-be-discovered June Allyson and Gordon MacRae. At

the end of 1940, he appeared as a dancer in the original stage production of *Pal Joey*, which brought its star Gene Kelly to Hollywood's attention. (Eddie remained friends with Kelly and later claimed responsibility for introducing him to another friend, Leslie Caron, when Kelly was seeking an unknown French co-star for his 1951 film, *An American in Paris*.) *Pal Joey* ran for 374 performances, during which time Eddie augmented his earnings as a Radio City Music Hall singer and also on radio and records with the Lyn Murray Singers and the Ray Charles Singers. His voice also appeared in advertising jingles produced by Gene Lowell (Lowenthal) for CBS and NBC in the early 1940s. It was during this period that Eddie met and married his first wife, Helene Musil, an accomplished Chicago-born ballet dancer who was also performing at Radio City Music Hall.

One of Eddie's best friends in the music business was Frank Sinatra, with whom he cut three remarkable *a cappella* 78s in 1943 ("Close To You"/"You'll Never Know," "Sunday, Monday, or Always"/"If You Please," and "People Will Say We're in Love"/"Oh, What a Beautiful Mornin'") as a member of the background chorus, The Bobby Tucker Singers. These were six of Sinatra's first ten recordings under his new solo artist contract with Columbia Records, and the *a cappella* nature of the recordings was the company's clever way of circumventing the musician's union strike of 1942–1944 and getting Sinatra's products into stores.

It's interesting that Eddie's collaboration with Sinatra was an anti-unionist venture because, in his private life, he was a sympathizer and probable member of the American Communist Party—as were approximately 200,000 other Americans during the wartime years, when the Soviet Union was America's political ally. At the height of World War II, being a communist meant being anti-fascist, but it came to mean "un-American" after 1945, when the House Committee on Un-American Activities was made a standing committee in 1945.

Within two years, the committee's investigations into possible anti-American activities led to the "Second Red Scare," epitomized by the Hollywood blacklist of 1947.

Eddie's son, Lemmy—named after Lemmy Caution, of course—recalls that "Eddie was very leftist, communist, and always hated the other side."

Lemmy and Tanya Constantine are skeptical that the HCUAA's increasingly aggressive inquiries into the lives of show business performers had anything to do with Eddie's decision to leave the United States in 1947, the year of the infamous Hollywood blacklist. Instead, it was during this lean period that Eddie's wife, Helene, received an invitation to join the celebrated Ballet Russe. Eddie had no comparably secure work offers in New York, and it was a great opportunity for his wife, so they had to go. Helene left for Europe first, 3-year-old Tanya in tow, with the understanding that Eddie would follow when he got enough money together to book a sea passage. According to a 1956 interview with the military newspaper *Stars and Stripes*, Eddie bought his ticket with a $40 loan from Joan Crawford.

Once in Paris, Eddie started pounding the rues, singing American standards in any French nightclub that would have him. "Most places, I didn't get paid," he told Kevin Thomas of the *Los Angeles Times* (January 9, 1977). "Oh, maybe three dollars or a sandwich." In 1949, his fortunes changed dramatically when he attended a concert by the celebrated French singer, Édith Piaf. It was not long after the October 1949 death of Piaf's great love, the boxer Marcel Cerdan, who perished in a transcontinental plane crash. "She was singing in this club on the Champs-Élysées," Eddie told Thomas. "Three hundred people were waiting for her at the stage door. Eventually, out came this little woman in a black dress. She picked me out of that crowd—she saw something in me, some kind of star quality that attracted her—and said, 'Come here.' I went into her dressing room and stayed eight months."

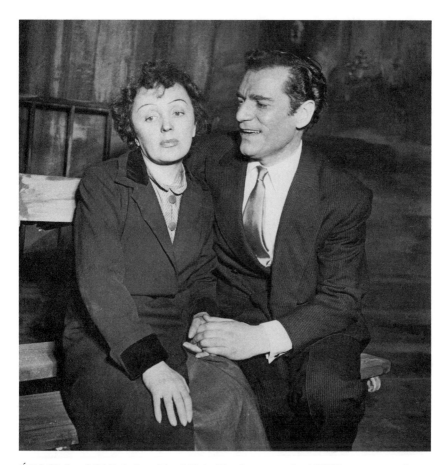

Édith Piaf and Eddie in La p'tite Lili *in March 1951 at the ABC Theatre promo shot*
ROGER VIOLLET/LIPNITZKI-VIOLLET

Though Eddie's French was not very good at this time, he had man-
aged to translate into English the lyrics of some of Piaf's best-known
songs, including "La vie en rose" and "Hymne à l'amour." These trans-
lations became the basis of her only album of songs in English, a spon-
sorship, and another love affair. Thanks to the interest Piaf took in her
lover's career, 1950 became Eddie's breakthrough year. At age 37, he
was one of several singers spotlighted in Henri Verneuil's documentary
musical short *Les chansons s'envolent* ("*Songs That Soar*," 1950), and he
was signed by Mercury to cut his first solo recordings, which were

released that year as an album of eight songs. In 1951, he co-starred with Piaf in the successful stage musical *La p'tite Lili* ("*Little Lili*"). Unfortunately, the ascent of Eddie's star was on a collision course with unhappy and divisive events in the life of Mme. Piaf. Following the success of *La p'tite Lili*, Piaf drifted away from Eddie into a new relationship with another young singer/songwriter, Charles Aznavour, with whom she was involved in a serious automobile accident that caused her to become addicted to morphine. Once Eddie's love affair with Piaf was over, he was out—not unemployed, but no longer part of Piaf's golden circle.

According to Lemmy Constantine, "Eddie regularly got his international papers at the kiosk of the Hotel George V. The girl selling the papers told him one day that casting was being held in one of the salons in the hotel." Eddie himself gave additional details to Kevin Thomas, recalling that the girl's name was Gisèle and that she sometimes slipped him the current issue of *Variety* when he couldn't afford it. "She knew I wasn't working and recommended me to a producer, Victor Stoloff, who was making a picture in Egypt and needed an American actor for one of the parts."

That picture was *Egypt by Three* (1953), which Eddie described in his 1955 autobiography *Cet homme n'est pas dangereux* ("*This Man Isn't Dangerous*") as a real mutt of a picture—"directed by a Russian [Victor Stoloff], starring an American, produced in Egypt, edited in Paris, and dubbed in London." Nevertheless, when it was released, it was seen by the wife of writer-producer-director Bernard Borderie, who was then seeking an actor—preferably an unknown—to play the role of Lemmy Caution. The two-fisted, hard-drinking G-man with a name like a sleazy warning made his literary debut in Peter Cheyney's 1935 novel *This Man Is Dangerous*, which was followed by a dozen more just like it. (The title of Eddie Constantine's autobiography *Cet homme n'est pas dangereux* was a play on the title of Cheyney's novel, which became the basis of

the second Caution film.) Mme. Borderie was impressed by Eddie's screen presence and recommended him to her husband.

Difficult as it is to imagine anyone else in the role, Eddie Constantine was not the first actor to play Lemmy Caution on screen. This honor fell to Dutch actor John van Dreelen, who starred as Lemmy in the "Je suis un tendre" segment of the portmanteau thriller *Brelan d'as* ("*Full House*," 1952), a French-German co-production that also featured Michel Simon as Georges Simenon's Inspector Maigret and Raymond Rouleau as S.A. Steeman's lesser-known character Inspector Wens. As it happens, the film's director was none other than Henri Verneuil, whose earlier documentary about singers had played an important role in making Constantine a household name in France. According to Eddie's autobiography—which was ghostwritten and, one must stress, is not always reliable—Raymond Rouleau was an early supporter of his acting ambitions and encouraged Eddie to meet with Verneuil when he was casting the part. "I need a real Lemmy Caution," Verneuil supposedly told Eddie by way of rejection. "You don't have the right physique for the role."

If this story is true, Eddie's luck was likely undone by Peter Cheyney's publishers, who had been using an artist's conception of Lemmy Caution on his book jackets for years, an image which John van Dreelen fit to a T. However, van Dreelen's performance did not lead to bigger things in Europe, and his career ultimately took the opposite path to Constantine's, taking him to America, where he spent his career toiling in popular television series and low-budget films. When Bernard Borderie's wife took notice of Eddie's gravelly bravado in *Egypt by Three*, she spotted an earthy American swagger, which the Peter Cheyney books lost in being translated to French. "My American gangster persona interested Borderie," Eddie recalled. "He decided right away that I had the kind of personality he was looking for."

It was Borderie's most inspired idea to reject the hardboiled (indeed

Eddie and Jean Marais hamming it up for the photographer

deep-fried, almost fish-and-chipsy), frankly lunkheaded tone of the literary Caution. He didn't throw out the entire recipe—Lemmy Caution would still be two-fisted, hard-drinking, and caddish in the romance department—but Constantine's breezy, bulletproof charisma gave the G-man an extra dimension. He's not a neanderthal idiot but a fantasy character: your basic meat-and-potatoes kind of guy who can hold his own in sophisticated circles and death traps by virtue of hard knuckles and his distrust of anything or anyone too hoity-toity.

"I'm a reaction to the sissyish, beautifully dressed French leading

men," he told Hollywood columnist Earl Wilson in 1955. "When I kiss or slap a dame, a French guy says, 'That could be me.'"

His unruffled charm, winning smile, and American credentials made him virtually untouchable. Indeed, Eddie's Lemmy Caution was a working-class prototype of James Bond, who made his literary debut in Ian Fleming's *Casino Royale* the same year that his portrayal reached the silver screen.

With the release of his first Lemmy Caution adventure, *La Môme Vert-de-Gris* ("*Poison Ivy*"), on May 27, 1953, Eddie Constantine had finally arrived. People on the streets of Paris—including some who had curtly addressed him as "Constantine" not long before—began to greet him with jubilant cries of "Bonjour, Lemmy!" Eddie Barclay, owner of the Barclay Disques record label, signed Eddie to a new recording contract and the records began again. Soon, he was averaging three movies per year and performing onstage at the Moulin Rouge and Folies Bergère between pictures. Around the same time, Eddie began recording songs in German (which he had learned during his early years in Vienna) to capitalize on his even greater success in Germany as a film star. A taste of his continental celebrity is imparted by no less a film than Henri-Georges Clouzot's *Les diaboliques* ("*Diabolique,*" 1955), in which one of the film's schoolboys gossips that the man visiting the school's headmistress is a detective, and another cries with glee, "Lemmy Caution! Rat-a-tat-tat!" imitating a machine gun.

Eddie's moment of success was in some ways emblematic of America's status during the postwar years, as Lemmy Constantine rightly notes. "We're talking early 1950s—America had saved the world, they were cool with their huge cars, filtered cigarettes, accents, hats, chewing gum. They were tough with the guys, cool with the girls. They represented progress, the future. Guys liked Eddie because he wasn't a pretty face. He wasn't competition to other men. He just knew how to handle situations."

This "handling situations" aspect is one of the reasons why the pre-*Alphaville* Caution films have stood up to the test of time. Yes, they are compact, efficient, entertaining French thrillers, piloted by a charismatic actor with his joie de vivre at full sail. And as they develop over time, we begin to see in them the seeds of the James Bond films and even the Beatles films. (E.g., 1962's *Lemmy pour les dames*/"*Ladies' Man*" opens with Lemmy, a supposedly secret agent, being chased through the streets by teenage girls—a full two years before *A Hard Day's Night*.) However, on a level of subtext, some have noted that Borderie's vision of Lemmy Caution—who is, after all, a brawling, drunken American who leers at French women and brings his unbossable fisticuffs to bear on Europe's internal problems—is a thinly veiled, contemptuous riposte to America's tendency to meddle in foreign affairs. Given the revelation of Eddie's own communist leanings—which, we must remember, were not anti-American so much as "un-American" in the strictest HCUAA definition—the Lemmy Caution films are an outstanding example of how cinema sometimes reveals hidden truths about its stars, not unlike the films of Eddie's secretly gay contemporary Rock Hudson, which often (*Pillow Talk, Man's Favorite Sport, Seconds*) are about a man pretending to be someone he is not. They also venture comment about the complexity of America's global image that no other films dared to make at the time. Indeed, the first three Caution films predate Graham Greene's bestselling novel *The Quiet American*, whose frankly anti-American stance was whitewashed from its 1958 filming by Joseph L. Mankiewicz, causing Greene to condemn it as "propaganda for America."

One of the reasons the Lemmy Caution films are not better known in English-speaking countries is that they had no domestic theatrical exhibition, though one doubts their sly subtext had anything to do with this. Instead, they were held up until late 1964, at which time they became part of the Westhampton Film Corporation library, which had

been acquired by Desilu and sold into television syndication. It is these 16mm Westhampton prints that are the source for the VHS and DVD-R copies presently available in America from the internet and mail-order labels Sinister Cinema and Something Weird Video.

After making three films in the Lemmy Caution series, Eddie Constantine decided to take a break in an attempt to persuade the French film industry that he was capable of playing other kinds of roles. It led to a five-year stalemate. These years found Eddie and Helene adding two more children to their family—Barbara (born 1955) and Lemmy (born 1957)—while Eddie continued to make records and television appearances, this aspect of his career rejuvenated by the success of "L'homme et l'enfant" with Tanya. He also used his fortune to provide his own opportunities in well-made but neglected pictures like Henri Decoin's lavish color musical *Folies-Bergère* (1956), the sentimental character study *L'homme et l'enfant* (1956), and the ambitious and winning *SOS Pacific* (1959).

During this period, Bernard Borderie made a few internationally co-produced adventure films, including one with Eddie Constantine, *Ces dames préfèrent le mambo* ("*Some Dames Like to Mambo*," 1957), which was likewise sold directly to the Westhampton Film Corporation TV package under the export title *Dishonorable Discharge*. In 1960, having played his best hand with *SOS Pacific*, Eddie surrendered to the inevitable and agreed to return to harness as Lemmy Caution. He appeared in the trailer for *Comment qu'elle est?* as himself, at home on his ranch, juggling youngsters Barbara and Lemmy on his lap, graciously acceding to a telephoned request to be interviewed at the fence of his private property about his comeback.

A toi de faire... mignonne ("*Your Turn, Darling*," 1963) was the last of the Lemmy Caution films released prior to *Alphaville*, ushering in a three-year lull that indicated the series had ceased to be profitable or that Eddie Constantine's contract with Borderie had run out. After

this, the two men went their separate ways professionally. Borderie was soon swept up by the biggest commercial success of his directorial career, the *Angélique* series of costume romances starring Michèle Mercier—five films in three years. He died in 1978 at the premature age of 53. As for Eddie, his career had already taken its next fateful turn.

In 1962, prior to making *A toi de faire... mignonne,* Eddie had the unexpected pleasure of working with the dark prince of the French New Wave, Jean-Luc Godard. He was cast as himself in Godard's segment of *Les sept péchés capitaux,* a portmanteau film about the seven deadly sins. Godard wrote and directed *La paresse,* an amusingly deadpan comedy on the theme of sloth, in which actress Nicole Mirel sees Eddie Constantine sitting in his new convertible outside the film studios, cajoles from him a lift back to her flat, and attempts to seduce the movie star. Alas, Eddie is feeling lazy—so lazy that he offers a gas station attendant 10,000 francs rather than bend over to tie his own shoelace. It's a hilarious send-up, not only of sloth but of Jean-Paul Sartre's then-fashionable views on existential nausea and ennui.

Godard could have chosen any number of better-known French actors for the role, had his intention simply been to cast a famous face, but his selection of Eddie Constantine bears connection with his decision to dedicate *À bout de souffle* (*"Breathless,"* 1959) to Monogram Pictures. Godard adored American B movies and crime pictures, and he saw Eddie Constantine as shorthand for all that. Eddie, whose most coveted desire was to work in comedy, embraced the opportunity wholeheartedly and played himself in the stone-faced manner of Buster Keaton—indeed, he was playing himself, someone quite unlike Lemmy Caution. It was also during this interval that Godard involved Eddie in a side project he agreed to do with Anna Karina, Agnès Varda's *Cléo de 5 à 7* (*"Cleo from 5 to 7,"* 1962), the silent film-within-the-film in which Eddie appears in blackface.

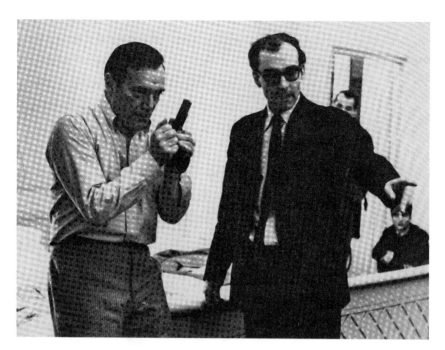

Eddie and Jean-Luc Godard during the shooting of Alphaville

In the process of Eddie's transposition from B movies to the epicenter of the Nouvelle Vague, Godard reconsecrated him as one of the great sacred beasts of cinema—solemn and impassive, long-suffering, ironic, iconic. When they reunited in 1965 to make *Alphaville*, Eddie was asked to play a role that he wanted to be done with—Lemmy Caution—but Godard, working without a finished script, insisted that he play himself rather than the animated, charming Lemmy of old. He knew it would be to their mutual benefit if Eddie was allowed to embody the baggage of Lemmy Caution, sick to death of carrying it, sick to death of being who he was, and yet knowing he's the last man alive capable to save the world—or at least one woman—from its imminent dehumanization.

Strange as it may seem, Eddie Constantine's most famous film and acting role did nothing to buoy his dwindling celebrity in France. His own view of the Lemmy Caution films had turned negative, reflecting

his disappointment at never being accepted by the public in different kinds of roles. Interviewed six months after the completion of *Alphaville*, Eddie told Newsweek on September 6, 1965: "I made my first movie and I hated it. So I thought I'd make a second and improve it. Then I hated the second. Now I'm on the 51st and I still hate them. I'm tired of knocking people out and breaking furniture. I want to get away from all the lousy scripts schlemiels send me to read. I'd love to break out of this and do a Cary Grant type of comedy. After September, I'm not going to sign any more contracts, unless it's something spectacular, something that really excites me... I suppose if someone arrives with another bad script and a fat check, I might change my mind."

He did as he suspected. At best, the films Eddie was offered after *Alphaville* further compromised his goals, as when he appeared in Raoul André's comedy *Ces messieurs de la famille* (1967) as... Cousin Lemmy. As the '60s became the '70s, Eddie found himself accepting more and more work in West Germany, where his movies and recordings continued to be successful. His long marriage to Helene finally collapsed in 1973. At the end of a decade spent working with the likes of Rainer Werner Fassbinder (*Beware of a Holy Whore*, *The Third Generation*), Ulli Lommel (*Haytabo*), and Mika Kaurismäki (*Helsinki Napoli: All Night Long*), following a short-lived second union to Dorothea Gibson, Eddie married for the third and last time to German television producer Maya Faber-Jansen in 1979, and—at age 65—fathered his fourth and last child, a daughter named Mia Bella Marie.

In his last decade of screen work, Eddie became more amenable to playing Lemmy Caution—which, after all, he now played as an extension of himself, albeit always in guest or cameo appearances—in *Panische Zeiten* ("Panic Time," 1980), two episodes of the television series *Kottan Ermitelt* (1983), Peter Patzak's parody *Tiger - Frühling in Wien* ("*Springtime in Vienna*," 1984—opposite William Berger as Philip Marboe), the TV miniseries *Une aventure de Phil Perfect* (1984), *Makaroni*

Blues (1986), and Josée Dayan's TV movie *Le retour de Lemmy Caution* ("*The Return of Lemmy Caution,*" 1989).

In the context of these films (and others, which cast him as gangsters, two-bit crooks, or himself), Eddie Constantine became the commercial element that enabled many German films with challenging artistic and political points of view to be produced. And meanwhile, Lemmy Caution—in the context of *Alphaville,* a tongue-in-cheek (in French, *au deuxième degré/*"twice-removed") shorthand for B cinema—became yet another degree removed from his original conception, something between a cartoon caricature and a ghost.

However, when the Berlin Wall began to be dismantled on November 9, 1989, Jean-Luc Godard conceived of a reason to reclaim Lemmy Caution. Only Godard was able to see Eddie and Lemmy for what they truly had become: relics of a moment in time that contained the substance of many people's entire lifetimes, but no longer existed. Eddie/Lemmy had seasoned into a complex symbol of two kinds of cinema that had passed, the B picture and the Nouvelle Vague, as well as a symbol of survival and the personal toll that survival takes. Lemmy Caution was now portrayed as "The Last Spy" in Godard's elegiac essay about the Americanization of Europe, *Allemagne 90 neuf zéro* ("*Germany Year 90 Nine Zero,*" 1991).

This final Lemmy Caution story was very nearly Eddie Constantine's last work on screen. As it happens, it was followed by two more gangster roles in 1993, both played opposite Udo Kier: Andy Bausch's *Three Shake-A-Leg Steps to Heaven* and Lars von Trier's abandoned sci-fi noir epic, *Dimension 1991–2024,* for which the director intended to film three minutes of unscripted footage each year for a period of 33 years. Trier abandoned the project, leaving it in the form of a 27-minute short that was included as part of a giveaway DVD called Nordic Short Films. The first two minutes of the film can be found on YouTube and, in two scenes photographed over a period of a couple of years, Eddie's

alarming weight loss is obvious. He died of a heart attack in Wiesbaden, Germany, where he and his new family made their home, on February 25, 1993. He was 79.

* * *

"The Last Spy" has been gone for 25 years, but his daughter Tanya Constantine restores him palpably to life in the following memoir. With great courage, she takes us behind the broad and irresistible smile of one of the movies' greatest tough guys, presenting us with a man who—in his private life—was vulnerable, frightened, and incessantly needy, too starved for love to be emotionally available to his family. For fans of Eddie Constantine, it will be a startling and sometimes heartbreaking account of his inability to break free of his own image or to control his own life, either in the whirlwind of celebrity or in the aggravating calm following the storm when the roles dried up. For everyone else, it's an important document about the temptations and intoxications of success and the compulsions actors often feel to become— indeed, to succumb to—the characters they portray.

After Sean Connery, there were many James Bonds; since Adam West, there have been many Batmans. But since the death of Eddie Constantine, Lemmy Caution has taken no more cases. Ironically, the most fitting words left to be said of "The Last Spy" are found in the sage, ironic epitaph spoken by his enemy Leonard Nosferatu/Professor von Braun in Godard's *Alphaville*: "Look at yourself. Men of your type will be soon extinct. You'll become something worse than dead. You'll become a legend, Mr. Caution..."

His legend survives in this book intact. It mustn't be forgotten that the films and recordings of Eddie Constantine have brought pleasure and escape to millions of people all over the world throughout the past half-century. And it is a testament to his legend that Eddie Constantine emerges from the candor of his daughter's autobiography somehow

strengthened by her revelations of the compulsions and insecurities he suffered and made those closest to him suffer. I believe this is because her book presents us with universal truths about the difficulties experienced within family relationships, by people from all walks of life—most of whom openly or secretly aspire to celebrity. This book takes us behind the curtain of celebrity and the fixed smiles of publicity photos in a way few books ever do.

I also believe that the troubled and volatile husband and father whom Tanya sketches so painstakingly, and occasionally at no small cost to herself, is exactly the sort of complex role Eddie would have relished to portray on screen. For this reason, Tanya Constantine has given us what Eddie could not—an honest accounting of himself—and she has given her father the gift of deconstructing the very image he himself yearned to shatter. It can't be done painlessly, but any lingering hurt fades unmistakably into forgiveness.

June 2011
©2011 by Tim Lucas

Prologue

IN THE PROCESS of emerging out of my father's shadow, a lot keeps bubbling up. Memories of occurrences that shaped and colored my attitudes and behavior early on—thoughts, ideas, beliefs, conclusions. I keep coming up with an incredible array of contradictions, and I wonder how in the world I was able to sift through the morass and stay sane throughout my life.

When I first started writing this story, it was originally in the form of a biography of Eddie Constantine in which I entirely avoided talking about any of my own experiences or expressing any feelings about them. At the time, I felt that I needed to protect him, to avoid revealing anything too personal for fear it would affect his reputation. I struggled to ensure that nothing too harsh would come to light, ending up with a superficial manuscript. The story read as though there was very little honesty or authenticity in the words.

I must confess as well that I had an ulterior motive in this endeavor: to finally get the recognition I had always wanted from him. I knew that if I wrote a book about him, he would be happy. But as I wrote, it became clear that, although revolving around Eddie Constantine,

there was so much to my own story. I needed to shift the focus of the book. This was a revelation for me, and with the clarity of this new understanding, I started writing all over again.

A long process of cleansing began to occur as I delved into the places that hurt me the most—that left deep scars—and I cried bitter tears and went through a series of profound purges. My husband, John, spent days attempting to console me, to lift me out of my bottomless pit.

Eddie was an angry man, always reactive to me. I figured there must have been a reason, but I never tried to trace the origins of his rage. It all makes sense to me now: He was afraid I would find out that he felt inadequate. His character was of the type that identified with image, accomplishment, and success. Most people might believe those to be good traits, but for him to have to hide this secret feeling of insecurity underneath all those layers of false confidence was a heavy burden. The disparity between the character he played in films and how he was in real life was enormous. It's no wonder he drank a bottle of whiskey a day!

I can understand how he'd want to escape from his own darkness. I'm convinced that's why he kept the light on all night. He said he couldn't sleep, but I knew he was just afraid of the dark. He complained of insomnia, and I suffered from it too; but also, just like him, I suffered from a sense of inadequacy. The difference between us was that I was committed to knowing myself, to searching high and low in order to discover and understand myself. I don't believe he ever did.

Eventually, I realized that this catharsis of writing about my experiences and my feelings was an absolute blessing. No longer reliant on my father's approval, I could now stand on my own two feet and find my own answers. I've been living in my father's shadow for so long, and only now am I able to see the light at the end of the tunnel.

Eddie at the farm in Jours de France *magazine, July 1965* Yves Manciet

1. CAUSE TOUJOURS, MON LAPIN

("Keep Talking, Baby")

I'VE JUST DIALED my father's number in Germany. I'm a bit nervous about this call. I don't really know what to expect. My father's responses have never been predictable in the past, and I wonder what he's going to say this time. But I'm very excited about my project, and I can't help but be my ebullient and enthusiastic self. "Guess what, Dad! I'm writing a book! And it's about you!"

I can tell he's picking up on my energy, and amazingly, his response is very different from what I would have thought: "Fantastic! I like the idea! But... can you write?" His tone is doubtful. I register the incredulity, but I figure if that's the extent of his hesitation, I won't make an issue of it. He adds, "No, it doesn't matter. You can always find a ghostwriter to do it for you." Of course he would come up with something derogatory. Then he says, "I know just how you should do it!"

How can he know what I "should" do? He's done this all my life, always thinking he knows what's best for me. I choose not to respond to his remark and say instead, "I need you to tell me your stories. Can I come for a visit and we can talk?"

"Sure, why not?"

"Great! I'll see you in two weeks!"

I hang up the receiver. It wasn't so bad, I guess. He even sounded encouraging, and that's more than I'd expected.

Two weeks later, I'm at the San Francisco International Airport, destination: Wiesbaden, Germany. First, there's a delay of a couple of hours due to engine trouble. I hate to have to wait, especially at airports. The attendant makes an announcement: The departure is further delayed one more hour. They claim they still have more work to do, and I guess it's better they spend more time on it than rush it. But it seems endless. More announcements. More waiting. I'm feeling a lot of trepidation, wondering how my dad is going to greet me. "Is he going to judge me—again? Will he approve of me this time?" I wonder.

We finally take off after 10 hours of waiting, and then it's an 11-hour flight to Brussels. After going through Customs and retrieving my bags from the baggage claim, I find out there's a three-hour wait for the next train to Frankfurt. I wonder what I've done to deserve such a trip; what did I do wrong? The train ride to Frankfurt is an endless-seeming six hours, with frequent stops along the way. After yet another hour wait for the shuttle to Wiesbaden, I finally board—the last 30 minutes of a 35-hour journey.

Bleary-eyed, with my shoulders aching from carrying my heavy bags, I'm thankful Eddie and his wife, Maya, are there to greet me at the train station. Their daughter, Mia, is there, too. She's about 10 now, very tall for her age, and she looks just like our dad. Although we all haven't seen each other in a couple of years, we act as if it was just yesterday. We drive off to Eddie's apartment as I chatter away, complaining the whole way about my long trip, my aches and pains.

Walking into his apartment on the first floor, I notice the framed, poster-sized black-and-white photos of Mia on most of the walls. I comment on how professional the photos are, and as I walk through the corridor that leads to the bathroom, I notice a 3×5 snapshot of me,

unframed, tacked to the wall. I can't help but feel slighted. I register the sinking feeling in my stomach and make a mental note to remember to deal with that issue in therapy, but for the moment, I'm going to let it pass.

I flop myself onto the living room sofa as Maya busies herself in the bedroom. My dad pours himself a drink and nonchalantly says to me, "You know, I've been cast in a German film—isn't that great? I'm leaving for Czechoslovakia in three days."

"Huh? What about working on this book?"

"Oh, I'll just be there for four weeks. You can stay here while I'm gone."

I sheepishly suggest, "Well, maybe we can work hard during the next three days, huh? Maybe that will be enough for me to get started."

"Sure."

Later, I pull out my tape recorder and set it on the table, just in case Eddie gets in the mood to talk. It's my way of pushing without being obnoxious. But he's not responding at all. I figure since there's no time to waste, I'll keep trying. I say, "Tell me about what happened with you and Joan Crawford."

"No, not now."

After dinner, I try again: "Dad, come on. Tell me some fun stories."

He says, "Oh, I'm tired. Maybe tomorrow."

Worried I might have to write this book on my own, I notice some anxiety surfacing. I do my best to stifle the welling emotion, but I just don't seem to have a grip. He's so dismissive; I feel totally disempowered when I get around him. I feel weak and untalented and stupid, and I hate myself for feeling this way.

In the midst of my gloom, Eddie suddenly walks into the room and says, "I was talking to John Wayne the other day..." Jumping up from my chair, I grab the tape recorder, turn it on, and set it in front of my

Eddie with his grandaughter, Jessica

dad. I say, "Go on." He starts up again in the same exact tone and describes an anecdote with John Wayne, but it doesn't go any further, and soon, we're back to silence.

Eventually, he comes up with a disturbing and bizarre story—a most embarrassing one, but somehow, he takes pride in telling me. He was meeting his longtime friend Frank Sinatra at a bar in Paris for a get-together organized by Barclay Records. Eddie had arrived on time—actually early—as he always did for any meeting or appointment. He had time then to down a few drinks before Frank finally showed up. Eddie was a bit inebriated to say the least, and he tended to get

contentious and quarrelsome when he had too many shots of Jack Daniel's. Frank was known to indulge in heavy drinking too, but he hadn't had time to get to the same state. Frank was intentionally ignoring him, holding court instead with the other people there. Eddie kept looking for something to get Frank's attention and was getting more and more belligerent. Then, out of the blue, Eddie had an idea, knowing full well that it would be the wrong thing to do. But he didn't care. He reached out and grabbed Frank's toupee, drunkenly blaring, "Is that your own hair, Frank?" The hairpiece landed in his hand. Needless to say, Frank was irate. And that was the last time they ever saw each other.

During the next three days in Wiesbaden, it's more of the same— these hit-and-miss interactions—and the frustration is really starting to get to me. Most of my attempts to engage him are foiled, and I end up with nothing to call home for other than one lousy cassette of interviews. I'm very disappointed, and I can feel the resentment taking hold of the cells of my body.

The last evening of my visit, Eddie switches on his VCR: "Watch this!" It's a taped program of *Le Grand Échiquier* (*"The Grand Chessboard"*), which was a live, prime-time French television show. Intrigued, I sit on the couch and make myself comfortable. My 16-year-old daughter, Jessica, appears on the screen, standing next to a piano. She's just begun the first verse of "The Man and the Child," the very same duet I sang with my father a whole generation ago.

I find it incredibly eerie to see my daughter—my father's granddaughter—singing the same song he and I had sung together when I was 11. Jessica looks so sweet, and she sounds just like me. It feels like time has taken on another dimension; the past is merging into the present. By the end of the song, my mind was swimming in memories, flashing back many decades to when it all started...

Eddie and me in promotional photo in Nice for Ça va barder

2. L'HOMME ET L'ENFANT

("The Man and the Child")

I WAS IN THE CLASSROOM one sunny afternoon at the Lycée Molière—an all-girls high school in the 16th arrondissement of Paris—when a knock on the door interrupted our 6th-grade math lesson. The superintendent walked in accompanied by Jacky Maitre, my father's secretary. Taken by surprise, I wondered why he'd come to get me. I thought right away that something bad must have happened at home, but his cheerful demeanor told me that wasn't the case.

As I obediently walked out of class to follow Jacky, I could hear the whole room humming behind me. I knew all the girls in my class were wondering what was going on. They were already awfully jealous that I missed school all the time, and that I got to travel all over the world without having to do much homework. In spite of my low grades, I always managed to miraculously pass into the next grade, year after year. It seemed kind of strange. Thankfully, no one ever suspected that my mother had to bribe the superintendent every time!

At school, some of the meaner girls would pull my ponytail whenever they had the chance. Even the teachers had a bad attitude toward me. My Latin teacher said to me one day, "We're not in America here! Why don't you go back where you came from?" This kind of behavior made me feel like an alien; I knew I didn't belong there.

My family didn't offer much support either. When I brought home a report card with bad grades, my father would often say with a twinge of pride (or was it sarcasm?): "You're a daughter after my own heart. I was always the last one in *my* class!"

My mother even disapproved of my reading novels, claiming that it was a waste of time. I remember lying on the couch one day reading my latest discovery, *The Diary of Anne Frank*, which absolutely captivated me. I hadn't gotten through more than 20 pages before my mother ran into the room, flailing her arms and screaming, "Why don't you answer when I call you? What are you doing reading a book when there are so many more important things to do around here?"

"What's wrong with reading? I love this story!"

"But there's so much to be done! I can't do it all by myself!"

She carried resentment about the fact that she had to run a household. Clearly, she would rather have been doing what she loved most: dancing on stage. In this sense, she was bitter and felt unfulfilled in her life, what with my father making it so big in movies and on stage. No offers were coming to *her* from ballet companies!

But back to my story. Walking through those cold and empty stone-walled corridors of the Lycée Molière, I pulled off my gray cotton school uniform as Jacky briefly explained, "Your father wants you to replace the girl in *L'homme et l'enfant* [*'The Man and the Child'*]."

"Me? But I don't even know the song!"

"Oh, you'll learn it."

This duet that Eddie was about to record in the French language was originally done in English, in America, by Frankie Laine and Jimmy Boyd, with lyrics by Wayne Shanklin. Eddie Barclay—of Barclay Records—secured the rights to the song and had the lyrics translated into French by René Rouzaud. He then offered the song to my father.

At first, he had hired a professionally trained 10-year-old girl to sing the role of the child, but Eddie didn't like her. He claimed she just

Eddie, Jeff Davis and me in 1954 in our Paris apartment where we first rehearsed
"L'Homme et l'enfant"

wasn't the part. He said the song required a quality of innocence that
this little girl had already lost. He said, "This is not the way I under-
stand this song. It needs someone without sophistication, with no
training, someone who can sing from her heart." And he stormed out
of the rehearsal room, all upset, hollering, "Get somebody else!"

By the time he returned home, there was an urgent phone message
from Barclay saying, "How about doing it with Tanya? Wouldn't that be
a good gimmick? Eddie and his 11-year-old daughter?"

My father wasn't convinced. Right away, he disagreed with the idea,
and I don't really know why—maybe he was afraid it would reflect on
him if I bombed. But Barclay was pushy and kept insisting. Finally, after
a lot of coaxing, he was able to persuade my father. He said that it was
bound to be a hit because of the "father-daughter relationship" thing.
Before he hung up the phone, he said, "See you later at the studio!"

Walking into my parents' living room, I instantly felt intimidated. My father's pianist, Jeff Davis, was sitting at the piano; Eddie was close by, listening to him play, and there were two other men I didn't know standing around. Immediately, I glanced over at my father to see what kind of mood he was in—he was actually pretty excited. He grabbed me by the arm and pulled me over, took out a comb from his pocket, and started to comb my hair. He always seemed proud of my long hair, often commenting on its reddish hues. He made me promise that I'd never cut it. I wondered why he'd chosen this moment, in front of these men, to say such a thing. It felt awkward. When he was finished, he said, "You're lucky. The recording session has been postponed until this evening. You have a few hours to learn the song!"

I thought of all the times Eddie and his pianist had rehearsed, often for weeks on end, to perfect the nuances of a song. Here I'm expected to learn it in one afternoon?

To get me acquainted with the melody, Eddie put on the American version of the song on the record player; I listened intently. I tentatively sang along, and after a few times, I started to get acquainted with the melody. Someone shoved the French words in front of me. I picked up the sheet and glanced at the lyrics:

"Say, man, old man
Is the world really round?"

I thought, "Do I really have to sing those silly words?"

As Jeff played the first bars of the intro, he suggested, "Let's give it a try." I sang along unsteadily, still a bit unfamiliar with the words, not to mention entirely inexperienced singing in front of people. My stomach tightened as we went along.

In a stern tone, Eddie said, "Do it again. Just keep doing it and doing it."

I took a deep breath and thought, "Boy, this is going to be hard!

How do I sing a song that requires so much feeling when I can't even stand the words?" But I repeated the song over and over again, at least until it was familiar enough.

When Eddie and I walked into the recording studio that evening, I was feeling self-conscious—but also excited. The whole thing seemed like an adventure. Eddie was in a high mood, ready for the challenge. Barclay was there with the technicians, as well as Eddie's artistic director and a few other people I didn't know.

Far from knowing the words by heart, I had the lyrics on a stand in front of me. The first run-through was awful. I was trying my best to sound professional, but what came out sounded nothing remotely like what I had hoped; it was an amateurish voice that I absolutely despised. My lack of training was so obvious, it made me feel terribly awkward.

Eddie made a suggestion: "Don't sing from your throat; that's not what's needed here. Use your head voice!" I tried what he said, but it made me feel like crawling in a hole. I hated that sound. I went back to the throat, hoping no one would notice. He caught me right away and interjected, "Sing softly, almost like a murmur. Don't force."

I was feeling very uncomfortable and was beginning to perspire. I went back to my head voice, but the technician called in to say that either I needed to sing louder or get closer to the mike. My stomach was cramping, the anxiety welling up. Eddie was getting impatient. He snapped at me, "Let's try it again!"

This time I started louder, but Eddie still didn't like it. Raising his voice, he growled at me, "Sing with your heart! Try it again!"

I thought, "I don't know what that means—to sing with my heart. How do I do that? How do I sing from my heart when I don't even love the song I'm singing?" I didn't understand the difference between a head voice and a chest voice. I believed the head voice was for people who had not studied singing and therefore was less desirable. Of course, I wanted to be a professional Broadway singer, but I didn't have

the training. I was only 11 years old, totally in the dark, and my dad was not helping me in the least.

Eddie was getting exasperated. He'd noticed the frown on my face, and he didn't like it one bit. The technician came in to adjust the microphone closer. Glancing at me with a slight bit of concern, he said, "Watch out for your SHs and Ses. The mike is picking up the hissing."

He walked back to the booth, and I tried again. My father interrupted me and screamed, "I'm tired of this bad mood, Tanya! Wipe that scowl off your face! Sing with feeling! Do it! *Now!*"

I was on the verge of tears. My throat was totally contracted, and I had to stifle my sobs. From the sound booth, I heard Barclay's voice: "Relax, Eddie, take it easy!" Realizing my predicament, Barclay asked, "Tanya, is there anything we can do to make this any easier?"

"No, I just have to do it right!"

I tried my best to smile through the tears that were now beginning to pour out. Someone brought me some Kleenex and I blew my nose. I felt terribly embarrassed by all this display of emotion—in fact, I was mortified. Looking at me with menacing eyes, my dad announced, "We're gonna do this again, and this time, it'll be right."

As the music intro began, I realized I wasn't going to get anywhere if I kept fighting him. He was stronger than I was. And he had much more power. I figured I might as well give in and comply with his wishes—even if I didn't agree.

Concentrating intently, I started my verse, singing exactly the way he wanted me to, with feeling and emotion. It was difficult for me to display this sort of sentimentality in front of people, but I had no choice. Instantly, I received an air of approval from the technicians in the booth.

When it was Eddie's turn to sing his verse, he sang it with profound sensitivity. At the end of the run-through, Barclay ran into the room and triumphantly announced, "That was great! Come and listen!"

Exhilarated, my father walked over to the booth. I sheepishly followed. Though terribly hurt, I did my best to pretend everything was fine. We stood in the crowded booth listening to the cut, and I cringed the whole way through. I thought it was awful, but everybody kept raving about it.

The recording needed just a little more tweaking; my SHs and Ses were still whistling. We went back and did a few more takes until all the details were corrected. In the end, everyone was delighted with the cut. They all felt it had just the right quality to become a hit single.

Well, they were right. Almost overnight, that song was an enormous success. It remained number one on the charts for months, and it was on the radio nonstop for nearly three years. Throughout all of France, one could even hear it in the streets, being sung and whistled by practically everybody. And the record sold over two million copies! We even received a gold record. How ironic that I could be so wrong, so totally wrong—good thing no one ever asked my opinion!

Because the song was such a big hit, my father chose to incorporate it into his singing tours, which meant of course that I, too, had to come along. I can't say I appreciated the opportunity; I was confronted to the core and cowered throughout most of the shows. I must admit, however, that I enjoyed that feeling of specialness. I thrived on it actually, and that was what really carried me through the difficulty of performing in public.

The performance was staged: My father and I would stand behind our microphones, which were placed on opposite sides of the stage, and we'd sing looking at each other all the way to the last verse, at which point my father would take his mike off the stand, and we'd walk toward one another until I ended up in his arms.

Eddie was always able to sing with depth of feeling and emotion— even when he'd been in a bad mood just a few minutes before. The audience had no idea what went on behind the wings; they simply

loved what they heard and loved what they saw. People were moved to tears, and the show would frequently conclude with a standing ovation!

For me, however, the whole thing was a farce, and a terribly embarrassing experience. The emotional display seemed insincere, and I suffered horribly from my own awkwardness and inability to expose my feelings in public. Had I been a bit less judgmental, I might have been able to appreciate the beauty and archetypal symbolism in the lyrics. If I hadn't been so obsessed with authenticity and perfection, I might have gotten the point. But I didn't know how to deal with the reactions I was having back then; I didn't have the maturity to understand. I've sorted out all those reactions, and now I can fully appreciate the true depth of meaning that song carries. The lyrics are so moving that I now often tear up whenever I hear it.

> Me: *"Old man, old man, is the world really round?*
> *Tell me, where in the world can a bluebird be found?*
> *Tell me, why is the sky up above so blue?*
> *And when you were a boy, did you cry like I do?*
> *What becomes of the sun when it falls to the sea?*
> *And who lights it again so that we can see?*
> *Tell me, why can't I fly without wings when I try?*
> *I just can't understand why you're crying, old man."*

> Eddie: *"Little child, little child, yes, it's true the world's round*
> *But I never did find where a bluebird is found*
> *And the sky is blue just because of love*
> *May your sky always be like the blue sky above*
> *And the sun only seems to fall into the sea*
> *If the sun always shone, how could moonlight be?*
> *Little child, you can't fly; why, you'd fall! Didn't I?*
> *Well, goodbye, little child, goodbye!"*

In April of 1956, Prince Rainier and Grace Kelly were planning their wedding in Monte Carlo, and my father and I were invited to sing our duet at the reception. As a publicity stunt, Eddie devised a plan to have me offer our gold record to them as a wedding gift—an act that was sure to get a lot of coverage in the newspapers. It was an unbelievably big event, and there was a lot of commotion around the palace. Even though the hungry paparazzi were refused access, they were still desperate for pictures. One of the photographers from *France Dimanche* approached me and asked if I'd be willing to install a photographic device under my dress. When I was close enough to the bride and groom, all I'd have to do was press on the button to get a good shot of them.

Although I knew it was a terrible idea, I accepted the offer. It was a way for me to vent my disapproval of my father without being too overt about it. I really disdained such excessive displays of wealth and have always tended to support the underdog. I related more to the trials and tribulations of the working class than to the artifice and self-centeredness of most wealthy people I knew in those days.

At the reception, all was going according to plan. Eddie and I had sung our song, and our performance was met with great success. But all I could think about that whole time was being an accomplice to this insidious plot. I hardly even noticed the enthusiasm with which Prince Rainier and Grace Kelly were applauding us.

Mere minutes before approaching them with our gift, my father ran up to me and pulled me into a corner, yanking the device off from under my skirt. Apparently, he'd been tipped off about the scheme. Seething with rage, he uttered between his teeth, "How could you do such a thing?" Terrified, I felt caught between the reporter on one side and my father on the other. Eddie kept muttering under his breath so no one else could hear, "Never associate with journalists! They're opportunists! They're the worst!"

Needless to say, I was a nervous wreck. In the midst of all this commotion, trembling from head to toe, I mustered the courage and bravely walked down the aisle, all eyes on me. Grace Kelly and Prince Rainier were seated in a sumptuous floral setting under a gazebo, and Grace had to be the most magnificent and exquisite woman I'd ever seen in my life. Hands shaking, I offered her the gold record, which was encased in an open box and tied with a big red velvet bow.

Being so close to Grace, I was dazzled by her astonishing beauty. I felt like I was looking at the divine goddess herself, and it took my breath away. She seemed absolutely delighted with her gift and graciously accepted it, thanking me with a wonderfully warm hug. When I turned to look at Prince Rainier, he gave me a smile that swept me off my feet. I walked away on cloud nine.

Some months later, Barclay came up with the idea of having me and my father record an album of Christmas songs. Eddie would sing "White Christmas," and I was to do a couple of modern French carols. He also picked an old hit song, "Petit Papa Noël," that had originally been recorded by the French singer Tino Rossi. Though not initially a duet, we were able to reconfigure the song for two singers in hopes that it would be yet another big success.

The session was arranged, and we met in the recording studio. Right away, I had problems with my Ps—it sounded like I was spitting into the mike. In those days, they didn't have the technology to muffle the noise. They tried tying a handkerchief around the microphone, but that didn't do it; they tried toning down the sharps, but that didn't seem to make any difference either. My father was getting agitated. In all his years of recording, he'd never once encountered this problem. I think he believed that I wasn't cooperating with the technicians. He didn't realize that, because I lacked a strong voice, I had to sing very close to the mike in order to be heard.

After many hours of struggling, I was advised to step back whenever

Eddie, Tino Rossi, and Luis Mariano PUBLICITY PHOTO

a P occurred in the lyrics. Of course, it didn't sound very good, but somehow the producer approved of the cut, and they went ahead with the recording. In spite of its obvious flaws, the record was released and sold well—which, in retrospect, is quite baffling!

The following year, due to the success of the first recording of "L'homme et l'enfant" in France, a German record company (Electrola) decided to cash in on it—Eddie being just as famous in Germany as he was in France. With the lyrics having been translated, all was set to go. The recording session was scheduled in Cologne, and my father and I were now on our way to Germany.

Unfortunately, we ran up against the same problem that had plagued our previous sessions: I kept trying to sound like a trained singer (at least that was how everyone else perceived it to be). The real reason, however, was far more complicated; it involved a battle of wills

between father and daughter. From my perspective, my father wasn't showing me *what* to do; he just sounded like he was unhappy with what I *did* do. I was left feeling confused, when I could have actually used some professional advice. He repeatedly told me, "Use your head voice, sing from your heart," but what I didn't understand were more practical matters—like at which point to take a breath in the melody so I would have enough air to sing the line. He was getting more and more irritated with me, while I became increasingly withdrawn and even more confused.

He accused me, "You're so moody! I can't stand it!"

"But I don't know how to do it the way you want me to!"

"Yes, you do! You're just stubborn!"

As we continued to rehearse, Eddie was getting nasty. "You're absolutely impossible!"

Suddenly he lost patience, and in a fit of rage slapped me across the face—right in front of the technicians, the producers, all the other people present. Everything stopped. An uncomfortable moment of silence spread throughout the studio, and everyone was in shock—especially me. I turned red with embarrassment, and tears immediately started pouring out, running down my face. I did my best to stifle the grief and frustration, but all I could do was sob. Someone brought a box of Kleenex, and meekly, I blew my nose. I hated my father for humiliating me like this in public! *How dare he? How could he do this to me?*

A few minutes later, my father impatiently announced we would try it again: "This time, it should be taped." As I stood there, totally disempowered, feeling the hurt and the pain and the humiliation inside, I couldn't help but express all that emotion as I intonated the first verse of the song. In that moment, there was feeling in my voice. It was very expressive, and, to everyone's satisfaction, we finished the taping.

As we walked out of the studio that evening, droves of photographers were there waiting to take pictures of us. As soon as my father saw

them, he removed his glasses and exhibited his usual broad smile. Already having been through such an ordeal, I was hoping I'd be forgotten, and so I bashfully stood behind my dad. Unfortunately, it didn't escape his notice. As he exhibited his phony grin to the photographers, he very roughly pinched my arm, snarling at me between clenched teeth, "Smile!"

Fearing another slap, I obediently moved next to him and smiled as best I could, but inside, I was furious. I didn't have the same values and needs as he did; I was an idealist, yearning for truth and authenticity. He had his career and, consequently the showy, social obligations that went along with the whole scene.

During this time, I often wondered, "Why doesn't he leave me out of all this? Why do I have to participate in his life? Why do I have to do things I hate to do?" But as much as I wished otherwise, I couldn't escape my destiny. I knew that I was still the daughter of a movie star, that I was an integral part of him. Although I desperately fought to maintain a sense of individuality, I was somehow inextricably linked to him, into being a part of his life, and I resented that severely.

Shortly after this, I had an experience that made an indelible mark on me. My father and I were invited to participate in Josephine Baker's gala, "Adieux." It was a farewell variety show in the largest theatre in Paris at the time, Gaumont-Palace, which could seat up to 5500 people. Eddie was scheduled to sing in the first part of the program, and the organizers billed me in the second act singing a Josephine Baker song—all by myself. I'd never sung it before, and I'd only been given a few days to learn the lyrics.

I wasn't yet at ease with it when the night of the performance arrived. This was the first time I'd ever sung alone on stage, and I was absolutely terrified. To top it off, the venue was packed with the Parisian elite: Anybody who was anybody was in the audience, all decked out in high fashion. I couldn't have been in a more intimidating situation.

With my stomach in my throat, I kept repeating the words to the song—over and over—to make sure I wouldn't forget. I was thinking just before going on that I had only ever sung with my father, and I hadn't realized until that moment just how much security that gave me. This time, there wouldn't be anyone to rescue me if I flubbed.

For some reason, the show was way off schedule. No one had any idea when I'd be going on. All I could do was wait in the wings, pacing up and down until it was my turn. Pretty soon it was well past midnight, and I was getting exhausted from the tension, feeling droopy and almost sleepy. When the MC finally called my name, I valiantly took my first step. I walked across the gigantic stage over to the microphone, the front lights blaring in my eyes. I noted with dismay that the mike wasn't adjusted to my height. Resigned to make the best of it, I stood as tall as I could in order to reach the mike. The song began playing.

The sound of my voice shocked the hell out of me—it was incredibly loud and distorted. But I carried on, glancing over at Josephine Baker who was sitting in the front row smiling at me. She looked like she was in heaven. I was doing well, actually enjoying the experience and happy at how well I was remembering the words, when suddenly at the second coda, my mind went blank. I tried to concentrate but nothing came to me. Nothing. No words, nothing. Desperate, I looked over at Josephine Baker, who was mouthing the words to me, but I couldn't understand what she was trying to convey. Totally panicked, I stood there with the proverbial finger in my mouth, unable to remember a single word. The music continued. The song seemed endless. When the last chorus finally ended, I didn't even bow—I ran off the stage. The audience was stunned, and though there were some polite applauds, I was destroyed. I desperately ran behind the curtains into my mother's arms and sobbed uncontrollably.

Trying to console me, she said, "It wasn't that bad, dear!" But I knew better.

Eddie and Ray Ventura at the Olympia Music Hall, 1955 Aldo

I assume my father was embarrassed, but he expressed it in a different way: He went around blaming the organizers of the show, screaming, "You're crazy to have kept her waiting so long! That was a terrible thing to do to her!" Although he stood up for me, I was inconsolable.

In the newspapers the next morning, I got deplorable notices. The critics demolished me with total lack of compassion, remarking that there was no excuse for a professional singer to allow herself to be so amateurish. I must explain that the word "amateurish" was an exceptionally bad word in our family. If you had the misfortune of being labeled as such, then you were powerless. There was no more reason to stick around.

Needless to say, I was more than devastated. I came to some radical conclusions about myself that night: that I was valueless, worthless, and untalented. I decided then that I was a failed version of my father. And

Eddie and me in Nice
A.Traverso

yet despite all these horrible feelings, I was still able to wake up the next morning with the realization that, no matter what happens, life does go on.

Some months later, my father signed a contract to star in a cops-and-robbers film that used the title *L'homme et l'enfant*. The producer—a jazz bandleader and composer named Ray Ventura—wanted to bank on the success of the album. Raoul André would direct it. There was the role of a little girl in the film, and Ray Ventura mentioned that he'd found a nice 13-year-old girl.

Surprised, the director complained, "But I don't understand. 'L'homme et l'enfant'—who did it? Eddie and Tanya, no? So why do a film with someone else?"

Eddie shrugged his shoulders, unwilling to take a stand on the issue. Perhaps he was still holding me to my failure to perform

*Eddie and me
in Nice filming*
L'homme
et l'enfant
WILLY RIZZO

adequately. He washed his hands of it and said, "I don't care. It doesn't matter to me."

But Raoul André insisted, "It doesn't make any sense to do it without Tanya!"

Personally, I was flattered that someone was fighting for me. Under Raoul's continuous pressure, Ventura finally agreed to hire me to play the role of the little girl. It was a small part, but I still had some lines to say. In the plot, I am kidnapped, and at the end of the film, Eddie saves me from my abductors. It was a true B movie script in my opinion (although to this day, my father's fans still think it's a good film).

During the shooting at the studio in Nice—a coastal town on the French Riviera—there was a scene in which I'm locked in a room that was on fire and I'm trying to escape. I had to pound on the door and cry and scream for help. On the day of the scene, Raoul André, whom

I loved dearly, took me aside and explained what he wanted. He gave me my lines, which were short and easy, and he acted out what he wanted me to do. He explained that at the end of the scene, Eddie would fling the door wide open, grab me in his arms, and carry me off. He said there would be smoke coming from under the door, but not to worry. And very matter-of-factly, he said, "You'll need to shed a few tears."

Concerned, I was thinking, "I don't know if I can do that! Cry on demand, just like that, in front of everyone here?" But I boldly took my place, praying that I'd have the courage to go through with it. When the set was totally silent, he bellowed, "Action!"

Timidly, I banged on the door and yelled as loud as I could. The smoke started to come up from under the door—but I had no tears. I tried to force them out, but nothing came. I noticed the tone of my voice also sounded very inauthentic. I felt completely inadequate and unprepared. I just didn't seem to be able to act at all.

At the end of what seemed an interminably long time, Raoul André yelled, "Cut!" and walked over to me with a grim look on his face. He exclaimed in an irritable tone, "Is that the best you can do? That's very disappointing!"

Wham! Did that ever hurt! My chest welled up with emotion, and tears started flooding my eyes. Raoul immediately moved me in front of the camera, announced the second take, and yelled, "Action!"

This time, I played the scene like I really meant it: I cried and sobbed and screamed hysterically, pounding on that door as if it were the end of the world. Then my father flung the door open, rescued me from the fire, and dramatically carried me off.

As soon as Raoul yelled, "Cut!" he came running over to me and took me in his arms, thanking me for having done such a beautiful job. He apologized for having hurt my feelings and said, "You know, I had to do it. Look at the result! Wasn't it worth it? You were great!" But I

continued sobbing—uncontrollably and for the longest time—swept away with endless sadness and grief.

Days later, we were shooting at sea, aboard a yacht off the coast of Cannes. The water that day was rough, and on the yacht, it was even worse than I'd imagined. The boat was violently rocking back and forth. I couldn't stand up straight for an instant. I was green with fright, and after glancing over at my dad, I realized that he was too—but his response to fear was to get angry.

Meanwhile, a small airplane was flying overhead, and the cameraman was filming shots of us from the boat. In between takes, the pilot was showing off. I was very nervous and upset about his shenanigans, worried that he might crash into our boat.

Well, it turned out I was right. Just a few minutes later, only a hundred feet away from us, he crashed into the water! As soon as the plane hit the water, it burst into flames. The pilot was severely burned. People were screaming; rubber boats were thrown overboard; men were jumping into the water to help; there was dark smoke all over the place—it was absolute mayhem!

After all the excitement had died down, my father and I were quickly shoved into a motorboat to start rehearsals for the next shot. In this scene, Eddie had to jump into the sea and swim a couple hundred yards to the boat. I was supposed to be there to give him a hand as he climbed into the boat. The weather was not cooperative; the swells were 12 feet high and the wind was getting stronger by the minute. I was petrified that my father was going to drown! Just in case, two stuntmen were stationed next to the camera, ready to jump in and rescue him if need be.

After doing the scene a couple of times, Eddie was getting tired. By the third take, I just couldn't watch anymore, and so I turned away. Just then, I heard Raoul André order the men to jump in. I saw them fly through the air like bullets while my dad was thrashing around in the

water, his head bobbing up and down. They quickly grabbed him and dragged him up from the water. Overcome with fear and upset, I burst into tears. I was hysterical, blaming the director, "It's all your fault! You almost killed my father! You're an idiot! You're the worst movie director in the whole world!"

Eventually, I calmed down and went over to apologize for my behavior. Later that evening, after everyone gathered around the bar for drinks to relax, Eddie went over to the two stuntmen and thanked them for having rescued him. He said, "You know, you guys saved my life!" and gallantly handed them each a few French francs as a token of his appreciation. (I later heard he'd given them 10 francs each, which was about 5 dollars! I guess he thought he was being generous!)

The next day, in spite of the stormy weather, Eddie and I were hauled down to a Chris-Craft boat. The swells were as high as the day before, the wind was even stronger, and, to top it off, a helicopter was hovering over us to film the scene, as Eddie steered our way through the waves. Every time we passed under the helicopter, the wind was so strong that the boat would lift up into the air and lose control. My father was doing his best to ride over the waves, but a few times we almost turned over. We were both terribly frightened. Eddie kept screaming, "This is ridiculous! Why do we have to do this today? Why don't we do it tomorrow?"

Here we were in the middle of the sea—stuck in this boat, angry as hell, pretending to be happy and smiling for the cameras. These were the last shots of the film. We were mouthing the words to the theme song of the film, "L'homme et l'enfant." The camera pans over us with the last bars of the melody as we ride off into the sunset, singing the words (translated from the French): "My child, you'll go further than the day! The bluebird is love!"

3. LES FEMMES S'EN BALANCENT

("Dames Don't Care")

In spite of the success of the French record, the German version, and the film *L'homme et l'enfant*, I never received a penny for my participation. Being a minor at the time, the funds automatically went into Eddie's account, and no allowance was ever made for any trust fund in my name. In those days in France, there weren't any set rules for children in the cinema business. A child could work as long as the director needed, without necessitating, as it would today, that a tutor be present on the set, and unfortunately for me, there were no regulations in place for a child to receive compensation.

As a token gift, however, I was offered an 18-karat gold chain bracelet from the producer, Ray Ventura. It was very considerate of him and I was grateful, but it still didn't diminish the sense of having been given the short end of the stick. And it certainly didn't make me feel valued. Barclay Records also gave me a miniature brooch in the shape of a bluebird, made of gold and sapphire. Nevertheless, knowing that Eddie was getting paid the big bucks, I couldn't help but feel slighted. I never dared talk about the issue openly. I was afraid of being reprimanded, so I kept my resentful thoughts to myself.

My father often complained about how much money he was spending, claiming it was costing him a fortune for my upkeep. If he had ever

looked in my closet, he would have been witness to the fact that my wardrobe was spare, to say the least. I felt like a peon, of no essential value or importance in my father's life other than to serve his career. And the bitterness I felt toward him grew stronger each day.

Earlier on, before Eddie became a household name, I was going to a school just down the street from where we lived in Neuilly, on the outskirts of Paris. My mother had enrolled me in a pottery class. I had made an ashtray out of clay, which I painted dark green. I remember the glaze turned out nicely once it was fired. I was very proud of myself. I decided to give it to my dad for his birthday.

When he opened the box, he jokingly said, in the way he always did when he didn't like a gift, "Oh! just what I need!" He made fun of it, and, adding insult to injury, he commented, "It isn't very well made!"

My heart sank. I remember feeling totally deflated. I was happy with what I'd made, and I'd wanted so badly to please him. At that moment, I concluded that if my father didn't think my work had any value, then that meant I was worth nothing too. This thought caused me a tremendous amount of pain—pain that made it seem real. Over the years, I have had many other experiences that confirm this belief.

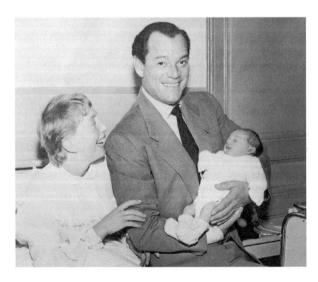

Eddie and Helene with baby Barbara at the clinic in Nice in 1955
J.NOVENTI

It was 1957, and we were staying at the Hotel Negresco in Nice. My sister, Barbara, was about two years old at the time. My parents had gone down to the lobby for a meeting with reporters. While they were gone, Barbara had gotten a hold of a knife and was carrying it by the blade. Frightened that she would hurt herself, I grabbed the knife and pulled it right out of her hand. Blood instantly squirted out. She started howling. Realizing I'd made a terrible mistake, I panicked. My vision blurred, and I was on the verge of fainting.

I managed to carry her to the bathroom. I filled a glass with water and dunked her tiny hand in it. When it instantly turned bright red, we both became even more scared, and Barbara's cries redoubled with intensity. I was frantic—with all the blood flowing out and the screaming—but I managed to call a maid, who ran down to get my parents.

There was a lot of commotion when they arrived. Helene was hysterical. Glaring at me menacingly, Eddie asked, "How did this happen?"

After briefly explaining, I quickly added, "Oh! I learned my lesson! I'll never do that again!" But my words went unheard in the midst of the chaos.

Eddie went around the room, frantically opening all the drawers to find an elastic band. Luckily, he found one and quickly tied it around my sister's wrist to stop the blood from flowing. The hotel nurse arrived and bandaged Barbara's hand up within minutes.

It turned out that she hadn't been cut as deeply as it first appeared, and it was all much ado about nothing. But I felt terrible about what I'd done. I blamed myself mercilessly for making such a mistake, and in my book, mistakes were unforgivable. I hadn't yet figured out that mistakes were part of the learning process. In those days, I was convinced making a mistake meant that I'd be abandoned—and in some ways, that was actually true for me.

That same year, 1957, we went on a two-week vacation to the mountains in Switzerland: my father, my mother, my father's pianist Jeff

Davis, my sister and her nanny, and me. We all rode the overnight train from Paris to St. Moritz and slept in the sleeping berths. My mother had packed 21 of her newly acquired evening gowns. She'd recently been on a shopping binge in retaliation against one of my father's extramarital affairs. You see, this was a very sore spot for her. She yearned to be an example to the world of how a family, in spite of stardom, could remain happily together.

But my dad kept violating this agreement. Her way of getting even was to go out and spend his money—and that's what she did! Her problems during this trip were further aggravated by the fact that she was pregnant (and having a difficult pregnancy, at that), so she spent most of her time in bed due to the complications.

The Badrutt's Palace Hotel was (and probably still is) one of the most luxurious hotels on the planet. Eddie and Jeff spent most of their time sitting in the lobby, watching people go by and partaking in their favorite pastime—cracking jokes at the expense of others. They'd make up stories about some of these "elite" people carrying skis on their shoulders just for show, pretending they were skiers but in fact never having gone down a single slope! Other times, their jokes were scatological, and I often couldn't help but join in the laughter. But there were times when the humor was a bit sharp-tongued, and I was grateful I wasn't on the other side of their fence!

At dinnertime, Eddie, Jeff and I would rub elbows with people like the Maharani of Baroda, the Rothschilds, Stavros Niarcos, Aristotle Onassis, Gianni Agnelli, movie stars such as Rita Hayworth, and numerous other world-renowned figures. Eddie pretended not to care about all the fuss around the royalty and the famous figureheads, but he was thrilled to pieces when these people recognized him. And when they came over to say hello, he was in seventh heaven! He loved to be part of the "in" crowd—especially *this* crowd. I remember him saying that he was considering purchasing a family emblem so that he could be a

baron or a count. Baron Constantine—that had a ring to it! It never happened, but he definitely dreamed of it.

There was a funny scene one time involving Aristotle Onassis. To keep Helene company, my father, Jeff, and I would take our lunches in her hotel room and order room service. We'd noticed this private airplane landing on the tarmac nearby, as we had a direct view of the landing strip from our window. The waiter who was serving us got all excited and said, "Oh! It's Onassis!" not realizing he was pouring the pot of hollandaise sauce on Jeff's lap. Jeff was furious, but my father and I roared laughing!

It was during our stay that I had my first experience of being kissed by a boy. He was a 15-year-old Danish boy, the most handsome thing I'd ever seen. Blond, blue-eyed, tall, handsome, charming—a dream of a boy. It was as if he'd stepped right out of a Hans Christian Andersen tale. I still remember his name: Peter Skaarup.

For weeks, I couldn't bring myself to go up to him. My heart would start beating faster every time I saw him on the skating rink. Then one day, a girl my age came up to me, and putting her face inches away from mine, she asked out of the blue, "Tanya, would you be my friend?" Having recognized me from being in the newspapers, she decided to approach me. Joanna Harcourt-Smith—with whom I am still connected to this day and who later became Timothy Leary's wife—was cute and outgoing, and she had a knack for making friends. I was thrilled, and together we joined forces to corral the kids and have some fun during our stay at Badrutt's Palace Hotel in St. Moritz—and boy, did we create havoc! We organized many parties, and we would play games of hide-and-go-seek in all the dark corners of the hotel, even down in the basement. Both Joanna and I had a whole slew of boys running after us, but I was only interested in Peter.

That night, Peter and I found ourselves sitting on a bench in the dark—in the basement, no less! He kissed me on the lips first, but then he pushed his tongue in my mouth. It seemed strange to me, but I let him do it. I had the thought that I should be moving my tongue too, or doing something with it. He stopped and whispered in my ear, "The next time we meet, I'll teach you how to kiss." He was warm and tender, and I just melted in his arms. But we never had the occasion to be alone again, and soon, he was on his way back to Denmark.

Come to think of it, Peter's was not my first kiss. Believe it or not, my first kiss was my father's! I had just turned 6, and I remember the moment as if it were yesterday. My dad was lying on his back, comfortably nestled on the couch in the living room of our rented house in Neuilly. I was lying on top of him with my arms around his neck, laughing and giggling and being silly. We were giving each other Eskimo kisses, nose to nose, and then he showed me how to French kiss. I thought nothing of it. I was innocently exploring this new way of relating, and it felt really warm and fuzzy. Then suddenly, when my mother walked in, I felt a sharp rush of adrenaline run through my stomach. She was giving me the evil eye, signaling to me that I had done something wrong—*really* wrong! I felt my father withdraw. I sensed that I couldn't rely on him to protect me anymore. Although we never verbally acknowledged it, it was at that moment that I experienced our split-up. From then on, there was an unspoken tension between us that rarely ever let up.

Back to my story in St. Moritz. There was another young man at the hotel who was trying to woo me. His name was Jean, and he was a troubled boy, about 17 years old. He was the son of a French business magnate who owned a chain of dime stores all throughout France called Prisunic. He kept trying to get my attention and claimed that if I refused to have a relationship with him, he'd commit suicide. His neediness made me feel very uncomfortable. I wondered why he had

grown so attached to me in such a short time, and I avoided him more often than not.

Then one day, Jean announced that he was going up the most difficult ski slope on the mountain and was planning on killing himself. It was an obvious ploy for attention, but it made for big-time drama. His parents were alerted, and the police went searching for him up and down the mountains until late into the night. Around 2 o'clock in the morning, he finally came back on his own. I guess because it was so bitterly cold out there, he'd changed his mind. Nonetheless, the whole commotion didn't open up my heart, and he and I ended our stay giving each other the cold shoulder.

With vacation over, it was time for us to return home on the train. My mother was in the bottom bunk, Eddie and Barbara were up above, and I was in the next compartment with the nanny. In the middle of the night, my mother woke up in a sweat. Noticing that Eddie was stirring, she whispered, "It's so hot! Can you open the window?" Eddie was gracious enough to get up. He fiddled around, trying to get the latch unlocked. Pressing down hard with his hand, he must have put too much pressure because his fist suddenly went through the window-pane, shattering the glass into millions of pieces. Helene let out a shriek and quickly turned on the light to see what had happened. Blood was pouring out of Eddie's hand, and there was glass all over. It was an awful sight!

My mother screamed, "Oh, you're ruining the bags! You're getting blood all over them!"

Eddie was hysterical, yelling, "Do something! Do something!"

My mother couldn't tell if it was the train or her legs that were trembling the most, and it took all of her energy to reach the button to call for the attendant. Taking a closer look at Eddie's hand—and seeing the sheets and the bed covers and Eddie's clothes all covered with blood—her knees gave way and she passed out.

When the train attendant arrived, he rushed over to assist Helene, but my Dad anxiously reminded him, "I'm the one who needs help, not my wife!"

The man hastened to get supplies and returned with a bandage and a tourniquet. When he was done, he hurried off to send a message to the next stop, alerting them to have a doctor ready to come on board. They had a strange way of communicating in those days: The man wrote his message on a piece of paper, wrapped it around a stone with an elastic band, and threw it out the window just as the train was passing by the next station at full speed.

When we rolled into the next scheduled stop, this archaic system had worked. Sure enough, a doctor was there waiting to see the extent of the injury. After one look at Eddie's hand, he said, "There's nothing I can do for you. The glass has to be removed, and I can't do that here." He tied up Eddie's arm so it would stop bleeding and gave him painkillers.

When we arrived in Paris the next morning, Eddie went directly to the hospital, where his personal doctor was waiting to work on him. In order to get rid of all the tiny pieces of glass embedded under the skin, the doctor had to scrub his hand and arm with a steel brush. Eddie was in agony, screaming holy hell and calling his doctor all sorts of names. Eddie said he'd never experienced pain like that in his whole life. They sewed him up with numerous stitches.

Just as the job was completed, the doctor started to turn pale. He looked at Eddie and said under his breath, "You know, the cut was really close to the vein." His knees suddenly buckled. He fell to his knees and passed out!

About a month after our return from St. Moritz, Jean sent me a letter bitterly complaining about how badly I'd treated him. He claimed that I had acted irresponsibly and that he was very offended by my behavior.

He said I needed to grow up and learn some respect. I was pretty upset and read the letter to my mother to see what she thought of it. She remained neutral, letting me come to my own conclusions—which was very wise of her. I didn't even bother to answer and figured I'd never hear from him again.

Soon enough, however, I received a phone call from him, inviting me to the movies to see *The King and I* with Yul Brynner. The film had just come out and was showing at a movie theatre on the Champs-Élysées. I was flattered that he still wanted to be friends with me, and so I agreed. He said he'd send his chauffeur to pick me up with his Rolls-Royce on Sunday morning at 11 o'clock. I got so swept up in the excitement of it all that I didn't dare tell him that on Sunday mornings I always went to church with my mother.

When I hung up, I realized that I had to think of a good excuse. I went over my options: "Maybe I could tell her that I'm sick… no, that wouldn't work. Oh, I know! I'll tell her I have so much homework at school that I have to go to my friend Christiane's house so her parents can tutor me. Yes. Maybe she'll buy that."

That Sunday morning, I was all happy getting ready for my first date. My plan seemed to be working. Helene had accepted my excuse for not going to church, and it looked like the road was clear. But then all of a sudden, the plan broke down. Helene was late to leave for church, and Jean was early to arrive. And exactly what I didn't want to happen happened: Jean's Rolls-Royce came up the driveway just as my mother was walking out the door of our building. I watched the scene unfold from my bedroom window. One look at my mother's face and I was frozen to the bone—I'll never forget that look. I crumbled inside, and I felt like crawling in a hole. She knew instantly that I'd lied to her, and I knew she would never forgive me for this. It wasn't the issue of having a date with Jean; it was that I'd lied to her and betrayed her trust.

Feeling really low, I still decided I wasn't going to let this ruin my

date. I walked out the door to join Jean just as he was shaking hands with my mom and saying, "Don't worry, she's in good hands with me!" Thankfully, he didn't have a clue about what was happening, and I was glad for that. As my mother walked over to her car, our eyes met for a quick glance, and my stomach tightened. I knew I was in big trouble when I got back home.

I had a great time with Jean that day. We held hands during the film, and then later, we went out to the Plaza Athénée for lunch. I loved being lavished with attention, and the idea of being driven around in such luxury was appealing to me.

I was dreading having to go back home, but when I walked through the door that evening, my mother didn't give me the hard time I thought she would. She simply acknowledged that she was hurt that I had lied to her. Then she left to her room and went to bed—that was it. I guess I got off pretty well, especially considering I was only 13 years old!

But it wasn't just boys that I fell for; I also had a teenage crush on Sir Laurence Olivier. And this was a classic case of the Oedipus complex because he reminded me of my father—in fact, he looked just like him. I saw his films, I read about him in the papers, and I dreamed of seeing him on stage.

One day, that opportunity presented itself. He was performing in *The Entertainer* at the Royal Court Theatre in London, and my father made arrangements for the two of us to fly to London. We did that sort of thing when Eddie had a free weekend. My mother didn't enjoy taking off with my dad, always claiming that she was too busy. At first, I was ambivalent, but then I got excited by all the adventurous possibilities—not to mention that I got to keep Eddie company and play wife with him for a few days.

Eddie had purchased tickets in the very front row of the orchestra, the best possible seats. Although I was acting cool, calm, and collected, I was beside myself with excitement. In the play, Olivier performed the

role of a second-rate actor. He was totally convincing, and Eddie and I were moved by his performance. I cried throughout the show, and I didn't want him to leave the stage at the last curtain call. I applauded until my palms were stinging.

After the show, Eddie suggested, "Let's go backstage and say hello to him."

Feeling much too shy, I protested, "You go alone. I'll wait here."

To this day, I hate going backstage after a show. I'm always afraid the performers don't want to be disturbed and just feign interest when in fact they just want to be left alone. But I really can't know if that's true. There I was, standing in a corner all withdrawn, worried my father was going to force me into an embarrassing situation. After a few minutes, Eddie returned in an excited state and said, "He wants to meet you. You've got to come up!" Thrilled beyond my wildest dreams, I eagerly followed my father up the stairs. My heart was pounding as Eddie knocked at his door.

The door opened. Sir Laurence took my hand and gallantly kissed it. My face flushed, but I was delighted; he was treating me like a queen! He had the most genuine smile and was a real gentleman, congratulating Eddie on his recent film, praising his performance. Eddie was ecstatic. The teenage fan that I was, I kept admiring Sir Laurence, watching every move he made. I asked him, "What are you doing next?"

He said the next thing on the schedule was Shakespeare's *Titus Andronicus*. We agreed we'd see each other then. By the time we left his dressing room, I was walking on air. Eddie felt pretty good too, and we swore nothing would prevent us from returning for his next play.

Unfortunately, Eddie had to fly to the South of France when Sir Laurence's next play ran, and we never did make it back. Disappointed at not being able to meet with him again, I wrote him a letter informing him of my profound regret. A month later, I received an answer from Zagreb, Croatia, written on beautiful light-blue stationery. In it,

Laurence Olivier said how sorry he was that I hadn't made it to see him. He said that the play had been successful and he was now in Zagreb to continue the run. He hoped we would have the opportunity to meet again soon. He also recommended I read all the classical literature I could put my hands on while I still had time. He said otherwise, I would end up like him, having no time but to read trashy scripts! It was good for me to hear this, because by then, I'd dropped out of school to devote my time exclusively to studying the arts: ballet, modern, jazz dance, voice, and drama.

I was very excited when I read that letter. He treated me with respect—and he didn't even mention my father. He was writing to me personally, and for once I didn't feel as though I was in my father's shadow. But regrettably, I never did see Sir Laurence Olivier again.

When I turned 15, Eddie decided it was time for me to have my nose done. He'd been saying for years, "I don't like your nose. It's too big. Oh, but it doesn't matter. We'll have it redone." He was so convincing that there was never a doubt in my mind that it could be any other way. It wasn't a question of whether I agreed or not; he had already decided for me. As far as he was concerned, I really had no mind of my own.

Eddie knew all the best plastic surgeons in Europe and made a point to stay informed about new ones. His latest discovery was a British surgeon, Dr. Mackintyre, who was supposed to be the best in the world at the time. My father made a few phone calls to London, and all was arranged for the operation. When Eddie learned that Dr. Mackintyre would refuse to perform this type of surgery if he knew I was under 16, he instructed me, "Just tell him you're 16. He'll never know the difference."

We flew to London to meet the doctor for the initial appointment and all went smoothly. I lied convincingly well, and no one asked me for identification. The operation was scheduled for the next morning.

My father kept reassuring me that I was in good hands. He said to appease me, "It's nothing at all. You won't feel a thing." I figured he knew what he was talking about—after all, he had his nose done just a few years before. And as far as I was concerned, I was just following in his footsteps.

The next morning, we showed up at the hospital and proceeded to one of the rooms. The nurse came in with the needle to give me the anesthetic. I tensed up and emitted a loud groan, but it was over quickly, and within minutes, I was swooning. My dad held my hand while he waited for me to be whisked into the operating room. I was drifting in and out of euphoria. I heard myself pouring my heart out, high as a kite, tears running down my face.

"You're so nice to me right now, Dad! I wish you were always like this! You know, I love you so much!"

I rarely ever opened up to my father to tell him that I loved him. I was always too frightened by him or angry with him. But in that moment, I felt completely uninhibited, free to express my feelings. My heart was full of gratitude, and all my resentments and judgments were gone. That was one of the few touching moments we ever had together. Eddie was right there with me, smiling real smiles.

When I emerged from the fog of the anesthesia, my dad was there, waiting in the room with all kinds of gifts, one of which was a record player. He also brought along some albums, like Perry Como, and I remember him singing, "*Catch a falling star and put it in your pocket, save it for a rainy day.*" I'll never forget how comforting it was to hear that song during that week. It felt good to be taken care of, and I was over-joyed my father was giving me so much attention.

My nose job turned out beautifully. Eddie was right—it fit me per-fectly. Because I'd had it done at the age of 15, my nose continued to grow for another year, giving it a natural look. No one ever knew I'd had it done.

In 1958, my father signed a contract to do a British film called *SOS Pacific,* which was scheduled to be shot in Las Palmas in the Canary Islands. Directed by Guy Green, the film co-starred Pier Angeli and Richard Attenborough. My mother signed a letter excusing me for the next two months of classes, and so I came along as well, despite the fact that I lacked a choice in the matter. But I did honestly enjoy the prospect of being exempt from school and of traveling to distant countries. It was a great opportunity to discover the world and improve my language skills. And with that, the whole family was off on a new journey.

After some initial exploration around the island searching for the best beaches, my mother discovered a full-fledged opera house on Las Palmas in the middle of nowhere. It so happened that a world-renowned opera singer, Alfredo Kraus, would be performing *The Pearl Fishers* by Bizet. Delighted to have something to do in this godforsaken place, my mother arranged to buy tickets for herself, Eddie, Jeff, and me.

Walking into the theatre, we were astonished by the architecture. It was so unexpectedly magnificent. We'd visited so many breathtaking sites throughout the world, and somehow here, in the Canary Islands, this opera house rivaled any of the most beautiful European monuments. We were impressed and amazed at the baroque paintings on the ceilings and the striking stone statues in every corner.

As we sat waiting for the performance to begin, I noticed a short, stooped older man, probably in his 70s, searching for his place at the back of the theatre. He began to go down row by row, seat by seat, trying to find his allotted chair. Inspecting every seat number, he was disturbing everyone as he moved along, making each patron stand up to let him pass. He was persistent and determined, and now he was going down our row. We all politely stood up to let him get through.

The lights soon went down, and the conductor began the intro. I glanced over and noticed the man was still seat-less, continuing his patient search. At this point, I'd elbowed Helene and she'd elbowed

Eddie, who then elbowed Jeff, and we were all looking over at him, starting to giggle. A mere glance at each other made us all giggle louder, and pretty soon we were in hysterics, our hands over our mouth, trying to contain ourselves and keep a straight face. As the show carried on, that poor man still hadn't found a seat.

Finally, when we'd managed to calm down somewhat, Alfredo Kraus appeared on the stage. He was wearing what seemed to be a white diaper between his legs, and he had a towel wrapped around his head. The sight of this instantly provoked uncontrollable peals of laughter, and we had to avoid each other's glance or else we'd burst into an even greater fit of hilarity. We were doing our best to remain as quiet as possible.

But Alfredo Kraus's exquisite voice contrasting with his ridiculous outfit was the funniest thing we'd ever seen. Our shoulders were quivering and it shook the whole row of seats, prompting a woman at the end of the row to send throat lozenges our way—she thought we were having coughing fits! This only added to our hysteria. It became increasingly difficult to muffle the noise, and we were now completely unmanageable.

At this point, an usher came over to our seats and asked us to leave the hall, as we were disturbing the performance. We politely stood and tiptoed out, still having to stifle our laughter. Of course, as soon as we were out of the theatre, we calmed down, but by then, we'd had enough of the opera and we returned to the hotel.

That was one of the fonder memories of life with my parents. It made me feel like I was included, and that was very important to me back then. I guess it still is in some ways. Although now I've come into my own, I still make sure that, no matter who I'm with, I am the one who includes myself.

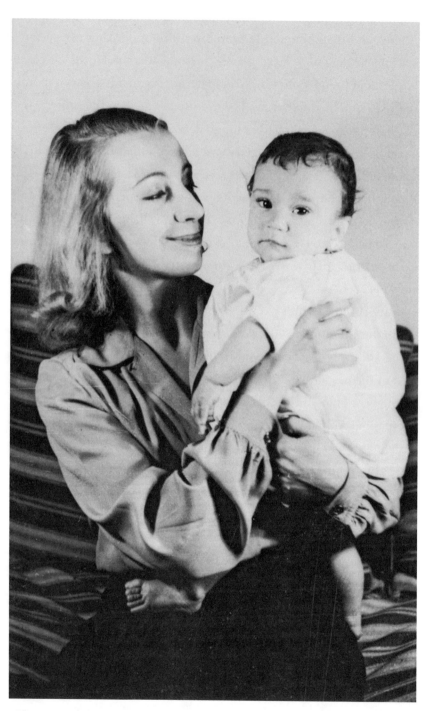

Helene and me in New York City in 1943

4. FOLIES-BERGÈRE

I WAS BORN A VIRGO on September 9, 1943, in Lenox Hill Hospital in Manhattan. My moon is in Capricorn and my rising sign is Libra—thus my search for perfection and my need for balance. Physically, I looked much like my father, with the same coloring in my dark eyes and black hair. My parents named me Joan Tanya: Joan after Joan Crawford and Tanya because there were three Tanyas in the Ballet Russe, which was the ballet company my mother joined.

Both of my parents worked at Radio City Music Hall. My mother worked in the ballet troupe and my father in the men's chorus. Anything that prevented my mother from dancing—whether it was a fever or a sprained ankle or an enlarged stomach—was either ignored or dismissed.

Helene was raised in Christian Science and a devout follower of Mary Baker Eddy's, and she studied her books daily. She taught me how to read and write in English by having me read passages from the Bible as well as the central textbook of Christian Science, *Science and Health with Key to the Scriptures*. Since we were living in France, she felt it was important that I be fluent in English. These lessons had the added incentive that I was being introduced at the same time to spiritual healing.

One of the primary rules in Christian Science was that one should never take drugs of any kind—including all medicine. My mother didn't even drink coffee for years because it altered her consciousness. When we were sick, there was no need to contact a medical doctor; instead, we phoned a practitioner to pray for healing. My mother followed that precept to a T, even when the situation was dire.

Leslie Caron, the Franco-American actress and dancer who knew my mother (after we'd moved to France) through their ballet performances at the Théatre des Champs-Élysées, wrote about such a situation in her autobiography, *Thank Heaven*: "Members of the company took little Tania [sic] Constantine to the doctor when they found her shivering with fever outside her parents' hotel room. Eddie and Helene Constantine were Christian Scientists and didn't believe in medical intervention. I think my colleagues may have saved Tania's life."

Thank heaven indeed, Leslie! She was wrong about Eddie being a Christian Scientist, though; he did have an interest in it for a while, but he soon lost faith in religion altogether.

Needless to say, soon after I was born, Helene was eager to get back to work. Just a few hours after delivery, she started doing her ballet exercises to get back into shape. Days later, one of the nurses caught her sitting in a chair and scolded her, "What are you doing? You're not supposed to be sitting up yet! Get back into bed!" The woman had no idea that Helene had been doing her exercises all along. When the hospital staff got wind of what she was doing, they complained, "This woman is crazy! We've got to let her go!" After signing a release, my mother left the hospital early the next day.

My parents truly had no idea what to do with me when they'd returned home. Neither of them had any experience with newborn babies; they didn't know how to change a diaper or how to prepare a bottle. There wasn't any question of breastfeeding. It wasn't in vogue at the time, and Helene had grown up believing breastfeeding was

repulsive. They tried to figure out what to do with formula and how to solve the mystery of putting plastic nipples on baby bottles.

My parents were relieved when they hired Cornelia, a housekeeper and nanny who'd had lots of experience in childcare. She took care of me the whole time we lived in New York, until I was 3 and a half years old. Then we left for France—I guess I can thank her for being alive today!

In the meantime, all my mother desired was to get back on stage. Her sole focus was to continue her dancing lessons. This whole pregnancy had been a big setback for her. After all, she was only 23 years old. She was still a dreamer and would get lost in thought, looking out the window for long periods of time. She imagined herself a fairy, dancing in the sky. She also believed that she had been a Bohemian princess in some far distant past who didn't ever have to deal with worldly issues. Interestingly enough, her grandparents had emigrated from Czechoslovakia, which was previously Bohemia. Nevertheless, she knew she didn't have much choice but to accept her new role as mother. She decided to be an example to other dancers and prove to the world that a dancer can have children—and still have a career!

That first day back at her dancing lessons, Helene thought she'd just do a few exercises at the ballet barre and then stop. She hadn't told her teacher Vincenzo Celli, who taught the Italian Cecchetti method of ballet, that she'd just had a baby. She was his prized student, and at the end of the barre exercises, Celli placed her in front of everyone to do the *adagios*. She did as she was told. Then, as he demonstrated a jumping step, Helene retreated as discreetly as possible. Celli noticed and bellowed, "Helene! I didn't see you do it! Here, do it alone!" Instead of explaining her situation, she obeyed and did the jumping step in front of the class. Feeling no discomfort, she continued on until the end of the class. Celli never found out until years later.

She was back in shape shortly afterward and resumed dancing at

Radio City, while Cornelia cared for me at our apartment. A little while later, Colonel de Basil's Original Ballet Russe was arranging a tour throughout Europe and invited Helene to join them in London, promising her important roles in their upcoming program. Already having been a part of the Ballet Russe in 1941, she'd made close friends with the other dancers. Unable to resist this wonderful offer, my mother consulted Eddie, and they decided that both she and I would leave for London. My father would join us after he was able to get some money together for his trip.

It was 1947, I was 4 years old, and I remember being in our room at the Strand Palace Hotel in London. My mother had ordered breakfast through room service—which was a luxury for us at the time. Ballet dancers were never paid high wages, and we often resorted to eating a bar of chocolate for lunch. That day, however, the tray had a plate of kippers for her and porridge for me. The porridge was steaming hot, with plenty of sugar and a big chunk of butter on top; it was like nectar to me. Porridge has never since tasted so good.

Though we were settling in to life in London, it turned out that Helene wasn't given the roles she was promised with Ballet Russe. Disappointed, she wiggled out of her contract and instead joined Roland Petit's Les Ballets des Champs-Élysées. This company brought innovative choreography and incorporated fantastic décors and costumes. Some of the same artists who had worked with Sergei Diaghilev's Ballets Russes also joined this unique new group: notably Jean Cocteau, Boris Kochno, and Christian Bérard. Helene was eagerly looking forward to this prospect, especially since Roland Petit promised her some important roles.

Eventually, Eddie was able to join us in London. After selling all our possessions back in New York, he had accumulated enough money to pay for his trip to England *and* lavish us with gifts.

*Me and Helene in London
in 1947, posing for a
publicity shot for
the Ballet Russe*
J. WALDORF

Roland Petit began rehearsing his new ballet, *La Nuit*, with music
by Henri Sauguet and décor by Christian Bérard. He had decided to
cast me as one of the dancers in this piece. My role consisted of being
carried on stage on the shoulders of Youly Algaroff—who was a princi-
pal dancer in the company—and then deposited downstage near the
foot ramps. There, I'd lay and pretend to be sleeping until the end of
the ballet, when he'd pick me up and carry me off into the night. It was
not much of a role, but it made me feel that I was an integral part of
the ballet, which made me very happy. It was exhilarating and such a
fulfilling experience to watch the performances from this vantage
point—with the lights blaring, the audience at my feet.

Unfortunately, in England at that time, it was illegal for a child
under the age of 12 to be on stage after dark. After just one week's run
of the show, the British police came to the theatre and escorted me out.

I felt terribly humiliated and disappointed as I was taken back to our hotel room—especially upon hearing that my character was replaced by a large oversized doll!

The story was talked about in the newspapers. A photographer came to our hotel room and took pictures of me sitting on the bed and knitting, looking sad. The photos appeared in the London papers— free publicity for the ballet company—but it gave me a sense of defeat, and I longed to be allowed back in the theatre.

Instead, at the age of 5, I was forced to face my worst nightmare: being alone in a hotel room. I kept the lights on all the time and tried to keep myself busy sewing my mother's satin ribbons on her toe shoes, drawing or painting, or working through the endless pages of additions, subtractions, and multiplications that my mother would prepare for me before running out the door.

Luckily, I did find one wonderful distraction in taking the company's daily dancing lessons. Being the only kid in the company, it was a rare opportunity to take classes like the pros. This made me feel very special. The barre was a little high for me, but I made do.

From day one, both Eddie and Helene had it in mind for me to be a dancer. As a baby, Eddie would often massage my feet, stretching my instep to develop a curve in my arch for when I'd be old enough to be *en pointe*. Helene, of course, was convinced that it was my destiny to become a prima ballerina.

In those days, Eddie had not yet landed any big gigs. We lived in hotel rooms on what Helene earned with the ballet company. We were so poor that Eddie made spoons out of paper for us to eat with! In order to heat our cans of chili, we placed a campfire burner in the bathtub. The burner came with a plastic bag of crystals, which we'd light with a match to ignite the flame. Of course, we kept the burner in the closet, so the hotel staff wouldn't find out we were cooking in the room.

One memory stands out very vividly while living in that little hotel on rue de Berri. It so happened that one of the paper spoons my dad made had gotten too close to the burner's flame and caught fire. Instead of disposing of it in the toilet, Eddie put it in a plastic bag, threw it into the wastebasket, and forgot about it. A few minutes later, my mother noticed a bright light reflected in the closet mirror. She suddenly realized that there were flames coming out of the closet and that our clothes were on fire! Eddie tried to grab the burning plastic bag, but the heat was so intense that he dropped it, and crystals poured out all over the floor. Flames were everywhere. Helene frantically grabbed some towels, swatting them wherever she could to try to extinguish the flares. Eddie was stamping his feet, fighting the flames coming up from all corners of the room. Desperate, I was doing all I could to help. Grabbing more and more towels, I ran back and forth from the bathroom to the room, helping to smother the flames on the ground. Helene was in a frenzy, tossing the towels in all directions, screaming and shouting, when suddenly—there was a knock at the door. The commotion instantly stopped. There was a moment of breathless silence. The bellhop's concerned voice came through the door: *"Madame? Vous avez besoin de quelquechose?"* ("Madam? Do you need anything?")

"Non, non, pas de problème!" ("No, no, no problem!")

Wild-eyed, Eddie and Helene looked at each other and had the same idea: In one fell swoop, they threw the towels over the whole mess, grabbed everything they could, and threw it all out the window.

That was it—we had to move to another hotel.

This reminds me of *La Cigale et la Fourmi* (*"The Grasshopper and the Ant"*), one of the fables by La Fontaine that my mother adored. Since she lived only to dance—and dealing with day-to-day survival was of no interest to her—she totally related to this poem. She could recite it by heart, in her strongly American-accented French, which was always a

great source of hilarity for all of us. The point of the piece is that the ant works assiduously at collecting food, whereas the grasshopper spends her time... dancing! That was my mom!

The Ballet Russe signed up to do a tour in Brazil, so the entire company set off en route to Rio de Janeiro. In an effort to economize on travel costs, the company's management rented a freight boat that was carrying meat from Argentina, via Rio de Janeiro, to Marseilles. Money-wise, it was a good deal for them, but for us, the passengers, the trip was awfully uncomfortable. Just imagine 40 people—most of them ballet dancers—onboard a slow, old, filthy, meat-carrying cargo boat!

With the vessel having no distractions to keep the dance troupe busy, several members of the cast were on the prowl for opportunities to have fun. One such occasion was at the end of a luncheon, when one of the dancers made a pile of tiny balls of bread. They looked like bullets. He started throwing them across the table, landing them on the heads of the other dancers. Immediately, there was retaliation, and within minutes, it was pandemonium. The whole company was at it— laughing, squealing, screeching—and all hell had broken loose. At first, I'd joined in the fun, but it quickly got out of hand, and I became frightened. I flew out of there to find a safe place to hide.

Later during that trip, the crew of the boat performed a ritual. This was something they always did whenever crossing the equator with uninitiated travelers. The ritual consisted of first covering each passenger's entire body with shaving cream, then plunging them into a makeshift swimming pool. The dancers thought it was great fun, but I didn't; I was utterly terror-stricken. I was convinced we were being put through some kind of death rite, and this scared me out of my mind. One of the dancers snatched me from under a bed where I had been hiding and forced me, against my will, into the ceremony. Thankfully, it didn't last long, and by the time they pulled me out of the pool, I realized I had

survived! Though somewhat relieved, I was still furious with the dancers for forcing me into doing something I was afraid of.

During this time of traveling throughout the world, my mother was homeschooling me. She would take me to the museums in every town we landed in, listen to classical music, have me solve pages and pages of math problems, and encourage me to draw and paint.

While my mother and I were on tour with the ballet company, my father was very motivated to get his singing career going. Recounting the event when he met Édith Piaf—France's darling at the time—in a nightclub in Paris where she was singing: Eddie had just recorded a single with Mercury Records and was excited to meet her. As he sat in the audience listening to her sing, he felt drawn to her like a magnet. She had so much talent and charisma! She kept glancing over at him to see his charming smile. In the middle of her last song, she walked over to his table and sang directly to him. That was the defining moment that sealed their connection.

Piaf fell for him instantly. She called him "Le Cowboy" because he was so American-looking, he walked with a swagger like John Wayne's, and he spoke with a cool drawl. It was the beginning of a great love affair, and it swept Eddie off his feet. He knew he was risking his relationship with Helene, but he couldn't help himself; he was in love. And from that moment on, they were inseparable.

Because Eddie hadn't yet learned to speak much French, he and Piaf communicated mostly through sign language and bits of what they liked to call "Franglais." This was fun for them at first, but Piaf soon grew tired of the effort. She decided to hire a tutor to teach him French.

An upcoming tour throughout Canada was scheduled for Piaf. She couldn't stand to be away from Eddie, and so she made arrangements for him to sing in the same program with her. This was a great opportunity for Eddie's career. He was beginning to feel that he was slowly breaking into French show business.

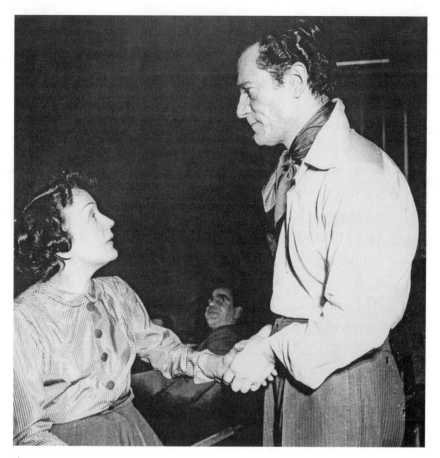

Édith Piaf and Eddie in La p'tite Lili *in March 1951 at the ABC Theatre*
ROGER VIOLLET

Wherever she went, Piaf always had a large entourage around her: Charles Aznavour, her sister Simone Berteaut, her agent, and many friends. She had a reputation for being tyrannical (or maybe we should say controlling!). Everything everyone did was always decided by Piaf. When she and Eddie went shopping, she would pick his clothes and wouldn't let him wear anything other than what she chose. She claimed he had no taste—"like most Americans."

While all this was going on, my mother was oblivious to the affair. Whenever there was the vaguest mention of it in the papers, or through

hearsay, she turned the other way. Eddie tried to hide it as long as he could and would make up stories about where he was going and with whom, until one day Helene saw a photo of them in a magazine. She was stunned. She'd never thought in a million years that he would run off with another woman, yet here it was in plain view. She could no longer pretend it wasn't happening.

When Eddie came home, she confronted him, and there was a horrible fight that day. I'll never forget it. They were going at it like crazy people, yelling and screaming so loud it could be heard all the way down the street. I was terribly frightened, certain that Eddie was going to kill her. It was getting worse by the minute. At one point, Helene was on the floor and Eddie was brutally shaking her by the shoulders, banging her head against the floor, over and over. She kept hollering, "Kill me! Go ahead! I want to die!" Worried that he was going to crack her skull open, I ran to him and pounded my fists against his back as hard as I could, screaming for him to stop. Turning toward me with a menacing look, he yelled, "Get out of here! Mind your own business!" as he thrust me across the room. A rush of adrenaline went through my whole body. He had such venom in his eyes! Immediately, leaning against the wall, I started sobbing, trying to tune out the noise to avoid witnessing what I believed would surely be my mother's murder.

But then she got up from the floor and darted toward the entrance door, screaming, "I'm gonna kill myself! I'm gonna throw myself into the Seine!" I dashed over to her, grabbed her by her skirt, and pulled with all my might to prevent her from running out the door. I felt as if everything in that moment depended on me. I had to make sure she didn't go beyond that door. It was a matter of life and death.

Finally, the screams died down. It appeared that the worst had blown over. My mother was now on the floor, sobbing. I closed the entrance door and tried to console her, but I quickly realized I could not make things okay for her; this left me feeling totally helpless and

ineffective. I felt so much resentment toward my dad and hated him with all my might.

The tension resolved, and my parents made an agreement. Eddie promised he would give up being Édith Piaf's lover, but there was one concession: He insisted that he continue working with her. He claimed it was very important for his career, and that he needed that boost. Helene reluctantly agreed.

In 1951, Piaf signed a contract to star in a musical stage play called *La p'tite Lili* written by Marcel Achard. She played the role of a seamstress and wanted Eddie to play the lead opposite her, despite the fact that he was still not fluent in French. During rehearsals, Eddie pronounced his lines as best he could, but the director wasn't happy with him and kept cutting his part out. Little by little, Eddie's role was reduced down to a bare minimum, leaving only what was absolutely necessary for the story line. Eddie ended up with hardly anything to say. He did get to sing several duets with Édith Piaf, as well as a few solos, one of which was "Petite si jolie" ("Pretty Little One"). Because of his fabulous voice, Eddie brought the house down with that song every night.

For seven months straight, the show played to a packed audience. It was an enormous success, and everyone was very happy. However, because no one but Piaf had wanted to hire Eddie, his wages were kept to a minimum. To make him feel as though he were doing well, Piaf had arranged with the producers to pay the extra amount out of her own pocket. This way, Eddie wouldn't know he was so poorly paid.

He didn't find out about this until years later, when Simone Berteaut talked about it in her book, *Piaf.* Eddie confided in me that he never believed the story, saying that Simone had made it up. He told me, "Piaf taught me everything about being on stage. She gave me confidence when I didn't have confidence. She gave me the desire to fight where I didn't feel I could fight. I never wanted to fight. She made me

Portrait of me at age 10

Headshot of me in 1954 in Paris HARCOURT

Portrait of me in 1955 HARCOURT

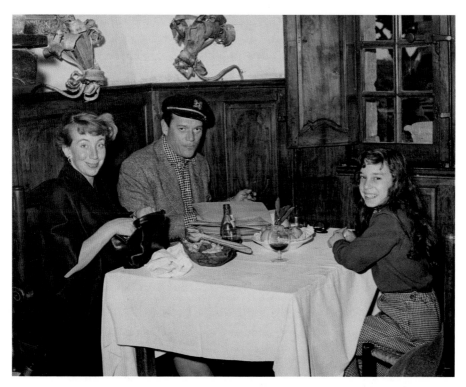

Helene, Eddie, and me in 1954 in Saint-Paul de Vence
JACQUES GOMOT

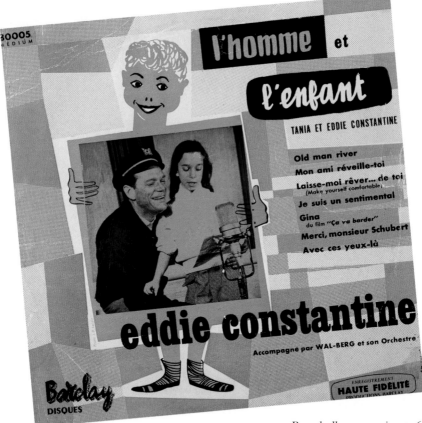

*Record album cover in 1956
for Barclay Records*

Eddie and me in promo photo for record

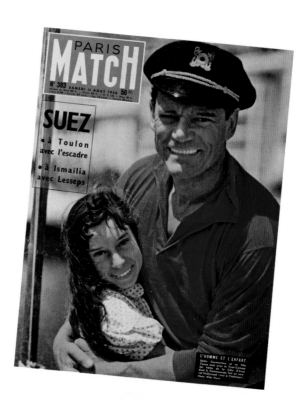

*Eddie and me on the cover
of Paris Match*
WILLY RIZZO

*Eddie Constantine
album for Mercury
Records*

Eddie and Doris Day
on film set in 1956

Eddie, Dominique Wilms, and Nadia Gray. Promo shot for Les femmes s'en balancent, *1952*

Eddie, Gregory Peck, Lemmy, and Gregory Peck's son at the farm

Eddie, Robert Lamoureux, and Yves Montand

Eddie, Jean-Luc Godard, and Anna Karina filming Alphaville RAOUL COUTARD

Eddie and Helene on the train to Canada

Eddie and his parents arriving from Los Angeles for a visit in 1956
STUDIO ISKENDER

Au fond de la cour carrée, ce qui était autrefois les communs de cette vieille ferme du XVII⁰ est devenu, aujourd'hui, la maison d'habit

Vestige de l'ancien corps d'habitation, cette tour domine les écuries.

CHEZ EDDIE CONSTANTINE

A l'écran c'est un "dur" qui n'aime que la bagarre, le whisky et les jolies filles... Dans la vie, c'est un paisible gentleman-farmer qui se consacre à sa famille, sa maison et son élevage. Il habite près d'Autheuil-le-Roi une de ces vieilles fermes de la Basse-Normandie qu'il a américanisée en un confortable ranch où depuis sept ans le cheval est roi. Il est vrai que ce violon d'Ingres, devenu passion, lui donne ses plus grandes joies quand il assiste sur les champs de courses au triomphe de ses couleurs. Eddie Constantine est un homme heureux.

Magazine photos of the farm for Jours de France, July 1965 BEYDA

-room, les murs blanchis à la chaux font ressortir le mobilier Louis XIII et un cuir de Cordoue entre deux bibliothèques.

un fumoir, la salle à manger, toute blanche elle aussi, réunit un mobilier colonial américain. Au mur, une gravure anglaise

*Living room at the farm
in Jours de France,
July 1965*
BEYDA

Eddie's promo photo for Polydor Records in the 1970s
RICHARD BALTAUSS

Eddie in Paris TANYA CONSTANTINE

Eddie reading his book, The God Player, *which was translated into German and titled* Der Favorit ISOLDE OHLBAUM

Cover of Eddie's book, The God Player, *1976*

Eddie and Lemmy: like father, like son, at the racetrack in Deauville in 1963 MAX RENAUD

Eddie, Lemmy, and me PETER SCHMIDT

Helene in 1970, rehearsing for her ballet company performances

Eddie and me at dance rehearsal for Helene's ballet company in 1971 HENRI TULLIO

*Eddie and Maya in
Paris in 1987*
Tanya Constantine

*Eddie and Maya in
Paris in 1987*
Tanya Constantine

think that I was somebody. She had a sort of genius that could confirm and reinforce a personality. She always said, 'You have class, Eddie. You're a future star!' Coming from her, that meant a lot to me!"

In spite of all this, Eddie was not prepared to give up his wife, and Piaf was starting to lose patience. In her desperation, she would call Eddie in the middle of the night and threaten to commit suicide if he didn't come over right away, and he'd run to her side. Eddie muses, "Piaf was a very changeable lady. She wanted a man she could train and build up into a monster and then break him down, like she always did. In the beginning, our affair was a totally absorbing passion, but a year later, it was over, and we both agreed to go our separate ways."

Soon after *La p'tite Lili,* in 1952, Eddie was cast in his first film, *Egypt by Three,* which was directed by Victor Stoloff and shot in Egypt. This really got the ball rolling for Eddie. When he saw the rushes (the raw footage of the film), he decided he needed a nose job. He felt strongly that he'd have a better chance of making it in show business if it weren't so obvious that he was Jewish. There was a tremendous amount of anti-Semitism both in France and in the U.S., especially after World War II. He had been persecuted as a child and wanted to avoid at all costs a repetition of the pain and suffering he had already experienced. Though he tried hard to hide his origins, he couldn't resist going down the street to the delicatessen on Fridays to get chopped liver, bagels, lox, and cream cheese. But he never ever made it public that he was Jewish; that, he kept secret.

Meanwhile, his record contract with Barclay Records required that he go on a singing tour throughout France. This is when he met his favorite pianist of all time, Jeff Davis, a Jewish-American musician living in Paris at the time. Jeff had graduated from Juilliard, where he had studied with Nadia Boulanger. He was a brilliant pianist. From the moment they met, they were inseparable. Everywhere Eddie went, Jeff went too. They deeply understood each other and had the same sense

of humor. He was a great companion for my father, serving as therapist whenever it was needed—to boot, he was somebody with whom Eddie could share his Friday escapades at the delicatessen!

Two weeks after his nose job, Eddie signed a contract to star in a film called *La môme vert-de-gris* ("*Poison Ivy*"), playing the lead role of an American FBI agent, Lemmy Caution. Bernard Borderie produced and directed the film, which was based on the book *Poison Ivy*—just one of a series involving the character Lemmy Caution—by the British noir crime fiction writer Peter Cheyney. The film was an instant hit. From one day to the next, Eddie became a household name.

Eddie was now on a roll. Bernard Borderie was ready to sign him up for another Lemmy Caution film, *Les femmes s'en balancent* ("*Dames Don't Care*"). This was another adaptation of the Peter Cheyney novels, and it promised to be the next great success. This time, his contract offered him a lot more money, and he was as high as a kite. He was now coming into full bloom—he'd become a star!

Even though he wouldn't admit it, fame was what he'd been after all along, and it was going directly to his head. He became more and more cocky, especially with me and my mother and his other subordinates. I disapproved of his behavior, and he sensed it. I didn't trust being around him because I never knew when he'd fly off the handle. He was out of his mind with stress.

For the opening night of *Les femmes s'en balancent*, he wanted both me and my mom to accompany him to the movie theatre to watch the public's reaction. We scrambled into a cab and drove off to the venue. Walking into the hall, the ushers recognized him immediately and ran up to ask what they could do for him. All fired up, he asked, "How is it going?"

"Oh, it's absolutely fantastic! We've broken all records today!"

Eddie was delirious over this news. He said he wanted to go in and see how the audience was responding to some of the scenes in the

picture. The ushers were more than happy to oblige and walked us over to the back of the packed theatre. Standing against the wall in the dark, we watched the people more than we did the film. I was flabbergasted. I'd never seen an audience participate the way they did. They were wild. They were completely involved in the action, yelling out their support at every opportunity. "Go get 'em, Lemmy!" "Watch out, Lemmy, he's right behind you!" No other film of the time got that kind of response. It was a real phenomenon.

That first night, Eddie wanted to stay till the end of the film. When the lights came up—after the words THE END—it only took a couple seconds before a few people in the audience recognized my father. Someone yelled, "There's Eddie Constantine!" and suddenly people started rushing over. Within seconds, the mob swarmed all around him, pushing and shoving, demanding autographs. They went absolutely wild. Frightened at the intensity of the mass hysteria, I weaseled my way through the crowd and got out of the way just in time. My mother was able to do the same. But Eddie was stuck and couldn't move: like vultures, people were pulling buttons off his suit and his shirt, pulling on his tie, yanking off his cufflinks, grabbing and tugging at him. Terrified, Eddie did his best to protect himself, putting his arms around his head. Soon enough, the guards rushed in to rescue him. They created a space for him to pass safely through, and finally, we were able to scurry off out the back door.

That experience really shook us up, and Eddie had to have a couple drinks as soon as we arrived back home. I was furious with him. I felt he was responsible for putting his family at risk for no reason other than to enjoy the fame. It took me a long time to get over it and forgive his stupidity. After that, he never risked staying till the end of the film. He still insisted on going in and watching for a few minutes, but he would then quickly walk out—much to my relief!

Thankfully, the critics were good to him, and he feverishly read all

the reviews in the papers. They liked his American style and his sense of humor. He managed to charm everyone—even Marcel Pagnol of the Académie française admired him. He wrote of my father, "*Eddie Constantine a jailli sur la France comme une comète et reste comme une étoile!*" ("Eddie Constantine shot out like a comet over France and stays up there like a star!")

At that time, every film Eddie did became an incredible hit, and they often broke attendance records. He was now being offered $150,000 per film, plus a percentage of the profits. Later, he was even paid as much as half a million dollars. This was a huge fortune back then, and it's been estimated that, along with Jean Gabin and Brigitte Bardot, he was the highest paid movie star in France between 1953 and 1959.

Eddie Constantine had become a myth incarnate: the myth of the virile hero. His fans looked to him as the strongest of the strong, the bravest of all men, the fearless tough guy who always came out of a dirty battle looking cool, calm, and collected. The titles of his pictures say it all: *Powder and Bullets, Dames Don't Care, All Hell's Breaking Loose, The Grand Bluff, Shudders Everywhere, and Keep Talking, Baby*—just to name a few.

"Cigarettes, whisky et p'tites pépées" ("Cigarettes, Whiskey and Wild Women") was not only the title of one of his hit songs; they were also the props he employed in all his films. He was portrayed as the tough guy with a warm heart and outstanding charm, who always had a couple of girls at his side, a cigarette in one hand and a glass of whiskey in the other, whose hair was never messed up no matter the situation.

In those days, movies often blended with real life. One day, Eddie was walking down the street, and a man suddenly came running toward him. Before Eddie had had time to brace himself, the guy threw him a punch in the stomach. Eddie had the wind knocked out of him, and it took a minute before he could recuperate from the blow. The man

claimed that he just wanted to see if Eddie was as relaxed in life as he was in his films! My dad was furious and swore he wouldn't go out in public unattended from then on.

On his first couple of movies, instead of whiskey, the prop man would always give him a glass of tea or watered-down Coca-Cola. But during the filming of *Votre dévoué Blake* (*"Your Devoted Blake"*), there was a scene in which Eddie, standing at the bar, had to gulp down a whole line of drinks. One of the stuntmen who loved to clown around decided to play a practical joke on him. Unbeknownst to Eddie, the glasses were filled with whiskey instead of tea. During that first take, he picked up the first glass and, not having a clue, drank it down without flinching. Taken by surprise, but not wanting to react in front of the camera, he went ahead with the scene. After the eighth glass, the director yelled, "Cut!", and Eddie had to be carried off the set. After that, he developed the habit of drinking the real thing during takes.

Eddie used to try to hide the fact that he drank whiskey all the time. His dresser, Henriette, would conceal a bottle of Johnny Walker Red in a brown paper bag, sneaking him glassfuls whenever he asked. Now it was all in the open. He was slowly becoming identified with his role as Lemmy Caution. With the pressures of stardom weighing heavily on him, he justified it as being a necessary reprieve to deal with it all.

Many years later, Eddie said to me, "It was a heavy responsibility for me to carry, to be a hero. Being a hero is a curse for an actor. It changes your whole life. A hero doesn't catch a cold. A hero never feels sick or weak. I had no right to feel weak. People expected me to always have beautiful girls around me, so it spun off into real life, and I had to be seen with beautiful girls. When you get to the point where people think that's really who you are, then you're stuck. You have to live up to it. And that's what was happening to me. I was thrown into it. I was caught up in a thing that was bigger than me, and I just couldn't renounce it."

I also interviewed John Berry, who directed three of Eddie's films:

Ça va barder (*"All Hell Is Breaking Loose"*), *Je suis un sentimental* (*"I'm a Sentimental Man"*), and *À tout casser* (*"The Great Chase"*). John Berry was a fascinating and brilliant man. He grew up in the Bronx and was planning on being a stage actor, when he had the opportunity to appear in Orson Welles' production of *Julius Caesar*. He played a role on Broadway in another Orson Welles' production, *Native Son*. Then he became Welles' assistant and worked with him at the Mercury Theatre in Chicago. Soon, he was directing his own films in Hollywood, among them *He Ran All the Way* with John Garfield. Blacklisted during the House Un-American Activities Committee days, John Berry made the decision to flee and ended up in France.

I absolutely adored John Berry and loved it when he came over to the house. I could listen to him talk about acting all day, whether it was about the Actors Studio, Lee Strasberg, Konstantin Stanislavski, or method acting. I was in awe of him. He had some insightful comments about my father:

> "Eddie's capabilities were extraordinary. He had a quality—I believe out of sheer terror—that came off the screen. Something really happened. I always wondered what that was. Well, I'll tell you what it was. He *marked*. And it's that peculiar phenomenon, that kind of magic, that nobody can explain, that makes certain people stars. I have a theory about that. I think it's selfishness. I think they are so self-involved that it creates this charisma and you can't figure it out! That's what Eddie had. He just did it. There was never any conflict about it. He never questioned it. At least he never questioned it openly. I don't know how deeply he questioned whether he was good or not. I think he had an enormous question that went beyond 'How good am I?' It was: 'How did this happen?' One fascinating thing about that quality that Eddie possessed was that it gave him an inherent and very

profound exterior confidence. But Eddie was not confident about anything! He didn't know who he was. How could he? Did he ever? I wonder about that. Because I think deep down, there was a non-aggressivity about him. Let me say something else: Here's this guy who was the number-one attraction, the top star in France, and women were falling down all around him. Well, believe it or not, he was the most timid guy. He wasn't really on the make. He was timid! We're talking about this when he was the top star! He was absolutely terrified. Now that's got to do something to your head. The dichotomy between what you're supposed to be and what you are, and how you have to act... it's got to drive you crazy. It's got to kill you with anguish and torment!"

During the shooting of the film *L'homme et l'enfant*, Eddie had an opportunity he couldn't pass up to get close to Juliette Gréco, who was cast as the female lead. A talented singer known throughout all of France, she was famous in the late 1940s for singing existential songs in Paris nightclubs. Eddie decided she needed her nose fixed. She'd already had it done once, but it hadn't turned out right. He said, "So, do it again."

"But Eddie, I can't afford it!"

"I'll pay for it!"

From that moment on, they became very close friends—or shall we say lovers. One evening at a restaurant in Paris, there was a celebration for the release of *L'homme et l'enfant*. Helene had gotten herself all dressed up for the occasion, taking advantage of the opportunity to wear one of her many Balenciaga evening gowns. Juliette Gréco was sitting between Darryl Zanuck and Eddie; Helene was on Eddie's other side, next to the producer Ray Ventura and his wife, along with his wife's lover.

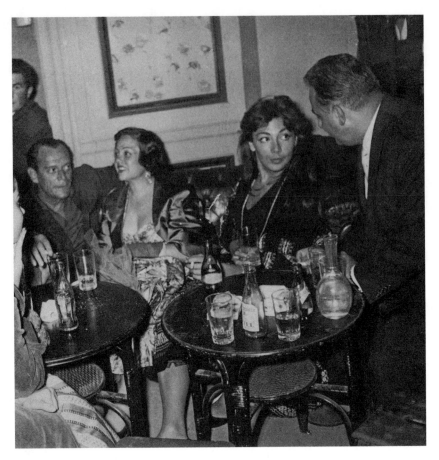

Eddie, Lucienne Boyer, Juliette Gréco, and Bruno Coquatrix at an after-show party at Olympia Hall

As soon as Helene sat down at the table, she felt as though she was playing second fiddle and wondered why she'd even been invited. Glancing over at Eddie, she noticed his knees touching Juliette's under the table. Feeling a wave of anger, she leaned over toward him, hoping no one would notice, and whispered in his ear through clenched teeth: "You better quit that right away!"

Eddie paid no attention and turned the other way, continuing on with the under-the-table play. Her rage mounting and in spite of her attempts to suppress it, Helene suddenly exploded. She stood up so

abruptly that the table tipped over—caviar, vodka, and glasses flew through the air, spilling all over the floor and on people's laps. Thunderstruck, everyone looked at Helene in amazement. Swept up in an emotional torrent, she stormed out of the restaurant.

Shocked by her display, Eddie maneuvered himself around the table and went dashing after her. He ran through the restaurant, out the door, and through the streets. He finally caught up with her just as she was crossing the street. Grabbing her by the arm, he screamed, "Don't be ridiculous!"

"Leave me alone, Eddie—you're making a fool out of me! I'm going home."

"You can't just leave like that!"

"Oh, but it's too embarrassing! I want to crawl in a hole!"

"But you know you're the only one I really love!"

Cajoling her, as he knew so well how to do, he reiterated that she was more important to him than anyone else. He kept denying that there was anything going on between him and Juliette. Standing on the sidewalk, with cars whizzing by, she broke down and cried. Pulling out all the stops, Eddie somehow managed to convince her that the play between him and Juliette was all a fabrication, that there really wasn't any validity to the story. She wanted to believe him so badly. She finally conceded that she might have been wrong. He suggested that she come back to the restaurant and act as if nothing had happened. Grinning through her last tears, she walked back with him, arm in arm, both of them smiling broadly with their phony public smiles.

After that episode, Juliette made an attempt at becoming friends with Helene. She invited her over to her apartment one day for tea and cookies, and they had a nice enough chat, although Helene maintained her distance. She wanted to make sure Juliette got the message that theirs was a marriage that was not to be toyed with. Juliette was curious as to what Eddie's intentions were after that, and the very next day, she

asked him, "What should I do? Should I wait for you? Can you offer me a life?"

Unable to respond, Eddie turned away, knowing he was unable to make a commitment. Regardless of the sadness he felt at seeing her go, he watched her leave without trying to stop her. And that was the end of their brief affair.

Another situation that brought Helene a lot of embarrassment happened while Eddie was working with Renée "Zizi" Jeanmaire during the filming of his movie, *Folies-Bergère*. Helene had known Zizi since 1947; they had danced together then with the Ballet Russe. Eddie was very attracted to Zizi, even though she was married to Roland Petit, and Zizi was obviously responsive to his advances.

One evening, Zizi and Roland were having a dinner party at their house. Eddie invited Helene to come with him. As they were ringing the bell, Zizi came running to open the door. When she saw both of them standing there, she opened her mouth wide. Terribly irritated, she exclaimed, "Oh! I didn't know *Helene* was coming!" Zizi was furious and stomped into the living room. She hollered, "There won't be enough food!"

Grabbing her coat, she stormed out of the house and announced that she was going down the street to see if the market was still open. Helene was terribly distressed and whispered in Eddie's ear that she thought she'd better leave, but Eddie said, "Don't be silly." Making the best of the situation, they both remained at the party.

Zizi returned 20 minutes later with a few old pastries, which she quickly threw on a plate and placed it on the table. Needless to say, this scene put a damper on the party's atmosphere; and Zizi's husband was as mortified as Helene.

The dinner turned out to be a fiasco. Although there was in fact enough food to feed an army, the entrée was a dish of pig's feet. Eddie

Eddie and Zizi Jeanmaire in a movie promo for Folies-Bergère

never minced words when he didn't approve of the menu, and so he just couldn't help himself when he said, "Pig's feet? How awful! How can anybody eat that?" No one dared touch the dish—except Helene. Helene was one of those people who ate anything! Having been raised in the Depression era, she never, *ever* left anything on her plate. This party marked yet another terribly tense moment for my parents and only served to put more fuel into their already volatile relationship.

In 1955, Eddie flew to Berlin to shoot a segment of his film *Je suis un sentimental* ("*I'm a Sentimental Man*"). Normally, Eddie liked to have the family come along, but this time, he went alone. Martine Carol, one of France's biggest stars at the time, was also in Berlin shooting a picture titled *Lola Montès*. It turned out that they were both staying in the same hotel.

After the day's work, they met one evening at the bar and shared a couple of whiskeys. They were getting pretty smashed, when Eddie suddenly remembered he was supposed to call Helene. He asked the barman if he could use the phone to call Paris. When he reached Helene, he was all excited to tell her that he was with Martine Carol.

Taken aback, Helene asked suspiciously, "What are you doing with her?"

"We're having a few drinks! I swear I'm not having an affair with her. Here, she's right next to me. I'll pass her the phone. She'll tell you!"

Martine, who was seeing double and slurring her words, grabbed the phone and started to tell Helene a convoluted story about how she happened to meet Eddie, how it had all been a marvelous coincidence, and how unusual the circumstances were. Eddie was happy he'd ironed out the problem and made a suggestion to Martine: "Now that we called Helene, why don't we have dinner together? There's a great Chinese restaurant down the street."

"Oh, I love Chinese food!"

After having dinner together, they returned to the hotel. Eddie followed her up to her hotel suite. Taking four sleeping pills with a glass of water, Martine announced, "Now I'm going to sleep."

Surprised and disappointed, Eddie said, "Okay. I'll see you tomorrow." Reluctantly, he returned to his room and went to bed.

At 6 in the morning, his phone rang. Helene was furious, screaming, "Where have you been all night?"

Opening his eyes, he said, "Here. I've been here, sleeping since 11 o'clock last night."

"But I've been calling you all night, and there was no answer! Were you with Martine?"

"I swear I was here the whole time!"

"Well, how can you explain that I've been calling you all night and there was no answer in your room?"

"I don't understand!"

"You dirty louse! How could you do such a thing? I want a divorce!"

After hanging up, Helene stormed through the apartment, sobbing hysterically, feeling as though her life was coming to an end. I was awakened by the loud noises. It sounded like something dreadful had happened. I ran to her room and asked, "What happened?"

In the midst of her tears, she told me the story. I tried my best to console her. She kept saying she was going to divorce him, but I didn't take her threats too seriously. It seemed like every other day she said she was going to divorce him, but she never did. It was ridiculous to keep up this pretense, and I sometimes wished that she'd follow through with it.

Eddie maintained his innocence. He claimed that the night switchboard operator had called the wrong room, and that it wasn't fixed until the early morning when they'd changed operators. Helene didn't believe him. Years later, Eddie still vehemently protested, "I was *not* with

Martine Carol that night. I would have liked to be, but she gave me that shit about loving me like a brother, so I realized I wasn't her type—unfortunately."

When Eddie returned to Paris, he and Helene continued their argument in person. That first night they fought like cats and dogs. By 2 o'clock in the morning, Helene was at her wits' end and was getting out of control. She screamed, "I hate you! I don't want to have anything to do with you!" In a hysterical fit, she opened her bedroom window, grabbed her box of jewelry, and threw the whole thing out into the night: her diamonds, rubies, sapphires, pearls, gold bracelets—jewelry they'd spent a fortune on at Boucheron, Cartier, and Van Cleef & Arpels.

Hours later, after their battle had died down and they were busy making up, it suddenly occurred to Helene that they'd better hurry up and go look for the jewelry before someone picked it all up. They hurried down the stairs, through the lobby, and out the door, feeling their way in the dark with a little flashlight, searching on their hands and knees through the gravel and the bushes. Worried they might have lost some expensive pieces, they were whispering in the dark, "Are you sure you didn't throw anything else out?"

"No, I think we've got it all."

"Do you have the pearls?"

"Let's see. Yes!"

"What about the sapphire necklace?"

"Oh, here it is."

Finally, they returned back up to the apartment, chuckling at how ridiculous it would've looked if someone had seen them!

A few weeks later, Eddie was getting ready to open at Olympia Hall, the famous Paris music hall, for a two-week run as the star of the program. It was a big to-do; he was preparing to sing 24 songs. He had the jitters

and was mostly worried that he would forget the lyrics to some of the songs. He had arrived very early, the day of that first show, horribly tense, pacing up and down the hallways backstage. He kept taking swigs of whiskey to calm his nerves, but nothing worked. He remained in the same state of tension. Still pacing and totally terrified, he kept practicing his vocal scales.

There was great excitement in the air as the show began. Sitting in the front row of the audience, in the seat next to Charlie Chaplin, I was enthralled by the atmosphere. As soon as Eddie stepped onto the stage and heard that first applause, all stage fright disappeared and he performed fantastically. His voice was deep and resonant, flowing with the melodies. Vibrant and romantic, he relaxed into the rhythms with incredible grace and self-confidence. Jeff was wonderful as his accompanist, and the audience was exhilarated, totally swept off their feet. It seemed as if the curtain calls would never end; my hands hurt from all the clapping.

After the performance, Charlie Chaplin and I shoved our way through to backstage, which, given the mob, was a real feat. The crowd was so dense, we were almost at a standstill. It took a lot of time to get to the stage door, let alone close to Eddie's dressing room. When we finally managed to get through, the bouncer had us wait until the room was cleared before knocking to let us in. The door opened wide to reveal Eddie, all sweaty, with a great big smile on his face. He and Charlie fell into each other's arms and Charlie said, "Eddie! What a voice! You're the greatest!" Eddie was happy.

Later that evening, after the ruckus had died down, we were walking out the stage door. The crowd was waiting for Eddie to reappear, chanting, "Eddie! Eddie! Eddie!" Shoving their programs in Eddie's face, they begged for autographs. Tonight, he didn't care how demanding they were. They could have asked for anything; he would have given it to them.

Eddie's promo photo from Barclay Records
J.J.Tilche

When he finally managed to pull himself away, we ended up going to his favorite private club, the Élysées-Matignon. Everyone in show business went there: Yves Montand, Simone Signoret, Marcel Pagnol, Fernandel—all the great ones of that time. Eddie was feeling good tonight. He had triumphed, and he wanted everyone to witness it. I must admit—*even I* was proud of my father that night!

When I listen to his records now, I am very moved and have tremendous admiration for his talent as a singer. He was trained in opera in Vienna; the critics in Austria at the time said that he was the youngest and greatest *basso profundo* they'd ever heard. He had a melodious tone that was absolutely delightful. My mother always used to say the quality and tone of his voice was soft and tender, like pure dark velvet, and I totally agree. But this contrast between the gentleness of his singing and his rage and temper as a father was really perplexing, and it still mystifies me today.

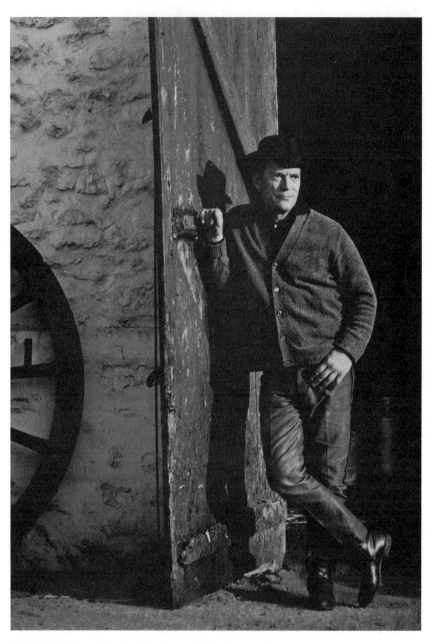

Eddie at the farm in front of the horse stables CLAUDE AZOULAY

5. DES FRISSONS PARTOUT

("Goosebumps
Everywhere")

EDDIE CONSTANTINE HAD A DREAM that he was intent on manifesting: to own a large country estate. Although my mother had always been terribly reluctant to live out in the country, Eddie disregarded her complaints. She feared being stuck out in the boonies with no ballet company to dance with, and she'd end up just like her mother: all alone, in the middle of nowhere. Her mother had been an accomplished concert pianist, but when she'd married, she and her husband moved to a little town near Chicago named Fox River Grove, and Grandma Helen never again performed publicly after that. My mother was awfully worried about following in her mother's footsteps, and she desperately clung to the notion of living in Paris.

Eddie believed she'd eventually change her mind, and so in spite of her protests, he went ahead and purchased a farm in Autouillet, a village 30 minutes west of Paris by car. The property, consisting of 110 acres of land. was originally a farm boasting 250 pigs, 30 cows, a 500-year-old stone tower, and a 200-year-old family residence with eight bedrooms and one bathtub. A family of farmers lived there on the premises, and they were invited to stay and continue to work on the household payroll.

Eddie had it in mind to transform the place into a country

estate—at first going about it slowly. Initially, he had decided to keep the pigs, but when the first summer crop of flies swarmed in, that did it. The builders were immediately ordered to start transforming the pig stalls into living quarters, extending the main residence. Then one of the large barns adjacent to the building was converted into a living room, with a walk-in fireplace and high-beamed ceilings. The attic was transformed into a theatre that could hold an audience of about 80 people: It came complete with a raised stage, a multicolored lighting ramp, and red velvet curtains. Underneath the old tower, the basement was converted into a wine cellar, which Eddie kept stocked with only the best French wines. He also had the exteriors of all the buildings painted white, and, surrounding the property and spreading for miles, a white picket fence was installed. The roof was also redone with antique mossy clay tiles, typical of the local Île-de-France region. Needless to say, this remodeling was a gargantuan endeavor and took many months to complete.

In order to supply our large family meals with meat and eggs, it was decided that we needed some chickens. Quite rapidly, the chicken coop came to house 2,000 chickens—the extra eggs were sold to villagers. The number of cows was reduced to six, and the extra milk was sold to the next-door neighbors. Walking through the wooden entrance gate, the first thing that would strike any visitor was the brightness of all the white walls. Here, all the structures together formed a square plaza, with the main living quarters on one side and stables on the three other sides. In the middle of the court, Helene planted a lawn and a weeping willow to shade the center—today, that weeping willow is humongous!

Crossing the courtyard and between two buildings, an open passage led to the kitchen area and also the farmers' living quarters. Beyond that, to the left, were steps up to a large walled-in garden where a swimming pool had just recently been built. To the right was another

Lemmy at 5 years old leading a horse at the farm in Autouillet HARVEY

farmers' living area, with cherry trees lining the lawn, and from there one could see the haystacks in the barn where the cows were brought in every morning to be milked. Further on was the chicken coop that sheltered the chickens. At the other end of the property sat the tennis court, and beyond that were fields all around, as far as the eye could see.

Initially, my parents had planned to use this place for weekends only. As the months went by, however, it seemed they were spending most of their time there. In fact, in one year's time, they realized they'd only spent three nights in their apartment in Paris! By this point, it wasn't a pig farm anymore; it was a country estate. But we still continued to refer to it as "The Farm."

Now that Helene wasn't performing as much, she spent most of her time in Autouillet. With passion, she threw herself into working on her ivory tower and decorating the house. She had a preference for Old English and Early American styles, and so she went searching through all the antique stores and the Paris flea market to find just the right *objets d'art*, looking for unique and unusual furniture. She spent many long hours choosing fabrics for curtains. To go with the wooden

cabinets she'd designed, she had copper pots specially ordered from the United States to hang on the walls of the kitchen. She discovered a Spanish leather painting from the 18th century— eight feet high, 20 feet long, and covering an entire wall—and the rest of the room was designed around it.

Helene was a great lover of flowers and planted a wide variety throughout the garden: cosmos, snapdragons, sweet peas, delphiniums, pansies, roses, lilacs, geraniums. It was truly an extraordinary array of plants of all kinds. She really put her heart and soul in her flowers, just as she'd done with ballet. And although she continued doing dance exercises every morning in the theatre, most of her energy was put into the farm.

Eddie, on the other hand, had a particular area he called his own: his plot of sweet corn. The seeds were sent from the U.S., and every year he planted his own private crop, taking meticulous care and even insisting on watering them himself. Growing sweet corn was a sacred ritual for him. It was something that reminded him that he was born in the United States, and he took pride in harvesting the best corn crop in France. Remember, at that time, the French were unaware of sweet corn; to them, corn was for feeding livestock, not for human consumption. The locals were convinced that Eddie was deep-down a crazy American.

When we first moved to the farm, Helene had the backfield plowed. She was preparing to plant an apple orchard, with all different varieties of apples. This required a lot of manpower and working hours, and she had to hire extra help to get it done. When it was finally completed, that orchard produced the best apples we'd ever tasted in our lives!

But then when Eddie began buying horses, he conceived of the backfield as being a space for his horses to graze. He really got behind that idea. The day he announced that he was going to turn over the whole orchard, my mother went wild. She ranted and screamed and

yelled, going so far as to threaten him with divorce, but Eddie was nevertheless determined and, in spite of all her threats, he ordered the workmen to drive in their tractors. By the end of that afternoon, every single one of the apple trees had disappeared from the ground. For days, Helene retreated to her room and wouldn't come out.

Eddie then came up with another one of his grand ideas. He was thinking of turning over the flower garden to grow a lawn. He claimed it would be much nicer if the whole area were flat and not so busy. Of course, Helene didn't agree, and they had numerous battles over the subject. Eddie would sit in the kitchen, sipping his whiskey, complaining that he never got to do what he wanted. He'd gripe, "How come I never get what I want around here? I spend all my money on everyone else, but me, I don't get anything!"

One morning, after Helene had gone out to do some errands, Eddie got out of bed in one of his nasty moods and, without consulting anyone, instructed the farmer to drive the tractor in and start plowing the garden. By the time my mother returned that afternoon, her fabulous garden was gone. Not surprisingly, she completely freaked out and fell into a deep depression.

Another complaint of Eddie's was the wall—over 400 years old and about 200 feet long—that separated the flower garden from the backfield. He'd been grumbling that it broke up the view, but no one really took him that seriously. In a menacing tone, he barked, "I'm tired of that back wall. I don't want to see it anymore!"

"Okay, so we'll tear it down," suggested one of the workers.

Reacting impatiently, Eddie hollered, "You say we'll tear it down, we'll tear it down. I want it done NOW!"

The guy meekly replied, "Okay. I'll go get some help."

All steamed up, Eddie hollered, "No, you don't have to get anyone. I'll do it myself!"

And so there he was, mallet in hand, hammering at that wall with

all his might, demolishing it bit by bit. With unbelievable rage and fury, he savagely attacked the stones until the whole wall was decimated. Helene went into shock. For days on end, she sequestered herself in her room, refusing to speak to Eddie.

It does seem bizarre that after each one of these episodes—all the fits and tears, all the threats of divorce—Eddie and Helene somehow managed to sweep these events under the rug and move on, as if nothing had ever happened.

At the farm, Helene often complained that she was the only one doing anything, even though there was plenty of help available. First of all, there was the family of farmers: the husband, François, who rose daily—even if it wasn't necessary—at 4:30 a.m., and who made a lot of noise to let everyone know he was working hard, along with his wife, Albina, who served as a cook, and their two daughters, who helped with all sorts of odds and ends. There was also an 80-year-old lady helping in the kitchen and the two stable boys as well.

Then there was the Spanish family: Vincent, Eddie's chauffeur and valet; his wife, Mila, the maid; Vincent's brother-in-law, Luis, a repairman who could fix just about anything; Vincent's sister, Consuelo, who helped clean the main house; Vincent's two nephews, Jorge and Jaime, who did construction and plumbing work; and Vincent's niece, Sara, who served as a nurse to my brother and sister.

These people were all like family to us and such great company when any of us felt lonely. They made us laugh and brought levity when things got tense. Sometimes they would even organize shows in our theatre, and they were better productions than we saw on TV!

Of course, there were drawbacks too. They'd often extend their lunch hour until 2 or 3 in the afternoon and would get very offended if anyone brought it to their attention. After all, they were from Spain; that's how it's done over there. Helene struggled to make demands on them, since she expected them to know what it was she wanted them

to do without having to tell them. She had trouble giving clear instructions to anyone and could not conceive that people were not able to read her mind. Consequently, her ongoing complaint was that nothing ever got done!

Vincent was the character of the bunch—and, above all, a comedian. He always managed to make people laugh, even when he made mistakes. One day, he was driving Eddie to the set in the Jaguar. As they entered a tunnel, Vincent's face turned white and he felt like he was going to faint. Stopping the car on the side of the road, he stumbled out and said, very apologetically, "I'm sorry, Monsieur, but I can't go on."

Alarmed to see Vincent in such a state, Eddie quickly got out of the car and climbed into the driver's seat, while Vincent plopped himself in the passenger side next to him. Driving off, he glanced over at Vincent, who was half-conscious, hoping he'd be all right. When they got to the other end of the long tunnel, Eddie asked how he was feeling.

"Better, Monsieur. I think I can drive now."

Vincent then took over and drove on. Eddie couldn't help but chuckle and later commented, "It's funny to have a chauffeur who you need to drive!"

Over the years, Vincent would pester Eddie about how much his talent was being wasted working as a chauffeur. He condescended to work as a servant, waiting for someone to offer him a role in a film. Eddie always made fun of him, but Vincent argued, "Listen, Monsieur, don't judge something you don't know. Put me in front of a camera, and you will see that I can do better than most!"

Making an effort, Eddie asked John Berry—the director of his next picture, À *tout casser*—if he could use Vincent, casually mentioning that he wanted to act. John Berry was enthusiastic. He replied, "Hey! I have a role for him!"

In Cormeilles-en-Parisis, where Eddie bought his first house. From left to right: Charles Aznavour's publicist, Helene, Eddie, Charles Aznavour, Liliane Alain, me, Jeff Davis, and Jacques Alain.

When Vincent auditioned, John Berry warned him, "But you know, you don't have any lines."

Disappointed, Vincent said, "Ah! Well, no, that won't do if I can't speak." John Berry laughed, thinking he was joking. But Vincent accepted anyway, overjoyed to have a role in the picture.

The scene was a comedy routine, in which Vincent was the center of the gag. He's in the kitchen cooking and an enormous fight breaks out, when about 200 plates start flying through the air. But he doesn't pay attention; he just watches out of curiosity while he continues

cooking spaghetti, except that instead of pouring salt in the sauce, he's pouring sugar. Even with no lines, Vincent was absolutely hilarious, and the scene got a big laugh.

Years later, Jean-Luc Godard—along with six other directors—was directing one of the seven short segments for a film called *The Seven Deadly Sins*. Godard cast Eddie as the lead for his short, titled *Sloth*. During the shooting, Vincent somehow finagled yet another bit role. Eddie cautioned him to follow Godard's direction. He warned, "Make sure you do what he says, okay, Vincent? You did well last time, but this is Godard."

"Okay, Monsieur."

At the beginning of a film, Jean-Luc Godard often worked without a script; only later would he come up with the dialogue. He typically had his actors improvise—though he was always in control. Vincent's particular scene took place in a kitchen, and he was supposed to be standing and talking with a young actress. Eddie would then open the door, walk in unexpectedly, and say, "Oh, I'm sorry!"

Godard gave his directions to Vincent and said, "Don't move. Just look at the girl and that's all. Just stand there."

Vincent thought, "Shit! What am I doing here if I can't move?"

The camera started rolling: Eddie opened the door, and Vincent made a gesture as if he were going to hit the girl on the rear end. Godard yelled, "Cut!" and started yelling at him, "I told you not to move!"

Vincent protested, "But what's the point? If Eddie comes in and says, 'Excuse me,' it must mean that we were in a compromising situation!"

Jean-Luc blew his top and screamed, "Get out of here! Right away!" And Vincent went back to his job at the farm. The funny thing is: Godard kept that shot in the film!

Before Eddie had bought the farm, the entrance plaza had a flower display that none of us really liked, including Eddie. So now he was ready to get rid of the flowers and plant a nice green lawn. Surrounding the display was a bed of stones that had made their way into the dirt. There were millions of these little stones mixed into the dirt, and they were all going to have to be removed if a lawn was expected to grow. Everyone joined in picking up the rocks, and to encourage participation, Helene had announced that the one who filled the most baskets of stones would get a prize. It was Lemmy who'd won—a big jar of peanut butter!

After Vincent sowed the seeds, Eddie wanted to be the first one to water it. That night, everyone was overjoyed at the satisfaction of having finished the lawn, and Vincent almost drank himself to death in the celebration.

At 5 o'clock that next morning, he was awakened by a knock at his door. He wondered who could be up this early and heard François, the farmer, whispering through the door, "Vincent! Come quickly!"

He'd guessed right away: A cow had gotten loose and had run around the newly planted lawn. It was a complete disaster! François—who, we were convinced, was really from another planet—used to tie up the cows with wire string only, and Eddie had told him repeatedly to go buy some metal chains, but he never did.

Frantic, François kept repeating, "But what can we do? Mr. Constantine mustn't find out!"

"How are you gonna hide it, moron?" said Vincent.

François' wife, Albina, had come out too, crying, "But Vincent, please, do something!"

Everyone was in absolute dread of Eddie's reaction! Sure enough, when he woke up, he was so mad that the whole estate was shaking like a leaf. No one had ever seen such an eruption of fury! After letting the dirt dry, Vincent filled the holes and started all over again.

On Sunday afternoon of the following week, Vincent was walking by the courtyard, glancing proudly at his work when, much to his amazement, Charles Aznavour was trotting on the lawn on horseback! Terribly upset, Vincent yelled out, "Monsieur! Please! Don't you see this is a newly planted lawn?"

He didn't seem to notice, replying, "What's wrong with you, Vincent? I don't appreciate your tone!" Although Vincent later apologized to him, he was upset at Aznavour's obvious disrespect for his lawn. Resentful, he went back to work, once again filling the holes and replanting the seeds.

When it came time for one of his horses to run its first race, Eddie was all excited, like a little kid, running around getting ready. He took out a selection of suits from his closet and tried one on with a white shirt, but it didn't look quite right. He pulled it off and threw it on the bed, grabbing another and trying it on with a different shirt. He wanted to be perfectly dressed for this formal occasion; everything had to be just right. After going through about 30 suits and at least a drawer full of shirts, he finally settled on a dark gray suit with a soft pink shirt and the right tie to go with it. At last, he was satisfied.

Eddie had invited a couple of guests over for lunch that day. Vincent announced that the meal was served, and we all walked into the dining room and sat down at the round ebony table. Eddie removed his jacket and put it on the back of his chair to make sure it wouldn't get wrinkled. When Vincent brought the main dish in, Eddie took one look at it and raised his eyebrows, muttering a quiet complaint to himself, "Oh, shit! Not again!"

Albina had made her famous "Floating Island" dish, as we liked to call it: three gallons of sauce with a few pieces of chicken floating on top. Albina's cooking was sort of hit-or-miss. Sometimes it was good; sometimes it was bad. And it didn't matter if Eddie requested specific dishes; she only ever prepared what she wanted to prepare. So we never

knew what to expect. Needless to say, today was *not* one of her good meals, and everyone looked quizzically at their plates.

After the first round of service, Vincent inquired, "Some more sauce, Monsieur?"

Eddie nodded. As Vincent moved forward, his foot got caught on the rung of the chair and he stumbled forward, spilling the contents of the bowl all over Eddie's trousers, tie, and shirt. Furious, Eddie hissed, "I have enough sauce, Vincent!"

There were dogs guarding the estate, all pedigreed boxers. Eddie had a particular affection for boxers, and his love dated from the early 1950s when he had brought home a puppy. He had come across Caroline while on tour singing in some godforsaken city in the South of France. There was a litter of boxer puppies right outside the theatre, and he was admiring them. The owner of the theatre came out and offered him the little runt as a gift. She was the cutest thing in the world. Since she was purebred, she had a pedigree, and in those days, the way they kept track of them was by assigning a letter for the year. Well, when we got her it was the year of the Cs, thus the name Caroline. We all loved that dog dearly, and she went everywhere with us. Unfortunately, she had a very weak stomach, and almost daily we had to mop up her vomit. But we still adored her, the little baby of our household.

Then one day at the farm, she ate some meat out of the garbage can that had gone bad. Her stomach couldn't handle it, and she quickly died. Everyone was terribly sad. Eddie helped Vincent dig a hole at the foot of a tree, and they put her in a wooden box and buried her in that field. Helene refused to attend the burial and instead watched from her window, mourning the loss.

Eddie was distraught that evening, sobbing in Helene's arms. I had never seen my dad cry. I was shocked when I walked into the living

room, and I immediately wanted to help console him. But Helene motioned for me to leave. I was horribly hurt by that. I didn't understand why he didn't want me to witness his sorrow. It felt awful to have my parents keep me at a distance at a time like that. I'd wanted to share in the family grief, and I felt deeply rejected.

Returning from Germany after shooting a movie one day, Eddie couldn't help himself: he brought home another purebred boxer. This one he named Mady (pronounced "may-dee")—it was the year of the Ms. In no time it seemed, Mady had eight puppies, who were absolutely adorable even though they peed all over the place. This was one chore that not one of the workers was willing to do. Each person said, "I wasn't hired for that!" It was me who usually ended up cleaning up the mess.

With eight dogs being far too much work, we decided to keep three of the nicest ones and give the others away. As they got older, they became good watchdogs. Eddie wasn't too happy with these boxers because they never recognized him when he came home, and they'd charge at him as if they'd never seen him before. He hated that!

Vincent often joked about how hard it was to be a dog living at our house. He mimicked them, growling just like them, "It's such a big job to watch the door all the time! And my master is always changing clothes! How am I supposed to recognize him?"

The dogs got into trouble with the bistro around the corner from the property. We received numerous complaints from the owners, when entire pies would disappear after they were left to cool on their windowsills. Or when a waiter would serve a plate of steak, he would set it down in front of the patron, and before the person had time to look at his plate, the steak would be gone! The customer would call the waiter in: "You brought me a plate, but there's no steak on it!"

And the waiter would reply, "But sir, I just brought it to you!"

"No, you brought me an empty plate!"

This would baffle the waiter, and it was always the client's word against his. This was a problem that happened often: the dogs sneaking out without ever being seen. Only once were they ever caught, and that was it for letting the boxers have the run of the place.

The dogs always loved when we had guests, because it meant more food. One Sunday afternoon, we invited Charles Aznavour and his girlfriend, Claude Maissiat, as well as a few French actors and some other friends—in all, there were 18 people for lunch. Vincent and Mila had taken off on their yearly vacation and Albina was off that day too. Helene was busy, and so I was the one to make the meal. I thought I'd make a crème caramel for dessert, which always seemed to look good and turn out well. I prepared two large bowls, set them to cool on the table right outside the kitchen, and went back in to continue my preparations for the meal.

A while later, I heard screams outside; Helene was yelling at the dogs. Glancing out the window, I noticed she was motioning for me to come and take a look. I stepped outside and, lo and behold, there was a gaping hole in each of my crème caramels! The dogs had eaten the top, and if Helene hadn't caught them, they would have finished them all off! I thought, "Shit! What am I going to do? Now I don't have a dessert!"

It was Sunday; everything was closed, Albina wasn't there to help, and lunch was going to be ready any minute. Deciding to make the best of it, I very matter-of-factly said, "Okay, Mom, don't say a word. I'll take care of this. No one will ever know!"

Later, after having served the dessert on individual plates, our guests were raving about how good it was. Charles Aznavour was particularly appreciative and said, "Tanya! You did so well with this crème caramel! It's delicious! You should give us the recipe!" Eddie glanced over at me approvingly, unaware of any problem. Helene and I winked at each other and secretly chuckled at the irony of the whole situation.

Charles Aznavour having lunch at the farm, taken the day the dogs ate the tops of the crème caramels.
TANYA CONSTANTINE

Having guests was a big part of life at the farm. We had people over all the time: Brigitte Bardot came over every so often; Gregory Peck and his wife, Véronique, were there whenever they were in France, and they'd even wanted to exchange houses with us for a six-month period—they had a house in Hollywood that was absolutely magnificent. The only reason Eddie and Helene didn't jump on the idea was because my mother was embarrassed that the farm was not in the best shape. She worried that Gregory Peck would not appreciate the problems with the plumbing and electricity.

Truly, the house was ancient. It was built in the 18th century, and the plumbing was not always manageable. Toilets often overflowed, seemingly always on a Sunday morning when no plumber was available. This was a source of great mortification for Helene. Eddie often complained, "We've got a swimming pool, but the filter works only when someone comes to see what's wrong with it. The heat runs the same way."

On some Saturday nights, we'd even have as many as 30 guests, many of whom stayed overnight. Come Sunday, there'd be just as many for lunch, and even more would show up for dinner. Once, after

already having thrown a big party, Eddie invited several guests to stay on for a couple of days; somehow, they ended up staying for a couple of weeks! There was one man who was around that whole time. Helene didn't know him at all; she just figured he was someone's friend. After a while, however, having asked each guest, she realized he wasn't anyone's friend. After two weeks, she felt too embarrassed to ask, "Who are you? What's your name?" Vincent seemed to be the only one who could get away with bad manners, and so Helene sent him to ask about this man. It turned out that he was a photographer and had been at the party two weeks before. The man had noticed people staying and so he'd stayed on too, having himself a wonderful vacation!

Other frequent guests were Paul Newman and Joanne Woodward, who would come to visit whenever they were in Paris. Paul and his family were over for lunch one day, and during the meal, he and Eddie were sitting next to each other at the table. Eddie was saying, "I like living in France because it's an anarchistic country; laws don't mean anything here."

With an inquisitive air, Paul asked, "Is anarchy left or right?"

Shocked, Eddie turned away and didn't answer, pretending he hadn't heard the question. But later, he commented, "I'll never forget that. That's one of the biggest booboos I've ever heard anyone say!"

Another time when Paul and Joanne were over at the house, Paul wanted to help Eddie cook. Eddie had a stone barbecue pit built into the wall with a metal turning handle, and he used it to make his favorite meals: hamburgers and grilled chicken. He liked his hamburgers well done. The French, however, prefer their meat rare—but none of his French friends ever dared complain. Well, Paul didn't realize he needed a glove to hold the metal handle, and sure enough, he burned his hand. He screamed, "Get some oil!"

But Eddie protested, "Are you kidding?"

Grabbing Paul's arm, Eddie pulled him over to a faucet and ran

cold water over his hand for a couple of minutes. Paul had never used cold water for burns before. Eddie felt good; he taught Paul Newman something he didn't know!

But I believe my father secretly envied Paul Newman for his fame and notoriety. Eddie did his best to compete, and he tried to have the upper hand wherever he could. The next time they saw each other, he offered Paul a magnanimous gift: a very expensive watch from Boucheron. Paul was shocked at his generosity, so taken aback that he didn't know what to say.

Eddie later complained, "I don't know if he liked it, because he hardly thanked me!" He hadn't gotten the response he wanted. That's the problem about giving in order to get: if it's not done freely, then one is bound to be disappointed. Eddie and Paul never saw each other again after that.

When guests were over, my father loved to invite them to go horseback riding around the property. To ensure they all had a horse to ride, Eddie bought enough saddle horses to accommodate most everyone, in the end purchasing 18 of them. We would go on long rides, following different paths—through fields, through woods, through the nearby villages—and when we'd get to a clearing, we'd whoop it up, screaming like cowboys and Indians and making a lot of noise. Eddie would always be shouting, "Cingarella! Pastasciutta!" He liked words that had a ring to them, even if he didn't know what they meant.

Sometimes, we even went horseback riding by moonlight. Although some of our guests didn't always know how to ride, we took the chance that they'd be okay. This particular evening, 12 of us had gone on a long ride through the woods. After a delightful couple of hours, we headed back to the stables. Eddie took a quick headcount and came up with 11 horses and 11 people. Immediately, we went out searching for the lost person.

We were very worried because whoever it was could have gotten

himself killed. We looked everywhere with no success. Two hours later, escorted by policemen, he was driven back to the farm. He told us his story: During the ride, he'd had some trouble with his horse, who was only wanting to return back home. Eventually, he lost control and the horse took off, galloping wildly, heading straight for the stables. It so happened that they were passing under a tree when this happened, and the guy went flying in the air and landed on the branch of an apple tree, hanging from the limb. Unfortunately, his glasses had fallen off so he couldn't see anything. Just then, the owner of the property he was on heard some noise. He dashed out of his house with a shotgun and threatened to blow the trespasser's brains out. He screamed, "No! Don't shoot! I fell off a horse! I'm with Eddie Constantine's party!" The landowner went home and called the police. After this fiasco, our guest was happy to get back to Paris that night, and he never did go on another ride with us again.

It didn't take long before Eddie had cleared a path through the backfields to create a genuine racetrack. And although he didn't have insurance to cover any injuries, a lot of big stars sure took a lot of risks riding on that track, such as Brigitte Bardot, Jeanne Moreau, Johnny Hallyday, Gene Kelly, Paul Newman, and Gregory Peck—just to name a few!

Jeanne Moreau was a famous actress in France. She starred in *Jules et Jim*, directed by François Truffaut, and also *Ascenseur pour l'échafaud* ("*Elevator to the Gallows*"), which was directed by Louis Malle. When she first visited the farm, she wanted to try riding a horse, even though she'd never done it before. She felt confident that she would learn quickly.

The stable boy helped her mount the horse and gave her a couple of instructions: how to hold the reins, how to get the animal to move, and other such pointers. She was so sure of herself that she proceeded to kick the horse in the ribs and took off in the backfield. Unbeknownst

to her, horses can sense when they can take over and when they cannot; within minutes, the horse had figured out that this woman did not know how to control him and he quickly took over. Jeanne realized, to her utter amazement, that she'd lost her grip. Making a sharp turn, the horse was now galloping down the field so rapidly that she dropped the reins! Frantically, she grabbed onto his mane, just barely able to wrap her arms around the horse's neck to stay in the saddle, holding on for dear life. He was heading directly toward the stable, and there was no slowing him down!

Eddie, who happened to be close by, was screaming and making a lot of commotion, waving his arms to get the horse's attention. Thankfully, he finally managed to stop the horse just before he got to the courtyard. It was close to a miracle. Jeanne could have gotten very badly hurt!

Eddie hollered to her, "A miss is as good as a mile, Jeanne!"

They both heaved a big sigh of relief. When she slid off the horse and onto the ground, she could hardly walk, her legs were hurting so badly. Whether it was the heat, the fear, the sweat, or the thirst, she took a few steps and passed out. She had to be driven home.

The next day, she wasn't able to show up on the set of the movie she was working on. For three days, she couldn't walk straight. Her thighs were literally black and blue for weeks—talk about a memorable weekend!

Tony Curtis and his wife, Christine Kaufmann, were visiting one day, and Christine was another one who had almost no experience horseback riding. That day, she'd gotten herself all spiffed up, dressed in riding breeches with the hat and the gloves; she sure looked the part. Tony was proud of her and watched her ride off. She was walking the horse slowly, all the way out to the track.

She gave a little kick in the ribs and got him started galloping down the path, slowly at first, and then faster and faster. She soon realized

that she'd lost control and cried out as the horse carried her off. Alerted by her screams and worried that she might get hurt if she fell at that speed, Eddie and Tony ran in the direction the horse was heading, yelling out to her, "Hold on! Don't let go!"

What else *could* she do but hold on? She grabbed the saddle. Sprinting as fast as they could toward the entrance of the stable area, both Eddie and Tony had arrived just in time, waving their arms to command the horse to stop—and he stopped. That was a big scare, and Eddie and Tony had to have a few drinks to relax after that!

But there were also times when we weren't so lucky. For example, Jean Lefèbvre, a famous French comedian, once put his horse in boarding at the farm. The horse was a beautiful white Arabian stallion named Athos. One day, Helene, Eddie, Vincent, and a few others were out horseback riding through the fields. They were having a good time until Eddie, who was riding a gelding, inadvertently crossed paths with Athos, who then suddenly lifted up on his hind legs and caught hold of Eddie's rear end. Athos bit into him, pulled him off the saddle, and dragged him down to the ground, still holding a firm grip on his butt.

Everyone started to scream, frantically trying to whip the horse with their sticks, but he wouldn't let go. No one could figure out what to do. But when Vincent jumped off his horse, that caused a reaction in the crazed animal, and Athos finally dropped his hold of Eddie. Everyone was flabbergasted, in complete disbelief that such a thing could happen.

Eddie was badly hurt and was writhing in atrocious pain. There was a lot of yelling and screaming; finally, someone sent for an ambulance, and he was driven to the nearest hospital. There, they sedated him before cleaning the deep gashes in his buttocks. They stitched him up and gave him a tetanus shot. For 10 days, he had to stay in the hospital, at least until the swelling went down and the injury began to heal.

As soon as he returned to the farm, the first thing he did was to get

rid of Athos. Although technically that horse didn't belong to Eddie, he sold Athos to the first buyer who showed up; and so Jean Lefèbvre lost his horse!

My father began purchasing thoroughbred racehorses. By 1960, he'd accumulated about 30 of them. Slowly but surely, he was reaching a stage where he considered making movies a hobby and horses his primary interest. Eddie bred and kept some of the horses at the farm, while others were in training in Chantilly, where they were boarded. He regularly got up before dawn and would leave home by 5:30 in the morning to drive to Chantilly, so that he could survey the training.

On Sundays, Eddie, Helene and I went to the races, particularly when one of his horses was running. It was exciting to sit in the owners' box next to the French aristocrats, watching the jockey wearing Eddie's blue and yellow colors, flying by on the way to the starting gate. There were times when I'd get so excited that I'd be jumping up and down before the race even began! And then, once they were off, I couldn't keep my binoculars steady enough to see anything. I'd be screaming and carrying on, not caring in the least if I was making a fool out of myself—just like Liza in *My Fair Lady*!

But Eddie always remained cool, appearing as if he had everything under control. It was a good act. He was playing the role of the dignified owner, and he worked hard at it. He would study all the breeding charts and knew the names of every winner. He often knew more about breeding than his trainer.

By then, Eddie had bred three yearlings, and he put them up for sale at the horse auction. Nobody bought them, however, and he was very upset. He'd waited two years to put them up for sale, and now there were no results. This put him in a very bad mood. Just for fun, he started reading the catalog to see what was up for sale. As he was thumbing through, he noticed this horse named Petrone by Prince Taj and Wild Miss by Wild Risk. It was a golden pedigree. He thought, "I

better take a look at this horse." But then he thought, "Oh! But he'll probably be much too expensive."

He went over to take a look, but there were so many people standing around the horse that he couldn't see him. On a spur of the moment, he decided to take a risk and go with the pedigree. He put in a bid. He lifted his hand up, and kept lifting it until it got to 40,000 francs ($8,000). Finally, it was announced over the loudspeaker, "Forty thousand, Eddie Constantine!"

In the meantime, Jacky Maitre, Eddie's personal assistant, was busy walking the unsold yearlings back into the truck. Hearing the announcement, he thought right away, "There he goes again! He bought another horse! His passion is gonna ruin him!" Jacky went over to see what Eddie had bought and ran into the trainer, who bitterly complained, "What stupidity, to buy a horse with three legs!"

Now Jacky was really worried. He hurried over to the stable and noticed that the horse had a knee that was as big as his head. Very concerned, he went over to Eddie and complained, "This horse is lame! Have you seen his knee, Monsieur Eddie?"

Irritated, Eddie replied in a nasty tone, "I'm big enough to make my own mistakes!" Fearful of confronting Eddie head-on, Jacky decided to swallow his pride. He went over to talk to two veterinarians to see if the sale could possibly be cancelled. They both agreed, however, that the swelling was insignificant. The sale held. And although it was clearly too big of a risk to buy a horse that has a problem with one of its legs, Eddie still felt good about his purchase—regardless of what everyone was saying.

Several weeks later, Eddie received a phone call from his trainer, who was all excited. He kept repeating, "This horse is fantastic! He's the best I've ever had!"

Feeling validated, Eddie proudly replied, "I know!"

When Petrone became a two-year-old, he was entered in an

important race, but unfortunately, he didn't do too well. Right after the race, the jockey who was riding him jumped off and said, "He's just a 2-year-old; he's not grown up yet. He shouldn't be running until next year."

Knowing instantly that the jockey was right, Eddie ordered his trainer to cancel all engagements. He decided to wait until the time was right. The trainer went out of his mind; he wanted to start cashing in on him right away, but Eddie knew the right decision was to wait.

That next year, Petrone was entered in one of the most prestigious races in France, the Grand Prix de Paris at Longchamp. He came in second place. Hailed as a great future champion, he was picked as the favorite when he turned 4, winning five big races in a row, including the Prix du Prince d'Orange and arriving third in the Ascot Gold Cup in England. Then in January of 1969, Eddie shipped him to the United States, where he won the San Juan Capistrano Handicap at Santa Anita. And in July of 1970, he won the Sunset Handicap in Hollywood Park. Despite people's initial doubts, Eddie was right: Petrone turned out to be a great winner!

After that race, however, Petrone tripped and injured his foot, and he had to be retired as a stallion. But Petrone sired a great line of winners and became a champion stud—and this was the horse whose purchase was a "stupidity!" This is just one of Eddie's success stories with his horses; he had many others. He seemed to have a flair for choosing winners, and he didn't seem to be afraid to take risks. He was willing to stick his neck out against all odds!

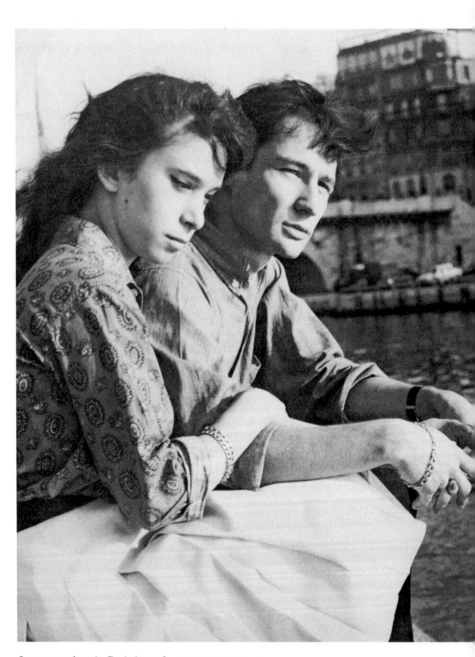

Lorenzo and me in Paris in 1962 DANIEL LEFEBVRE

6. ÇA VA BARDER

("All Hell Is Breaking Loose")

ONE SUNDAY AT THE FARM, after my mother and I had just returned from church, Charles Aznavour and his gang came over for a visit. He'd brought along his girlfriend, Claude Maissiat, and his agent and interior designer, Androutchka, as well as Androutchka's two friends, Lorenzo and Ricardo. By that time, I was a little over 15 years old, and I had almost grown as tall—or as *petite*, shall we say—as my mother. I could now fit in her clothes, which I often borrowed when I needed something dressy to wear. But this event was casual, and so after changing into blue jeans and cowboy boots, I went downstairs to join our guests.

Just a few weeks prior, Aznavour had given Eddie an Arabian horse as a gift. To keep the trade fair (or was it to get the upper hand?), my dad offered him a Hasselblad camera that he was very proud of. Aznavour was delighted with his new toy, and this exchange put Eddie in a great mood.

Vincent had a theory about Eddie's moods. He said that Eddie gave off the impression of being an extrovert, but that this was really a false image. He said, "If you counted the days he was withdrawn and the days when he was happy, there were far more days when he wanted to be left alone! The times he came out of himself, it was because something

happened out of the ordinary that grabbed his attention."

Androutchka was someone I'd seen at the farm a couple of times before. I'd always liked him. Helene had asked him to help her with the finishing touches on the farm, and he was making some astute suggestions. He was an accomplished artist and a famous Parisian interior designer, who had decorated many homes in the area, including Aznavour's. He was a chain-smoker, and he would light each cigarette with the previous one, holding it between his fingers as he talked, unaware of the ashes dropping onto his clothes. He was a bit of a dandy—wearing capes and ruffled shirts—and although he was gay, he loved young, straight men.

Lorenzo was one of these such men, a "special" friend. He was a handsome young man, recently turned 21, who was 5'6" with brown hair, dark eyes, and olive skin. He had sharp features and a slender, sexy body. Born in the South of France near Monte Carlo, he had a very slight accent until he managed to drop it years later in an effort to sound more Parisian. He wore tight blue jeans and would roll up the sleeves of his T-shirt to show off his muscles. He was flirtatious but aloof, which gave the impression that he knew something that others didn't. There was a certain mystery around him that was very attractive; no one could ever find out what he was about.

I was immediately drawn to him. I invited him to take a tour of the farm, and he gladly accepted. We walked all around the property, with me showing him the stables, the chicken coop, the cows, and the swimming pool as well. Naturally, we ended up in the theatre.

On the stage was a ping-pong table. With a seductive look, Lorenzo coaxed me into playing, and we started an exciting game of table tennis. There was an immediate chemistry between the two of us, and Lorenzo took advantage of it. He instinctively pulled the right strings to grab a hold of me, and I was more and more drawn to him as the minutes went by. Walking by, Androutchka caught a glimpse of us and

knew instantly that something was going on. By the end of that day, I was hooked.

Years later, believe it or not, I made a strange discovery about that day: I found out that Lorenzo and Ricardo had staked a bet on me. Ricardo had woken up early that Sunday morning and had said, "Hey, Lorenzo, why don't we go spend the day horseback riding at Aznavour's?"

Lorenzo was tired. He'd been up all night. Ricardo kept insisting, "Let's go visit the Constantines!"

"What for?"

"Well, Constantine has a daughter named Tanya, and she's very cute!"

Perking up at the possibility, he asked, "How old is she?"

"She's 15."

Insulted, he exclaimed, "What do you want me to do with a 15-year-old?"

"I'll make you a bet. Let's see which one of us seduces her first. Is that a deal?"

That week was the longest week of the century for me. On Saturday morning, Helene and I drove over to Aznavour's house, which was about 15 minutes away from the farm, and I was overjoyed when we walked through the door and there was Lorenzo. My mouth was dry, my palms were sweaty, and my feet were freezing. But I also felt great excitement! While Helene was busy discussing some decorating ideas with Androutchka, Lorenzo and I went for a long walk through the woods.

During that stroll, our romance really started to bloom. We held hands and would gaze into each other's eyes. I laughed bashfully, and we continued to walk and talk. I remember looking up to the sky and feeling like my energy was soaring as high as the treetops. It was a

delightful and memorable moment.

After returning back to the house and preparing to leave, Helene invited Lorenzo over to the farm to spend the night. My heart was racing with excitement, and when he accepted, I gave Helene a warm and grateful smile!

He slept in the theatre that first night, all the other rooms being taken. There was an extra bed up there—for emergency cases—and Vincent had prepared the bedding with clean sheets and covers. The next day, from breakfast until late that night, we spent every minute together: talking, flirting, riding horses, getting closer and closer.

He was invited to stay yet another night and this time, since most all the other guests had left, he moved into the guest room and stayed there for the remainder of the week. I was thrilled that he was able to stay this long, and to boot, he'd even been able to charm Eddie, who was enjoying having him around. That was really convenient!

In a way, Lorenzo was starstruck at the opportunity to hang out with a big star like Eddie Constantine. The two of them would joke around and go on long horseback rides together; they had a lot of laughs. Eddie would ask him things like "What do you want to do in life?"

"I want to be an actor in films." Lorenzo had just played the role of a hoodlum in a recently released film called *Pardonnez nos offenses* (*"Forgive Us Our Sins"*), directed by Robert Hossein.

"Oh, don't worry. I'll put you in my films. You're going to be working with me."

Eddie thought right away that Lorenzo would be perfect for the role of the young cowboy in his next picture, *Chien de pique* (*"Jack of Spades"*), which was set to be filmed in Camargue, in the South of France.

But meanwhile, attending Androutchka's art exhibit a few weeks later, there was a stunning and talented young man who caught my dad's eye named Pierre Clémenti. Sensing a potential talent, he said to

Clémenti, "You should be in movies with a face like that!" And so Eddie recommended that he audition for the director, Yves Allégret, and do a film test. The audition went so well that Allégret signed him up right away for the role of the young cowboy, and Lorenzo's great opportunity went flying out the window.

Before Eddie flew to Spain for his next film, *Me faire ça à moi* ("*How Could You Do This to Me?*"), directed by Pierre Grimblat, he invited Lorenzo to stay at the farm while he was away to "watch over the women and children," as he put it. Lorenzo was delighted to be our guardian and gladly accepted the job. He'd only just gotten back from his military service in the Sahara Desert, and he didn't have any plans. And anyway, he was flattered by all the attention.

Somehow, after a couple chaotic weeks of guests coming and going, Lorenzo was transferred from the guest room into the bedroom adjacent to mine. The bathroom was now the only thing that separated us! This transition happened so inadvertently and with such incredible ease that neither my mother nor my father seemed to notice. Needless to say, I was on top of the world!

My room was about 400 square feet and was furnished in the Napoleon III style: a wide-paneled wooden floor, a mahogany poster bed draped with white voile and black velvet ties, pink-and-white striped wallpaper, 19th-century black satin chairs, and wooden tables encrusted with mother of pearl. It was the ultimate romantic room, and I was very much enamored with it.

Typically, when it was time to go to bed, we all gave each other goodnight kisses on the cheeks and went to our respective rooms. One night, after the house was totally silent and everyone was asleep, Lorenzo tiptoed through the bathroom and opened the door. I stopped breathing when I heard him enter, and my heart started to race. I could hear my chest pounding. I was petrified. Excited, but petrified. I didn't dare move.

He slowly walked over to my bed. It was dark, but I could make out the contours of his body because of the outside lights coming through the window. I could tell he was wearing a white T-shirt, and I noticed a glimmer in his eyes. He lifted the sheet and slowly slipped in under the covers. At first, I was too scared to move an inch. For a few minutes, he simply lay there next to me. Then he cuddled up and put his arms around my shoulders. He knew he had to go slowly. After all, he was five years older than me—he was the adult! I'd never had this experience before, and it was all very new to me. I didn't know what I was expected to do. I truly believed I had no say. Sensing this, Lorenzo played me like a violin.

That first week, we merely hugged and kissed; it took another week before we went all the way. The element of risk added to the excitement of the whole affair. In the early morning, he'd tiptoe back to his room before the house began to stir. I was always afraid that someone would come in and discover us, but no one ever came. It seemed as if everyone knew what was going on, and that there was an unspoken agreement in the house that no one would acknowledge the situation. Helene would look the other way, but apparently, she didn't have a clue. She actually really liked Lorenzo! The two of them loved to talk for hours on end about their favorite subject—metaphysics—and they'd go at it until late into the night. I'd be so tired, I'd fall asleep on the couch.

One hot summer day, they were fooling around in the garden and being silly, teasing each other, hiding behind trees and trying to tickle each other. Then Lorenzo picked up one of my sister's water balloons and poured it over Helene's head. She retaliated and got my brother and sister to cooperate by filling up all the other balloons. The scene started to escalate when Lorenzo threw a whole pot of water over her head. Laughing and shrieking, Helene ran to the kitchen and grabbed a bigger pan, filled it up with water, and was ready for a bigger assault,

when suddenly Lorenzo jumped out from behind her with a water hose. He had a devilish smile on his face. She ran out of the house squealing as Lorenzo chased after her, hosing her down. They raced around the garden, carrying on like wild children, laughing and screeching and fighting over who would get the upper hand. At one point, they started running throughout the house; by then, the whole place was completely drenched.

With the fun finally over, it was now time to clean the mess. It took us hours to mop it all up. Personally, I enjoyed the theatricality of it all. It was outrageous behavior, and that was the way I liked to live. And I loved that Lorenzo had captivated my mother's attention in that way.

To help Helene with the finishing touches of the home décor, Androutchka came over. He would often stay overnight in one of the guest rooms. He'd bring his oils and canvases and do some paintings. He'd set up his easel in the room and the smell of his oil paints would linger long after he'd be done. He also made costumes and clothing. He once designed a dress and coat for me that Ted Lapidus—a Parisian fashion designer at the time—executed in blue taffeta, which I wore the following week at Judy Garland's one-woman show at the Palais de Chaillot in Paris.

As Eddie was getting ready to leave on another trip, an opportunity came up for me to dance on French television in a variety show with Michel Renault, one of the principal dancers at the Paris Opera. Eddie and I bounced around some ideas of what I'd do and agreed I should do two pieces: one modern and the other classical. The next issue— who would choreograph it? I knew I wasn't skilled enough to do it. But Eddie made a suggestion: "Why not Lorenzo? Couldn't he do it? He's a good dancer." I was surprised he even suggested it, but I kept my cool and didn't let up how excited I was. On that note, Eddie left on his trip to Spain.

Me and Michel Renault on prime TV in 1960 T. Bernard of Paris Match

This show was going to be a big deal. It was to be performed live on prime-time French television, and I was hopeful this experience would lead to more opportunities. I was thinking, "Who knows? Maybe I'll be discovered and my career will take off!"

For the show, we chose two pieces of music: "Barcarolle" by Jacques Offenbach for the classical *pas de deux*, and the Modern Jazz Quartet for the jazz solos and the finale. The enchanting part for me was that we conveniently arranged to rehearse in the theatre at the farm.

That Sunday, it so happened that Eddie's horse Petrone was running for the first time at Longchamp in an important race. Helene wanted someone to accompany her, as she hated going to the races alone, but none of us wanted to go. Lorenzo and I had the excuse that we needed to rehearse, and Androutchka claimed it was too hot to go to the races that day. Reluctantly, poor Helene went all by herself.

Well, Lorenzo and I didn't do a stitch of work that day. We fooled around instead and basked in the sun. When my mother returned from the racetrack late that afternoon and discovered that we'd played

hooky, she got very agitated. Feeling betrayed, she accused us of conspiring against her. She got herself so riled up that she threw a fit, yelling and screaming, "How dare you lie to me? This has gotten out of hand!"

She became violent. Racing up the stairs leading to my room, she stormed in and opened my closet, grabbing my blue taffeta outfit and tearing it to shreds. Vehemently reacting to her outburst, I hollered back and tried to slap her across the face, but she was on a rampage; nothing could stop her. Grabbing my hand, she pulled the ring off my finger—the ring that Lorenzo had just bought me—threw it in the toilet and flushed it down! That was too much for me. She'd overstepped my boundaries, and I pounced on her like a wild animal. We fought like two cats, scratching and biting wherever we could. I pulled her hair and she pulled mine. She grabbed my sweater, and I bit her hand. I was trying my best to win this battle, but her energy was tremendous! At the height of her frustration, she let go of me and ran to the phone to call my father, still huffing and puffing from the adrenaline rush. As soon as she got him on the line, she started to wail and scream and complain, "Lorenzo and Androutchka are taking advantage of us! This has gotten out of hand! They don't have any consideration for me! They're so disrespectful! And Tanya is just as bad! She's trying to hurt me; can you imagine that?"

Predictably, Eddie became infuriated. He hollered into the receiver, "Get rid of them! Get them out of my house right away!"

Feeling satisfied that someone had heard her complaints, she stomped back into the living room with a look of triumph in her eyes. She announced that Lorenzo and Androutchka were to leave the house immediately, and that I was never to see Lorenzo again. Shaking from head to toe with rage and fear, I helplessly watched as Lorenzo and Androutchka packed their bags and walked out the door. All I wanted was to go with them, but Lorenzo kept cautioning me that this would

only alienate me from my parents further. He didn't think that it was a good idea for me to leave. I cried bitter tears as they drove off, leaving me behind to deal with the horrid atmosphere lingering around the house.

In spite of the distance, Lorenzo and I continued preparing for the television show, rehearsing in town instead of at the farm. For a while, my mother conveniently swept the issue under the rug and pretended she didn't know we were meeting in Paris. There were no arguments over the subject; she acted as if she knew nothing about anything.

Feeling a bit cocky one day, I blatantly made a phone call to Lorenzo right in front of her. I guess by this time, she figured that if she fought too hard, it might very well push us even closer together. I can't profess to know what was going on in her mind, but one thing was for sure: She had decided to let the matter wear off on its own. With her complicity—and without Eddie knowing about it—she agreed to allow Lorenzo to return to the farm.

A few more weeks were spent rehearsing and training. Since I was dancing *en pointe* for the classical section, I worked hard at strengthening my footwork, dancing with pink satin toe shoes. The day the television program was taped, the ballet performance went quite well and the show was a great success. I especially excelled in the jazz section. I had had great expectations of being recruited to join a dance company, but it never happened. No one called after the show, and it turned out to be just a one-time deal.

Eventually, Lorenzo and I no longer felt the need to hide our love affair. We had become an item and were actually flaunting it in public. But then one day, Androutchka made an inadvertent remark that ended up shocking the hell out of my mother. He said, "Isn't it wonderful to see Tanya and Lorenzo getting along so well?" Startled by the comment, she realized that it was becoming obvious, which meant that it had gone too far—Eddie had to be alerted. Her phone call to Spain

delivered the bomb. Sure enough, Eddie flew off the handle at the thought of his 15-year-old daughter having an affair right under his roof!

This relationship became a very disturbing issue to my parents. My father was acutely aware of the potential danger it represented to me. He sensed both Lorenzo's opportunistic drive and my teenage vulnerability. He had high aspirations for me, and this young man wasn't part of the great plan. On the other hand, I was totally mesmerized by my sexual attraction, and all I could see was that Eddie was stubbornly trying to prevent me from getting what I wanted. It was a battle of wills: The more he erected barriers, the more I opposed him.

When my father returned from Spain, he was at a loss as to what he should do with me. He avoided confronting me directly. Instead, he continued to go horseback riding with Lorenzo, coaxing him into disclosing more about himself. He wanted to find out what he was up to, but Lorenzo was mysterious; there was nothing Eddie could put his finger on. He tried inviting Pierre Clémenti to spend time at the farm, hoping he'd turn my head away from Lorenzo, but I saw right through the scheme and didn't catch the bait.

Meals at the farm during that period were truly ordeals. Before even entering the front door, Eddie's hostility could be felt. The atmosphere worsened when we'd sit down around the table for lunch. There was no place to escape—we were trapped. If any one of us made a false move, Eddie would jump on our case and find fault. I really dreaded those meals. Sometimes we sat there in total silence; other times there were terrible arguments. It was a nightmare! I felt sorry for Barbara and Lemmy, having to live in this climate at such a young age.

Then one morning, Eddie woke up in a thunderous mood. I hadn't yet come down for breakfast, but I could feel the vibrations all the way up in my room. I was not looking forward to going downstairs and confronting him, but I knew that, sooner or later, I'd have to do it. I

was shaking in my boots, my stomach tied up in a knot, but I coura-geously walked into the kitchen and found Eddie sitting at the table, waiting for me. For several days, he'd been attempting to control his temper, but he just couldn't hold back anymore. He howled, "What is Lorenzo doing here? Doesn't he have a job?"

Upset at the attack, I exclaimed, "Why do you hate him so much?"

Infuriated, he lifted his arm to hit me. Alerted by the high-pitched voices, Lorenzo had nervously run into the kitchen and immediately intervened, yelling, "Don't touch her!"

This absolutely enraged Eddie and he went wild. He shouted, "I'm tired of you! Get out of my house immediately!"

I retorted, "If Lorenzo goes, I go!"

"Well, then, get the hell out of here! I'm tired of you, too!"

Shaking like leaves, we stormed out of the house and drove off, leaving the farm with Eddie still screaming profanities behind us. I had only just turned 16.

We drove to the hotel where Androutchka lived in Paris and stayed with him in his room. It was a miserable hotel where cockroaches crawled all over the walls and the sheets were never changed. At all times of the day or night, whores walked up and down the stairs, pre-venting us from sleeping. Although the experience itself was amazing, I eagerly returned home a week later. Eddie and Helene were starting to think of ways to distract me and were looking for creative ideas.

Plans were brewing for Eddie to fly to Hollywood to do *The Dinah Shore Show* on TV. This would be such an opportunity, and the timing was perfect. The whole family then took off for California while Lorenzo was left behind.

This TV program was big for my father. He had high hopes that this would be his lucky break in the United States, and he was revved up for the chance. He was the star of the show, and he was busy preparing to sing some of his most popular songs, with Jeff Davis accompanying him

at the piano. During those weeks, he was in great demand with photographers, reporters, and producers, not to mention all his movie star friends calling on him all day long.

The night of the airing our family went over to Dinah Shore's house for a big celebration, and we all watched the program together like one big happy family. The show was a great success; Eddie was the talk of the town. He thought, "This is it! Now my career is going to take off in America!" The phone kept ringing off the hook with compliments from friends and acquaintances, but no offer was made. Weeks later, we were back in Paris with no American film prospect—and I was still thinking of Lorenzo.

In the privacy of their bedroom, my parents talked endlessly about the "Lorenzo problem." Helene explained to Eddie that he would be better off keeping his cool. She felt that it was his antagonism that was actually pushing us into each other's arms. During these talks, Eddie would promise to behave and stay put, and my mother would feel sure that he'd actually make an effort and be patient. Half an hour later, however, she'd hear him in the kitchen screaming his brains out at me.

In hopes of putting distance between my father and me, Helene came up with the idea of taking me to New York to study modern dance at the Martha Graham School. She thought it would be good for me and would help keep me busy for some time. Soon after we arrived, I was enrolled in dance school. She took me to other dancing lessons too: ballet, jazz, modern, anything that was available. In the evenings, we went out to see all the shows playing both on and off Broadway. We had a good time together, just the two of us. After a couple of weeks, however, she went back to Paris, leaving me in a little hotel on 53rd Street with just enough money to pay for the room, my food, and my dance classes. It was fun for me to be alone in New York, and I made some new friends at the dance school.

I hadn't forgotten Lorenzo, of course, and I wrote him long love letters on a daily basis. After a month went by, my mother became suspicious and realized her efforts hadn't been very fruitful. She shared these suspicions with Eddie, and, under the pretext that it was costing him too much money for me to remain in New York City, my dad called me back to Paris.

Once back home, Lorenzo and I realized my parents weren't going to give us an inch. We put our heads together and came up with a brilliant idea. We devised a strategy that would enable us to both spend time together and also be far away from my parents' scrutiny. Playing on the idea that Helene wanted me to study ballet, I made the suggestion that I should study with Marika Besobrasova, who was then a famous ballet teacher in Monte Carlo. You see, Lorenzo's grandmother lived in Monte Carlo, and so he'd have a place to stay. I still don't know how I pulled it off. That lie was as big as a mountain—and my mother even knew about the grandmother—but somehow, I was persuasive enough for them to fall for the scheme. Arrangements were soon made for me to go down to Monaco straight away.

I was to live at Marika's home, and it was agreed that she would watch over me. I enrolled in daily dance classes, and the plan was turning out well. I even participated in a recital, in which I did a beautiful classical solo. It was tremendously successful, and I was becoming a promising student.

But about three months into the season, Marika caught me in a lie and discovered that Lorenzo and I were meeting secretly every night. Tragically, she blew the whistle on us, and that plan was over. Eddie called me back to Paris once again, and I had to return to the farm. I wasn't looking forward to facing my father, and I anticipated more of those tense meals ahead. I kept dreaming of running away for good; all I wanted was a safe place to live!

By this point, Eddie was at a loss. He gave me long lectures,

emphasizing the fact that I was jeopardizing my future by continuing this romance. He was angry and harsh, and this situation was getting harder and harder for me to deal with. He wasn't even speaking to me civilly anymore; he barked whenever he had anything to say. I hated being around him, and I found any excuse to get away.

Feeling close one day to being at the end of my rope, I figured I'd try one last strategy: I would make a deal and agree to Eddie's bargain, and I promised him that I would never see Lorenzo again. Instead, I'd busy myself by taking dance, piano, singing, and acting lessons. I'd live at our apartment in Paris during the week, and then Vincent would drive me to the farm, where I'd spend every weekend with my parents.

Interestingly enough, my friend Grace—whom I knew from the Christian Science Sunday School—was invited to be my chaperone. I don't know how that happened, but it did. She was elected to move into the apartment as well so that she could keep an eye on me. She was only two years older than I was, but my mother was convinced that Grace had her head on her shoulders and that she'd be a good influence.

During that time, I took acting classes with John Berry, who taught method acting in Paris. I loved him and really learned a lot from him. He was a great teacher and, in a way, a father figure to me. He encouraged me to break through my fears of expressing myself. In those days, I was very self-conscious and believed I was ugly and worthless. His classes brought me out of myself, and I gained confidence.

Another watchdog during my stay there was Eddie's friend Henri Cogan, a tough, husky stuntman who worked in all his films. He was very devoted to Eddie, and he proposed to move into the apartment in Paris to watch over me. He believed his presence would have a balancing effect, and if nothing else, he'd be a great bouncer if ever Lorenzo showed up!

I was starting to feel claustrophobic when he moved into the bedroom right next to mine. I was imprisoned between my two chaperones. The resentment I felt toward my father was gathering momentum, and it felt like the situation was just getting worse. In spite of all the precautions, Lorenzo climbed through the window and still managed to spend many nights with me.

One Sunday afternoon, driving back to Paris from the farm, we noticed there was trouble in the city. There were tanks at the Porte de Saint-Cloud, and it looked like all of Paris was being invaded. Grace and I anxiously held hands that night in the apartment while we waited to hear the news on television. That night, just as Charles de Gaulle was making his famous televised speech, saying, "*Français, Françaises, aidez-nous!*" ("Frenchmen, Frenchwomen, help us!"), Lorenzo knocked at the door. Worried there was going to be a civil war, we got swept up in the drama and Grace had no problem with letting Lorenzo stay. We didn't leave the apartment for two whole days. On Tuesday, however, peace seemed to be restored; Paris went back to normal, and so Lorenzo had to go back to his place.

Financially, I was completely dependent on the meager weekly allowance Helene gave me. I had just enough money to pay for my lessons and for food during the week—but I always needed more. I never had enough, and how could I? I was paying for Lorenzo's meals, too!

In spite of all my parents' efforts to keep us apart, Lorenzo and I always managed to see each other. The drama of it all escalated much further when—at almost 17 years old—I realized I was pregnant! At first, I refused to believe that such a thing could happen to me, and I ignored the obvious symptoms. But soon I couldn't avoid them anymore; I had to face facts. I was very frightened. I knew I was too young to have a child, but Lorenzo insisted we would manage. Whenever I thought of my parents' reaction, I'd have an anxiety attack. I couldn't

come up with a good way to announce this to my dad, and so I gave Henri Cogan the honor of announcing the bad news.

Both my parents were utterly devastated. They'd truly believed we weren't seeing each other anymore. The discovery that I'd been lying all along was especially painful. Eddie brought up the question of abortion, and both my parents supported the idea. I wasn't quite sure what to do. I was confused. Lorenzo wanted to keep the child. Naively, he thought our relationship would have more credibility in my parents' eyes if we had a child. That was a preposterous notion to me and not a good reason to have a child at all.

I felt terribly inadequate, being unable to fend for myself in the world. I wanted to rely on Lorenzo, but I could see he wasn't really capable of providing, and that was scaring the hell out of me. If I couldn't depend on him, what was I going to do? I saw no option, either way.

Taking advantage of my indecision, Eddie called a meeting at the house with his agent, Jacques Alain, as well as Helene, Lorenzo, and me. At that meeting, it became apparent that Eddie had been toying with the idea of having Lorenzo arrested for abduction of a minor. Jacques Alain was pressuring him to change his mind, claiming it would bring Eddie a lot of bad publicity, which he didn't need at the time. The other issue was that everyone in the room agreed that I should have an abortion—everyone except Lorenzo. Suddenly, the hostility generated against him became very strong, and it appeared that he was ambushed. The biggest blow to Lorenzo came when I expressed my desire to take some time off to think about our relationship. I secretly blamed him for my pregnancy. He was older than me; he should have known what to do. He seemed to be locked into only what he wanted and not on what was right or good for me. I knew I needed to take care of myself; I just didn't quite know how to do it yet.

The decision was made: My father made arrangements for the

abortion to take place in a clinic in Paris. I was to be in the best of hands, with the best possible doctor tending to me. To get around the legalities at the time, he simply declared it to be an appendectomy. The operation was swiftly scheduled and brought to its conclusion. Because it went so quickly, I didn't take the time to think too much about it.

After it was all over, Eddie vowed to lavish me with all sorts of gifts. He promised me a car, a bank account in my name, a house, men, whatever I wanted. He tried to tempt me with everything he could think of. It was amazing because it meant that I was worth something if he went that far to please me, and so I soaked it up as much as I could.

During that whole period, my father made an immense effort to treat me like a human being. He never yelled at me and went out of his way to be good to me. Both he and Helene would take me out to the theatre and to nightclubs, they introduced me to numerous men, and they especially attempted to prove to me that Lorenzo just wasn't good enough for me. Eddie said, "He's all right, but he's just not it. Plus, he's a pederast. You deserve much better!" But was it true? Was Lorenzo truly a homosexual? I didn't really know, and how could I know? I'd never caught him having sex with Androutchka, which led me to believe he was straight. It was a question I had virtually no answer to.

I was beginning to be swayed by all this advice and attention. One Sunday morning, Lorenzo decided to show up at church, where he was sure to find my mom and me. Taking me aside, he asked why I didn't want to see him. With my anger toward him still unresolved, I blurted out, "I don't want to have a relationship with a pederast!"

Surprised at my own audacity, I wondered why I'd never had the courage to mention the subject before. I always accepted his version of the story, that his relationship with Androutchka was strictly platonic. Figuring out this unclear area of his character had become of utmost

importance to me. I really hoped he could deny it, but Lorenzo thrived on mystery, and at that moment, he clammed up. He later admitted that he was so enraged that he felt the urge to kill me; instead, he swallowed his pride and walked away. Disappointed that he wasn't willing to talk about it, I went home feeling uneasy about our interaction. Sharing my feelings with my mother that day, I admitted, "I don't know why, but I feel sorry for him!"

As a side note, Androutchka was close friends with a famous novelist from the Académie française named Henri Troyat. I knew him too by way of his daughter, Minouche, with whom I was close friends at the time. Henri Troyat and Androutchka would spend many weekends together at Troyat's country home. There, Androutchka would share events that were happening in his life, and soon, Troyat had enough input to write a novel that was loosely based on the experiences of Androutchka, Lorenzo, and me. The name of the novel is *La Pierre, la Feuille, et les Ciseaux* ("*Stone, Paper, Scissors*"), published by Flammarion in 1972. For reasons of privacy, we were all given pseudonyms: Lorenzo is Aurelio, Androutchka is André, and I am Sabine. Interestingly, Troyat did not mince words about Androutchka and Lorenzo having consummated their relationship, but since he had *loosely* based his story on what had been reported to him, it is not guaranteed to be accurate. Nonetheless, it has an aura of authenticity and helps to provide more context to what was going on in our circle at that time.

A few weeks later, with guilt and a sense of incompletion weighing on my conscience, it was time for me to let my heart out, and so I phoned Lorenzo at his hotel. I loved hearing his voice, and it was comforting to talk to him. Again, I felt the impulse to run away from home and be with him. That's just how he made me feel.

All fired up after our phone call, I convinced Helene that I needed to work out all this emotional baggage, or else it would just remain

unfinished. She agreed to invite him over, and a couple of hours later, he was knocking at the door. As soon as he walked in, we threw ourselves into each other's arms with incredible passion. It was undeniable that, despite all the drama, there was a strong bond that united us. Helene lifted her eyes to the sky and sighed, at a loss as to what kind of advice to give me.

Since Eddie was gone working on a film in Nice, Helene made arrangements for our whole family to drive down to the South of France to join him. She would drive her Jaguar and Lorenzo would drive his new red Fiat that Androutchka had just bought him. My mother made no objections to the fact that Lorenzo was coming with us, as long as he didn't plan on staying at the same hotel. And so instead, he decided to stay with his grandmother in Monte Carlo.

We drove down, both cars following in tandem the whole way. I rode with Lorenzo in the Fiat, and we played the whole way down. Instead of driving straight to our destination—which normally would have taken about 10 hours—we took our time and stopped at all the good restaurants along the way, visiting the châteaux and staying at a couple of inns. Helene simply turned her head the other way. Meeting Eddie was yet another matter. And Lorenzo didn't stick around at the Hotel Negresco to test him either. He merely came by to pick me up, and then we'd run to the beach—which is where we spent most of our time.

During that stay in Nice, there was an actress named Barbara Laage who had become part of our extended family. Eddie had gotten her the lead in two of his recent pictures. He obviously liked her, but they were very discreet about it. If they *were* having an affair, no one ever caught them doing anything other than holding hands or calling each other endearing names. Lemmy, who was about 3 at the time, was already in competition with Dad; he liked her too and would "buy" many gifts for Barbara Laage (stealing money from my mother's purse to do so)!

Unfortunately, Barbara Laage made a few big mistakes with my father, the main one being that she stood up for Lorenzo. Of course, no one was supposed to do that, and just as I anticipated, she soon lost his favor. At first, to my father, she was adorable, brilliant, gorgeous, charming, and talented, but her support for Lorenzo turned her into a dumbbell, ugly, with no charm and no talent. My dad never hired her on another picture after those first two films.

Once we returned to Paris, Eddie was getting more and more upset that I was officially back together with Lorenzo. He and I were driving into town together one day, and it was very clear that he was terribly irritated with me. I wondered what was going on with him. He violently slammed the door and I thought, "Oh, boy, I'm in for a ride!" As we drove along, it was as if his anger—and not the engine—was gaining momentum. Everything was getting on his nerves, and finally he started yelling at me, "I'm sick and tired of you and Lorenzo! When are you going to drop that gigolo of yours? I hate him!"

He was out of control, ranting and raving about how bad Lorenzo was. Then, suddenly, he slugged me in the stomach with his right hand, holding the steering wheel with the other. Shocked and hurt, I shoved myself against the door to get as far away as I could. He could still reach me and proceeded to hit me in the chest. In a panicked state, I opened the door just as he was stopped at a red light. I jumped out of the car and made a dash to the street without turning back. I ran as fast as I could. I ran and ran and ran. My heart was pounding so fast that I felt my chest would explode. Each step I took was putting more distance between us, and that made me feel safer. At last, when I was good and tired, I slowed down my pace and came to a stop. I felt free, relieved.

Immediately, I thought of going to Androutchka's place. He had just recently rented an apartment with the money he'd made from selling a couple of his paintings. His space was on the 12th floor and consisted of one bedroom and a very large living room. This time, I

had an adequate roof over my head. I moved in right away—my only possessions being the clothes I was wearing that day. I never bothered calling my parents to let them know where I was.

We lived like gypsies in that apartment, and I had the time of my life. There were about 10 of us hanging out in two rooms: Androutchka, with whom I got along with really well (he was not jealous of me, and I was not jealous of him), his latest boyfriend, two or three derelicts he'd rescued from some club or other, and Lorenzo and me. His sister Mavra, his brother-in-law Maxime, and his niece Béatrice all lived on the 15th floor of that same building, and they would come over on a daily basis.

We did all sorts of activities there. During the day, we all played gin rummy and canasta or just hung out sipping coffee, chatting about deep metaphysical subjects. At night, we pulled out the mattresses and positioned them in rows, like at camp. None of us had a job, and no one had any money. Around meal times, we each gathered our pennies and would usually come up with enough to go to the market across the street and buy a box of pasta, a can of tomato paste, some garlic, onions, parsley, and a piece of sausage. Those were the best spaghetti feasts!

We did nothing concrete, nor did we accomplish anything to call home for—we just lived on a perpetual vacation. Androutchka was the only one who kept himself busy, focusing on his paintings. We'd serve as his models, and he'd dress us in costumes he designed for us when we had big parties. On Tuesdays (the only day it was free), we would go to the museums. There, Androutchka tutored me in French history, as well as in art and literature. He had me read most of the classic authors, ever encouraging me to explore more. Colette was his favorite author, so of course, I was influenced and loved her too.

During that period—which lasted about a year or so—I never contacted my parents, and they didn't search for me either. They knew I was somewhere in the city and hoped one day I would come to my

senses. Once, when I was in dire straits, I did end up contacting them and went to the farm for a visit.

While there, I stuffed myself with food and piled up on provisions. Eddie slipped a 100-franc bill in my hand when he said goodbye. I felt a little embarrassed that my dad had to give me money, but the discomfort was overshadowed by the thought that I'd finally be able to afford some necessary items. Lorenzo resented that I accepted this money and insisted I return it, and so reluctantly, I did. My father was furious: "What? He won't accept a donation I make to my own daughter? He's depriving her of what is rightly hers? Who does he think he is?"

Lorenzo had his pride!

The truth was that Lorenzo had a terrible time adapting to the world. As a high-school dropout, he hardly had any education, and I suspect he had a learning disability that prevented him from learning how to write, which he never overcame. He did read a lot—but he had to have others write his checks. He masked his disability with mystery. In his opinion, it wasn't worth his time to work a menial job for a low salary. He was unsure if he could ever make enough money to support the two of us.

This sort of reasoning didn't get him very far, and our situation always seemed to go from bad to worse. It worried me a lot. I wanted so badly to be independent of my father, but the fact was that I was failing. I still seemed to need him to survive, and that really pissed me off!

Finally, Lorenzo landed a job as a barman at Chez Régine, the famous Parisian nightclub. He began earning a small income, which was long overdue. I'd been living the whole time—can you imagine?— in one skirt, one shirt, one sweater, and one pair of shoes. Not that I cared that much, but I was definitely relieved to be able to buy myself some clothes. We rented a studio in the Île Saint-Louis for the equivalent of $25 a month and, much to his chagrin, moved out of Androutchka's apartment.

Shortly after that, a journalist from *Paris Match* came by our place. He interviewed me and wrote a story about us. A two-page centerfold photo in black and white came out the next week: It featured Lorenzo and me gazing into each other's eyes at the bar, showing him dressed as a barman. That photo made a big splash, and all of France had a chance to see it—including my parents. Up to that point, we'd managed to keep our relationship in the family, but suddenly it had become a public matter. Eddie had a fit over this, going so far as to publicly announce that he'd disinherited me. I retaliated, once again, by not giving my parents any sign of life for another six months.

I felt very hurt that he'd taken me out of his will; this I took as the ultimate rejection. Of course, it could be argued that I'd brought it on myself. After all, I was the one who'd run away from home! Still, it didn't feel very good, and I just wished that my parents could have understood me. I wish they could have allowed me to do what I thought was right. I guess that was a hopeless thought, but I was naive.

Meanwhile, a record producer contacted me to ask if I was interested in signing a contract with his company. He'd heard me sing with my father and saw the potential in me. I jumped on the idea, thinking, "Yes! Finally, someone has discovered me! Here is that lucky break I've been waiting for!" And so an audition was arranged for the following week.

During the next few days, Lorenzo thought he'd make himself useful: He had me listen to records of Brenda Lee—who was very big at that time—because he thought it would be great if I could sound just like her. Not knowing how to take care of myself, I let him push me around and make the decisions about what to sing at this audition. But my voice didn't sound anything like Brenda Lee's, and I wasn't in the least bit encouraged by his direction. On the contrary, I started to feel more inadequate than ever. In comparison to Brenda Lee, my untrained voice sounded really bad. My internal critic was way up in

arms, and I was beating myself up mercilessly. By the end of the week, I had gone into resignation, and I ended up losing most of my enthusiasm.

The day of the audition, Lorenzo insisted on accompanying me to the rendezvous, which was a *big* mistake. Had I been able to tell him that this was *my* opportunity and not *his*, I might have had a chance to break through. But I was too afraid of his judgment—too self-conscious, too inexperienced to stand up for myself—and I passively let him lead me around.

As we walked into the studio, my energy was very low. I had no enthusiasm and was filled with self-doubt. I glanced over at the piano where I noticed an open contract ready to be signed—and that scared me. My fear gripped me in the stomach and I cowered. I was supposed to sing when the accompanist began playing the first few bars of the song. Instead, I stood there looking around at all the people staring at me—waiting for me to perform—and I panicked. My throat tightened up so much that I couldn't even speak. Unable to break through my fear, I uttered a soft hum, as if that was the way I sang. When the song came to an end, the producer looked at me with disappointment in his eyes. He was courteous but quickly thanked me for coming and disappeared into the next room. That was it. It was all over.

I was utterly devastated after I left the building. I had sabotaged myself in the worst way possible. I fell into a depression for days, and I kept asking, "Why did I do that to myself?" It took me 30 years to get the message: My destiny was not to be a star; my commitment instead was to focus on becoming a free, authentic, self-realized being.

Sometime after that, Helene broke the ice and gave me call. We both sounded strained during that conversation. Again, I felt that knot in the pit of my stomach, but it did feel good to have some contact. She said Eddie wanted to see me and was inviting me along to spend some vacation time in the mountains.

He had planned a four-week vacation trip with the whole family, as well as his pianist, Jeff Davis. We stayed at the Grand Hôtel au Rond Point des Pistes, in a ski resort town in the French Alps called Courchevel. Having not seen anyone in the family for a long time, I was feeling up for it. When I asked my mother if Lorenzo could come too, she reluctantly said, "If you absolutely insist!" I joined them a week later, leaving Lorenzo behind until he was able to take a leave from his job.

When I arrived, the family greeted me with open arms. They were happy that I looked as well as I did. I guess they must have thought I'd look bad after living away from them for so long. Talk about arrogance!

We did a lot of skiing during the day: Helene, the kids, and me. Eddie would never have been caught skiing. Instead, he sat in the lobby with Jeff, and once in a while, they went for walks. Most evenings were spent in the hotel nightclub.

After a few days of being there, I happened to notice a young man staring at me while walking through the lobby of the hotel. He was a nice-looking guy, well dressed and sophisticated. I smiled back at him and thought, "Gee! That guy is kind of cute!" Barbara and Lemmy later informed me that the Maserati parked in front of the hotel belonged to him. I also found out that this guy, whose name was Jean, wore only cashmere clothes and that he lived in Switzerland. My interest was piqued.

Whenever I saw Jean in the lobby, we flirted from a distance by smiling at each other. Then one evening he was at the club, and he invited me to dance with him. I noticed that Eddie was elated by my interest.

Up until this point, I had absolutely no experience with men, in the sense that I skipped the dating process altogether by jumping into a relationship as a teenager. This idea of "dating" was a very new thing for me, and I was pretty excited.

Adding fuel to all the excitement, Lorenzo arrived a few days later from Paris—much to Eddie's dismay. The timing seemed awfully bad, and my father was very disturbed. It was always in his mind that I would marry someone with more stature than Lorenzo, someone with class, perhaps an aristocrat with a large fortune. But here I was at 17, ready to settle for an opportunist, a barman from a Paris nightclub!

That evening, we were all gathered together in the nightclub of the hotel, having a few drinks. Jean was at one table with some friends, and we were at another with our circle of friends. Just to get a brief glance, I was furtively looking over at Jean once in a while. Eddie, on the other hand, was in low spirits; his anger was growing as fast as his bottle of whiskey was diminishing. He kept glaring at Lorenzo across the table, and it was no great secret to the rest of our guests that if his eyes could kill, Lorenzo would be dead!

At one point, Ray Charles' hit song came over the stereo system. My dad started singing along, sarcastically referring to Lorenzo's legal name being Jacques: "Hit the road, Jack, and don't you come back no more, no more, no more, no more! Hit the road, Jack, and don't you come back no more!"

The whole table now knew that he meant business. Everyone could see his wrath. One by one, each person took leave under one pretext or another, feeling more and more uncomfortable as the minutes went by. In the end, the only ones left at the table were my dad, Lorenzo, and me. The knot in my stomach had become unbearable, and all I could think of was getting out of there as quickly as possible.

While Eddie was momentarily distracted by someone walking by, I leaned over to Lorenzo and whispered that I was running upstairs to the room. I told him, "Meet me in five minutes in the lobby." My plan was to pack our bags, order a taxi to pick us up, and drive to the station to take the next train back to Paris.

Shaking with terror, I got up and walked casually out of the club,

trying not to attract Eddie's suspicions. As soon as I was out of his sight, I made a dash to our room. I gathered our belongings and threw them in a bag, then rang the hotel manager and requested that a cab be ready immediately. Next, I rushed to the lobby with our luggage in each hand. Just as I was whizzing by, Lorenzo flew through the door— eyes popping out of his head with fear—and we both sprinted to the cab that had just pulled up in front of the hotel entrance.

Suddenly, my mother whirled toward us, flinging the cab door wide open, almost breaking the hinges. Furious at my mother's audacity, I jumped out of the cab and lunged at her. She grabbed me by the neck. My pearl necklace then broke, the beautiful tiny beads scattering all over the ground.

Eddie had come up to the lobby and was now lunging at Lorenzo, throwing punches wherever he found an opening. Lorenzo was trying to avoid his fists, and he managed to move away at just the right moments. Meanwhile, no one in the lobby dared interfere; they just looked at us with astonishment.

Helene was trying to kick Lorenzo in the shins. Then she grabbed a small side table and hurled it at me. Avoiding it by the skin of my teeth, I picked up an armchair and threatened her with it, but it was too heavy to throw and I had to put it down. Sensing that we needed an avenue of escape, I yelled out, "Lorenzo! Run down to the room!" And so we rushed toward the door leading to the basement, with Eddie and Helene following us down the staircase, chasing us through the hallway, then through another lobby, up a flight of stairs and down to the basement, through the kitchens, while Eddie was screaming at Lorenzo in English, "I'm gonna kill you! Just you wait!"

Lorenzo didn't speak English, and so he didn't understand what Eddie was saying. Still, as we raced through the lower lobby of the hotel, Eddie kept repeating, "If you don't understand English, you better learn!"

Lorenzo yelled, "*On est en France! Ici, on parle Français!*" ("We're in France! Here, we speak French!")

As we flew through the main kitchen, Eddie picked up a butcher knife he found lying on a counter and was now brandishing it at Lorenzo as he ran. Catching a glimpse of the knife out of the corner of my eye, adrenaline instantly surged through my body. I was hysterical. We ran up the last staircase and finally found the way to our room. Eddie and Helene were still chasing us at close proximity. We managed to unlock the door, scurry in, and slam the door shut behind us.

Panting from all the running, Eddie was banging on the door with his fists, threatening to break the door down and kill us both if we didn't open right away. The door was starting to crack from the strength of the hits, and I was really scared. I thought, "If that man breaks that door down, we're dead!"

Lorenzo ran to the balcony to explore possible alternatives but quickly returned empty-handed. We were out of ideas. Frantically checking around the room for something that could serve to protect us, he picked up a glass he found in the bathroom and banged the edge on the sink. Now he had a sharp-edged weapon in his hand. Menacingly, he directed it toward the closed door.

Eddie was still screaming, with Helene egging him on. Lorenzo couldn't understand a word, and even though I was completely terrorized in the midst of all the commotion, I had to keep translating every word that was being said. "You're a good-for-nothing son of a bitch! I'm gonna break down this door if you don't open up, and I'm gonna kill you!"

At one point, Lorenzo suggested I tell him to throw his knife away. I screamed as loud as I could: "Dad, throw your knife away!"

There was silence.

I started to cry, tears streaming down my face. Eddie's voice was lowering, and it appeared that the mood was beginning to shift.

Lorenzo had me ask again, "Dad, why don't you get rid of that knife? I'm scared!"

After a few moments of deliberating with Helene behind the door, we heard the distant sound of a knife sliding along the stone, landing at the other end of the hallway. Eddie said in a loud whisper, "It's all over!"

Still panting with fear, we slowly emerged from the madness that had so overwhelmed us, becoming aware of our environment and of the ridiculousness of the whole situation. Lorenzo took a harder look at the broken glass he was still gripping, and he threw it in the wastebasket. My dad muttered something about opening the door, but Lorenzo didn't feel safe yet and suggested (and I translated): "Why don't you go back to your room and we'll join you there in five minutes? Okay?"

Eddie and Helene agreed. With our ears glued to the door, Lorenzo and I kept track of their footsteps as they went down the corridor. We heard the noise of the elevator door open and then close, followed by dead silence.

We stood there for a few minutes just to make sure it was safe. We heaved a deep sigh of relief—the danger was over! And although the door was in pretty bad shape, we only had a few scratches ourselves. Lorenzo exclaimed, "You sure have crazy parents!"

Taking some deep breaths to help our bodies relax, we waited a few minutes and then slowly walked up to my parents' room. We knocked on their door. Before there was any time to think, Eddie opened it up and stood with his arms spread out wide, and we all fell sobbing into each other's arms. With his arms around Lorenzo, Eddie murmured through his tears, "Weep, Lorenzo. It's good for you!"

We cried for a long time. It was an intense catharsis for all of us. Nothing was changed, and nothing had been concluded, but we were able to vent and release tons of emotional tension.

About half an hour later, after we were able to review the event with a bit of humor, commenting on how much money it was going to cost to pay for the damages throughout the hotel, Eddie said, "Why don't we go to this party we were supposed to go to?"

I said, "Why not?"

And so we combed our hair, fixed ourselves up a bit, and marched out arm in arm through the lobby of the hotel, eyes swollen from the tears but smiling broadly.

Sure enough, the next morning, Eddie was presented with a bill for all the damages incurred: a smashed-in door, a broken leg of a chair, a missing doorknob, a cracked tabletop.

The drama wasn't over, however, and the next evening, we were back in the hotel nightclub having drinks. Eddie was somewhat relaxed, a bit sedated after all the emotional upheaval of the night before. My attraction to Jean was still as strong as ever, and we continued eyeing each other, trying our best to conceal our play from Lorenzo, but it was getting harder and harder. It was starting to show all over my face.

Finally, Jean walked over to our table and boldly invited me to dance. Lorenzo hadn't paid attention, but we still moved over to the other side of the dance floor where he couldn't see us. After going through several dances, Jean then abruptly took me by the hand and walked me out of the club and into the lobby of the hotel. I was so thrilled that I didn't even question his actions, and I let him take over. He directed me to his room, closed the door, and embraced me passionately. Then he suddenly stopped and said, "Run away with me! I'll take you to Switzerland!"

It seemed so preposterous, but I was totally swept away. I wasn't able to think of anything other than what was in front of me; all I wanted was to go with the flow. Without hesitating, I accepted. Grabbing his bag that was already prepared, we flew out of the room, through the lobby, and into his electric-blue Maserati. I was exhilarated; my knight

in shining armor had come to sweep me off my feet! What an adventure!

We drove through the night to Switzerland. It was a delightful trip, and I was feeling vitalized and exalted, being completely taken care of by this wonderfully masculine and decisive man. I stroked his cashmere sweater and thought I'd gone to heaven. When we arrived in the early morning at a chalet, Jean decided we'd stay for a couple of days.

After that first wild and crazy night, the initial flurry of intense energy simmered down. My fascination with Jean started to dwindle. My knight in shining armor didn't seem to be as passionate as I was. In fact, it appeared that he had very little interest in me. It left me wondering, and I couldn't understand why he'd lost his interest so quickly.

As the days went by, Jean's attraction to me was fading so rapidly that by the time we'd arrived at his apartment in Lausanne, we hardly even enjoyed each other's company anymore. The only remnant left of my infatuation was in his cashmere—25 cashmere sweaters, all neatly folded in his closet, 12 cashmere jackets, and a drawer full of cashmere socks. As if all this was so important to me!

Eventually, I felt the need to phone Paris and talk to Lorenzo. It was clear that I had become a nuisance to Jean, and he didn't know what to do with me. He was more than relieved when I asked him to put me on a train back to Paris after our 10-day fugue.

Years later, I uncovered the mystery surrounding my cashmere friend. When Eddie had noticed my interest, he had gone over to talk to Jean and cut a deal with him. I don't know if there was ever any exchange of money between them, but they definitely had some kind of deal. Eddie wanted Jean to romance me and take me away. He hoped it would separate Lorenzo and me once and for all. But in spite of all his best efforts, he'd only driven us closer together!

Back in Paris, Lorenzo greeted me with open arms. He felt wounded but happy that I'd returned. Humbled by my experience, I was ready

to open my heart and to see him with new eyes. I was overjoyed to see that he was so committed to our relationship that he wasn't going to let this passing romance come between us. His steadfastness impressed me, and I felt lucky to have him in my life.

We went back to our life in the Île Saint-Louis. Lorenzo earned just enough money to buy food and pay the rent—although we did accept donations from a few wealthy friends who felt sorry for us. I returned to my daily routine of ironing his shirts, cooking his meals, and waiting up for him all night.

My folks and I remained on poor speaking terms. I got a letter from them one day. It was a very nasty note I didn't keep; I threw it in the garbage right away. I remember it caused a big stir, and Lorenzo and I had a big argument over what my response should be. We finally decided that Lorenzo would dictate a letter (in French), which went as follows:

> *Paris, Feb. 22, 1963*
> *Dear Daddy and Mommy:*
>
> *I'm not asking you to see Lorenzo. I ask you only to let me love him without having to be separated from all of you. I only ask what a daughter usually asks her parents: an aid, a moral support. But you only respond with blame and accusations, because I don't do exactly what you want me to do. It is impossible and unnecessary to want to separate me from Lorenzo. As it seems incompatible with your "great love for me," I unfortunately do not see any immediate solution.*
>
> *Maybe, in the years to come, you will open your heart. I love you the way you are, with your vehemence, screams, qualities, and faults, and I want to ask you to try to love me not for the way you want me to be, but for the way I am.*
>
> *Love,*
>
> *Tanya*

This letter only served to infuriate Eddie and Helene even more than before. Because it was not in my style of writing, it was obvious to them that Lorenzo had dictated it. This gave them more ammunition for their quarrels with each other, which were getting worse. Soon after they'd exhausted quarrelling about Lorenzo and me, they'd start another fight of their own.

7. ME FAIRE
ÇA À MOI

("How Could You
Do This to Me?")

LORENZO AND I WERE AT HOME one afternoon when the phone rang. It was an emergency call from a friend announcing that Eddie's talent agent, Jacques Alain, had just been found dead in his apartment. Lorenzo was speechless. Then he composed himself and asked how it had happened.

"It looks like suicide. He's still here, lying on the floor. Can you come over to help me clean up?"

Still in shock, Lorenzo put down the receiver and relayed the news. We looked at each other in amazement—how strange. It had only been two days since we'd last seen Jacques Alain. He'd always been so nice to us, even going so far as to slip a few hundred francs in our pockets when he knew we needed it. He was a supporter of ours, and the only one close to my father who believed in us. How could it be that he was dead?

In a daze, Lorenzo managed to get himself dressed and run to his car. He drove over to Jacques Alain's place. Walking into the apartment, he was immediately taken aback; the smell of gas was still lingering. And there was Jacques' body lying on the kitchen floor. It was eerie. But most spooky and disturbing of all was that hundreds of lottery tickets were strewn all over the entire house—on the bed, on the floor, on the chairs, everywhere.

Lorenzo and his friend mustered the courage to carry the body onto the bed. They chose one of Jacques' many suits hanging in the closet and dressed the corpse. Cleaning up the mess, they tried to count the lottery tickets as they went along but ended up losing track.

The funeral took place two days later. Lots of people showed up: all sorts of friends and at least 20 of Jacques' girlfriends. They all had great affection for him, and everyone was very upset at the suddenness of his death. No one was aware that he had any financial problems. He'd started out with nothing; it was Eddie who had been his first big break. As the years went by, many other actors joined his growing talent agency. He had a reputation of having a heart of gold, being a staunch supporter of the arts, and always helping starving actors—especially the women.

Though everyone felt the loss, Eddie especially was devastated by this unfortunate turn of events. Curiously enough, Jacques Alain's funeral was the only funeral he ever attended. As the casket was being carried out of the church, he knocked on the wood three times. I guess he figured it might bring him good luck, and at that point in his life, he could have really used some!

Many of the circumstances surrounding Jacques Alain's death have remained a mystery. Even to this day, a shroud of ambiguity has clouded the whole matter. But I've actually managed to put several pieces of the puzzle together. When Eddie first began making big money, he felt that he was incapable of keeping track of it. Instead of having all the finances in his name, everything would go through Jacques Alain. Although he never trusted anyone (even my mother never knew anything about this), he found himself in the position of relinquishing his power of attorney to his agent, which he willingly and gratefully did.

All the while, however, Jacques Alain had finagled a way of orchestrating an elaborate and convoluted plan involving a whole slew of companies and land purchases in foreign countries. First, there was the

film distribution company in Portugal that swallowed millions but never brought in a cent, then the purchases of land in Switzerland in his wife's name, the purchase of the Columbia film offices in Paris for some 20 million francs in cash, and still many other business deals that no one alive knows anything about. Since none of these transactions were legitimate write-offs, and because the millions of francs that were channeled back and forth couldn't be traced, no one was able to keep track of any of it—except Jacques Alain himself!

But then one day while Eddie was in Courchevel on a six-week vacation with Helene, the hotel manager discreetly notified him of a bounced check that he had just received from the bank. Surprised, Eddie brushed him off and said it was a mistake; he just had to reissue it. Later that day, as Eddie was walking downtown, a store owner called him over and mentioned that the check he gave him a while back had been returned unpaid. Very embarrassed, Eddie gave the man a charming smile and recommended that he put it through again.

Feeling awkward about these matters, Eddie returned to the hotel and put a call in to Paris. As soon as Jacques Alain was on the line, Eddie hollered angrily, "What's happening? All the checks are bouncing here! Can you please take care of this? This is ridiculous! There must be some mistake!"

Jacques Alain promised to take care of it right away, and the problem did seem to blow over. On their way back to Paris, however, Eddie decided at the last minute to stop over in Geneva so that he could place an order for several pairs of custom-made shoes from his favorite shoemaker. Eddie and Helene then strolled over to the Swiss bank to pick up some pocket money. Just imagine Eddie's expression when the teller thrust a note in front of him showing that his account was at zero! Eddie's first thought was "Oh, Jacques must have funneled the money to another bank." Within minutes, he was back on the phone to Paris, anxious to find out where the money had been transferred. But Jacques

simply said in a trembling tone, "I'll explain it all when you get back to Paris. Let's meet at the airport."

Helene was venting her worries on their way to the airport to return to Paris. She could feel that something was seriously wrong. She voiced her disapproval of Eddie for having given so much power to one man. "That's such a dangerous thing!" she said. It just didn't make any sense to her.

Eddie remained silent throughout most of the ride, but as they were nearing the airport, he finally said, "He's nothing without me. I made him what he is. He would never betray me." Helene went into a long tirade, but he kept on protesting, "He's my friend! Our friendship is far more important than money!"

When they landed at the Paris Orly airport, Jacques was not there as promised. Eddie was starting to reconcile himself to the fact that there might be a big problem. Feeling a sense of foreboding, Eddie said under his breath, "I hope he doesn't do anything drastic." Vincent, who had been ordered to come and pick them up, told me years later that the song being played over the sound system at that moment had a dramatic effect on the mood of the Constantines. It was a Gilbert Bécaud song that contained the lyrics:

"Et maintenant, que vais-je faire, maintenant que tu es parti..." ("And now, what will I do, now that you are gone...").

Early the next day, a meeting was arranged at Eddie's Belmont Film offices in Paris. Two letters were hand-delivered that morning: one to Eddie and another to my father's secretary, Jacky Maitre. They were from Jacques Alain.

Eddie's letter read, "*You are still a big star, and you can surely create another fortune for yourself,*" announcing at the end of the note that he intended to commit suicide.

The other letter was to Jacky Maitre, and it read, "*You were right, and I should have listened to you,*" enumerating all the errors he had made

Eddie and Helene in New York in 1941

Eddie and me in New York City, 1943

Eddie and me in New York's Central Park with Fluffy

Me at a family get-together in the park

Me in 1947 at Grand Central Station

Eddie and me in Nice on the Promenade des Anglais in 1952

Me with no front teeth in Fox River Grove, IL, at my grandmother's house, where my parents sent me while they sorted out their marital problems with Édith Piaf

Me in a London park at 5 years old

Me and my grandparents in Cormeilles-en-Parisis, France

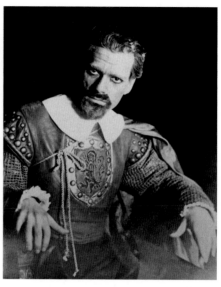

Eddie in 1930

Eddie in New York in 1940; close-up at Radio City Music Hall

Eddie's headshot in 1948
HARCOURT

Eddie's headshot in 1956

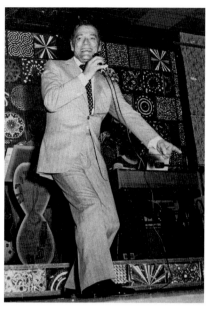

Eddie in Weisbaden
CHARLOTTE MARCH

Eddie singing in a nightclub

*Eddie posing on set—evidently, as he has
taken off his glasses* ERIK MORDACQ

Eddie in 1969

Helene at age 16 in Chicago Maurice Seymour

Helene at age 16 in Chicago

Helene in 1952 in Black Tights *in Paris*
Studio Useg

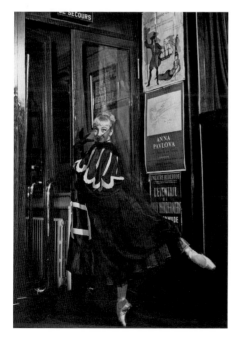

Helene in 1952 in Black Tights *in Paris*
Michel Petit

Helene in 1952 in Black Tights *in Paris*
Michel Petit

Helene, me, and Fluffy in Central Park in 1944

Helene and me at Grand Central Station in 1947

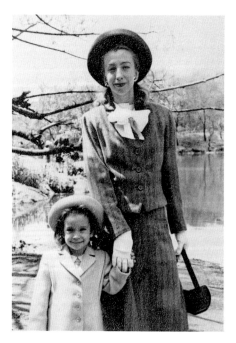

Helene and me in Central Park in 1946

Helene and me posing at Bloomingdale's in New York

Me and ballet company on tour in Amsterdam in 1948 with Helene
PARTICAM PICTURES

Me and Ballet des Champs-Élysées company on tour with Helene in 1948
PARTICAM PICTURES

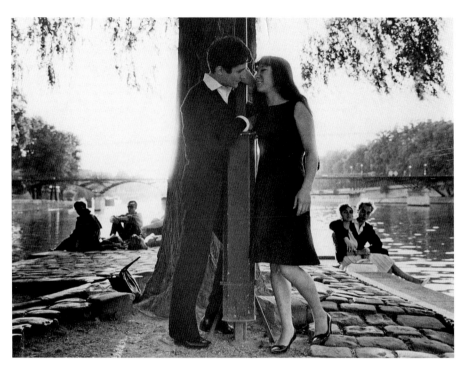

Lorenzo and me in 1962 in Paris WILLY RIZZO

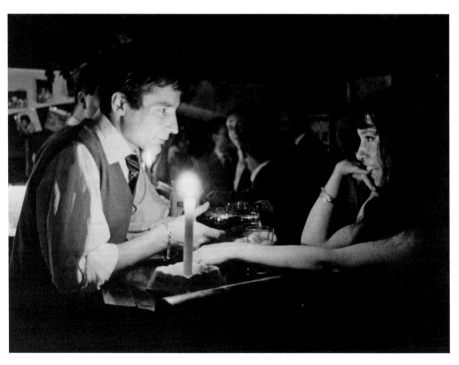

Me and Lorenzo in 1962 at Chez Régine in Paris CLAUDE AZOULAY

Lorenzo at age 21 in Montfort
TANYA

Lorenzo at 21 in the Bois de Boulogne
TANYA

Me and Lorenzo in Paris in 1963: I'm hiding my pregnancy under my coat

Left to right: Aunt Evie, Helene, and Aunt Fay at the Constantine home in Los Angeles

Me in Courchevel on the ski slopes in 1959

House under construction that Eddie was building for me in Autouillet

Eddie and me rehearsing on stage in 1956 *Eddie and me in 1970* PROMOPRESS

Me at the farm, 1963, 5 months pregnant *Me, Lorenzo, and Jessica, in Perpignan, 1964*
CLAUDE AZOULAY

*Jessica in 1967 at a
Paris flea market*

*Eddie and
Jessica at the
farm in 1970*

*Jessica at age 16 in
Paris in front of our
apartment*

Me and Edwina in 1966 at the Paris clinic

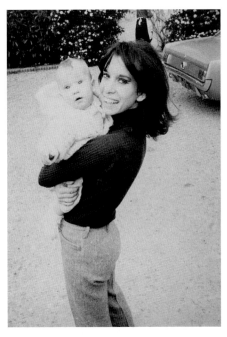

Me and Edwina at the farm in 1966
Claude Azoulay

Edwina at age 3

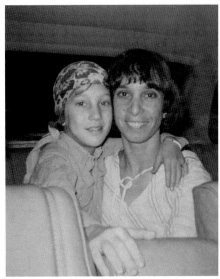

Edwina and me in California in 1978

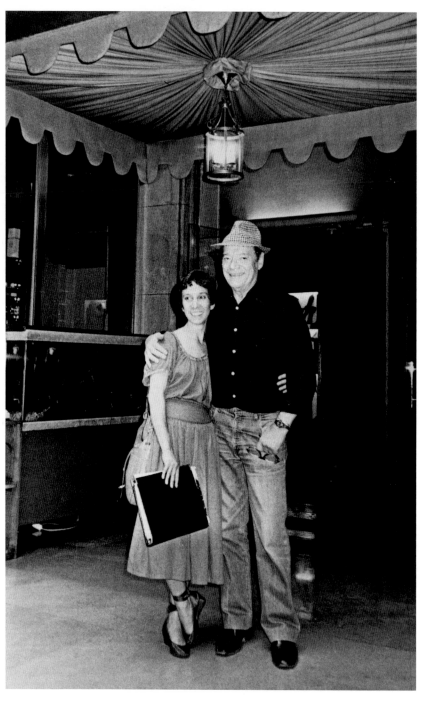

Eddie and me in Paris in 1987 RICARDO CANOVA

and confirming his intentions to kill himself.

A search was immediately launched to get in touch with Jacques Alain, but it was met with no success. In the midst of the turmoil and anxiety the phone rang. Jacky grabbed the receiver. "Allo, oui?"

"Allo, Jacky?" It was Jacques Alain's girlfriend calling. "They just found Jacques. He's dead."

Aghast, Jacky put the receiver down, and in the silence that pervaded the room, he made the announcement. Everyone's fears were now confirmed.

The story goes that Jacques Alain had devised a scheme that had gone sour. He had pinned a note on the front door of his apartment warning his neighbors not to light a match in order to avoid any risk of explosion in the building. He had also made arrangements with his girlfriend to meet him there at a specific time. But she didn't show up at the right time, and he was found in his apartment—his head in the oven, the gas knob turned on.

It was later discovered that his girlfriend had a lover, and they were both involved in spending my father's money. The rumor spread that this woman might have intentionally missed the appointment, therefore causing Jacques Alain's death. But this allegation has never been proven, and to this day, no one really knows what really transpired.

During the days that followed this lugubrious event, more problems erupted. A plethora of debts had been accumulated and charged to my father's account. Jacques Alain had forged numerous checks that all had to be reimbursed. Not only had Eddie lost his close confidant and all his money, he was now also facing monumental debts—for which he wasn't technically legally responsible, but which, given the dicey nature of the deals, he felt pressured to replace. Ultimately, the scheme had backfired. The whole matter was now turning into a total disaster, leaving Eddie completely ruined. This was only the beginning of a series of intensely difficult times for him.

In the aftermath of this tragedy, the Picasso, the Dufy, the Utrillo, and the Vlaminck paintings all disappeared from the walls of the farm house, sold to help pay off some of the debts. My mother later told me, "Nobody ever believed that something like that could happen to us! Eddie was supposed to be a superman!"

Eddie had always claimed he didn't care about possessions. For him, paintings and objects of art were investments—they held no emotional attachment or value. He used to say, "I'm not a culture vulture, unlike some people I know!"

He often said he never wanted to own *anything*. Despite all his hit records, Eddie never even owned a good record player; that sort of thing had no priority in our home. The farm itself had often appeared to be a burden to him: "It's better to have cash, because with cash, you're free. You're not held down to anything." Left to his own devices, who knows, he might never have bought the farm in the first place.

The director John Berry—who knew Eddie quite well—remarked in later years with brilliant insight: "I have the feeling that one of the reasons why Eddie gave over his signature to his agent and lost all his money was because he didn't think he deserved it. So he'd give it to somebody else to take care of, and he didn't watch it because that would disturb the magic. If he wanted it too much, it might stop his career!"

After this difficult episode, Eddie was deeply troubled. His whole life had been shaken up. He was facing problems no one really knew anything about, and he was left to deal with them on his own. Under the weight of all this drama, he was succumbing to a low-grade depression. After many promptings from his personal doctor, he agreed to meet with a psychiatrist, Dr. Chernok, who was a highly respected specialist in his field at the time. For about a year, he met with him regularly, though never divulging the intricate workings of his problematic business deals.

Around this time, our whole family had gone to Deauville for a weekend vacation. Eddie invited me to come along—without Lorenzo for a change—and I accepted. It so happened that Dr. Chernok was staying at the same hotel. Eddie wanted me to meet with him and maybe have a session or two, to see what he had to say about me. He thought it would help determine why I was so codependent on Lorenzo (as if that were so unnatural!). His hidden agenda was that the doctor would have some influence on me and thus incite me to separate from Lorenzo. It was yet another of my father's many desperate attempts. You've got to hand it to him!

Eddie arranged for a session at the Hotel Normandy in one of the lobbies. My secret agenda, on the other hand, was to prove my father wrong and have verification that I was mentally healthy. It was my first ever therapy session, and I remember it well. Endlessly, the doctor asked questions, probing into my deepest secrets. I actually enjoyed it, the kind of mental stretching it required. He wanted to know if I ever felt a feeling of joy or elation in my chest. I remember asking if he meant that blissful sensation that occurs when I take a deep breath. And I told him, "Yes, that happens to me every once in a while."

At the end of the session, Dr. Chernok said, "You know, to tell you the truth, I don't see anything wrong with you. I know your father is very upset about this relationship, but I truthfully can't say it's because you have any mental disorder. You're 19 years old, and you're in love. Nothing more normal."

I was more than happy with his prognosis. This was a real triumph for me—to win a round against my father! I was very grateful to this sensitive doctor, who wasn't willing to play my father's games. He said he would go talk to my dad.

A few hours later, Eddie's thundering voice could be heard throughout the hotel: "What a hypocrite! You don't know anything! You don't have the faintest idea about psychology!" My dad was so furious that he

threatened to withhold payment for the session, claiming Dr. Chernok didn't know anything about his business!

One morning, not long after my successful psychological examination, I woke up feeling nauseated. I took note that they were the same symptoms I'd had a couple of years before. I thought, "I bet I'm pregnant again. How could I have a child when I can't even take care of myself? How is Eddie going to take it?" Everything seemed very bleak, but I was most worried about what my dad would say. Our relationship was already so terribly strained. This would surely be the straw to break the camel's back.

Lorenzo, on the other hand, was excited about the prospect. He said he'd be a proud father, and he looked forward to the experience. His positive outlook did actually warm my heart; I felt encouraged to relax and accept my lot. It seemed like he really cared, that he was ready to support me through it, and that's what I needed to be certain of. Even with my doubts, I grew more and more confident that everything would work out okay.

Physically, I was hardly gaining any weight, and even after four months, my belly wasn't any larger, which was really quite convenient because it enabled me to hide it from my father as long as I could. But soon enough he was going to find out, and I really dreaded that moment.

I remember the day. I was at the farm during one of my weekend visits, in the kitchen washing dishes and complaining about how terribly thirsty I was. Eddie replied accusingly, "If you're that thirsty, you must be pregnant!"

"How did you know?"

"You must be kidding!"

I forced a smile and said, "No, I'm not kidding!"

He instantly went into a rage: "How can you do such a thing? You're out of your mind!"

He screamed and hollered, growing more violent by the minute. I could feel the adrenaline rushing through my body. In an attempt to move away from the heat of his anger, I ran upstairs to escape the loud noise, but he was gaining momentum. Scared out of my wits, I ran out of the house. I continued running through the courtyard, out through the gate, down the road, my father's roar still echoing behind me, "You're crazy! How can you do this to me? After everything I've done for you!"

I sprinted without looking back, praying the whole time that he wasn't chasing after me. Huffing and puffing, I kept a rapid pace for about a mile and a half until I got to a friend's house at the other end of the village, at which point I slowed down. Trying to catch my breath, I walked the rest of the way. I finally managed to relax a bit, feeling fairly sure Eddie hadn't followed me this far.

Distraught and upset, I gave my friends a detailed account of what had happened. They consoled me as best they could. Later, I phoned Lorenzo in Paris and asked him to come and pick me up. By the time he arrived, I was calm but still very shaken up. My legs were sore—particularly my knees, due to the adrenaline rush and all the running. It seems like that is where I felt the most vulnerable.

Lorenzo drove me back to the studio we'd been renting in the Île Saint-Louis. The studio was so dark, with its 12-foot high ceilings, that we had to keep the lights on all day long. The only window was facing a wall that was three feet away, which gave the unpleasant feeling of being in a basement. I opened the window for the air—not for the view. To add to this, the heater never worked too well, which meant that there was no hot water. I had to heat kettles on the stove to take a bath. To get to the toilet, we had to climb up the stairs to the next landing and share the cubby hole with the other tenants in the building. It was not a great place to live—let alone a romantic one—and Lorenzo sure wasn't the easiest person in the world to live with either. He was rarely

ever home, and when he was, he was often aloof and withdrawn. Still, in my mind, it was better than living in constant fear of my dad.

As I allowed myself to relax a bit further that day, I realized that my relationship with Eddie wasn't getting any better. It was incredible how reactive we were to each other. There was so much fire between us—so much conflict, so much tension! Our love-hate relationship was an old habit we just couldn't break, and each of us was as stubborn as the other.

In July of 1963, in the 4th arrondissement city hall in Paris, Lorenzo and I got married. I wasn't even 20 years old, and Lorenzo was 25. Needless to say, neither of our parents were present. Lorenzo's mother had abandoned him when he was 8 years old, and his father was busy cruising around as a waiter on board various ships. But at least all our friends could be there.

Reporters had gotten a hold of the story, and the paparazzi were there snapping pictures of us. I was wearing a white linen outfit that I had borrowed from my mother's closet, and Lorenzo wore his one and only dark-gray pinstriped suit. Although it wasn't the wedding I had dreamed of, we were a charming-looking couple, and despite the difficult circumstances, we made the best of it. After the ceremony, Androutchka had arranged a luncheon with money he'd recently earned decorating someone's home. With all our closest friends there, we had a splendid celebration.

The next day, the front page of *France Dimanche* printed in gigantic letters, "CONSTANTINE DESTROYED BY THE NEWS OF HIS DAUGHTER'S MARRIAGE!" accompanied by a photo of him looking terribly distraught. Then there was the front page of *Ici Paris* that read, "THE ONLY WOMAN WHO KNOCKED OUT CONSTANTINE!" It turned out that Eddie was even more upset than I thought he would be—at least in the way the papers portrayed him.

It's true that he had been under incredible pressure that past year: starring in a total of 11 films in two years, the awful drama with Jacques Alain, and now me running off to get married! I guess it was all a bit much for him. He fell into deep depression and wound up having a nervous breakdown.

His private physician began to come over to his house every morning. First, he'd take his pulse, and then to keep him energized, he'd give him injections of vitamin B12 and also Gerovital H3, which was an antiaging product developed by a Romanian physician, Dr. Aslan. The problem was that Eddie was not responding to any of his treatments. He decided instead to try "sleep therapy," which was in vogue at the time to help people deal with emotional problems.

Arrangements were made for Eddie to be sent to a clinic specializing in those kinds of alternative care. In France, they called this specific treatment *cure de sommeil* or "sleep cure." The basic idea was for the patient to spend a week or two under close medical supervision, sleeping with an IV in their arm. Then the patient wakes up feeling refreshed and eager to get back to life—at least that was the promise. I can't say for sure if it worked for my father—I wasn't there when he left the clinic—but at least it was surely a reprieve from his otherwise unsolvable problems.

Around that time, a very funny article appeared in a newspaper called *Le Hérisson* ("*The Porcupine*") that humorously synopsized the current events (translated from the French by me):

> *Reassure yourselves, sensitive readers. In spite of what the press says, Eddie Constantine is not completely crazy!" Written by Christian Vebel.*
>
> *I will tell you a very Parisian story. Last week, I buy a newspaper and I read it just before going to sleep. I see an enormous photo of Eddie*

Constantine, wild-eyed, his hat on sideways, the title announcing,
'Eddie Constantine almost goes crazy!' Oh! My God! I'm very
touched. 'They stole Tanya away from me!'

For those who don't know, Tanya is Eddie Constantine's oldest daughter.
She's the one who sang a few years ago, 'L'homme et l'enfant'. And
for those who don't know even the most rudimentary things, Tanya
ran away from home at 17, to fall into the arms of a barman.

I wouldn't permit myself to tell this story if this exploit hadn't made such
a ruckus as even the Nobel Prize doesn't even get!

We're lucky! We've had pictures of Tanya in school, of Tanya wearing a
tutu... photos of Lorenzo at his bar, in his underwear, kissing Tanya.
We've seen photos of Papa Constantine angry, Papa Constantine
distraught, of Mommy Constantine desperate. It was all very
upsetting, and all of Paris was rattled. Then, a few months later, a
new bomb: 'Lemmy Caution almost completely insane!' I avidly read
that Eddie is in an insane asylum. Tanya's adventure has hurt him
so much that he drinks a bottle of whiskey a day. His nerves have
cracked. Nervous breakdown. Hospitalization. And the newspaper
concludes: 'Tanya almost killed her father!'

You would think that instead of drinking a bottle of whiskey, Papa
would have grabbed his daughter by her neck and put her in a good
boarding school. Or maybe he thought it wasn't important enough,
and that everything would take care of itself. Or maybe if Papa
Constantine had a nervous breakdown, it could possibly have been
because, like all big stars, he works too hard (he just finished 11 films
in 2 years!).

But then again, you're not good readers. You think, you discuss. Me,
however, I believe everything I read. And the Constantine family has
been thrust into despair. I read, 'Tanya hasn't given sign of life for
months, not even a phone call.' They say, 'She lives in an attic...'

I fall asleep, and dream of my 9-year-old daughter running away to
Venice with a bus driver. I wake up borderline insane. In spite of my
torment, however, I go to lunch at the Champs-Élysées Drugstore.
And who do I see walk in, all bright and cheery, with her youngest
daughter, but Madame Constantine.

I think, 'Oh, great! At least she has dignity in her despair! She doesn't
want all of Paris to share in her grief! Who would think she has been
deprived of her ungrateful daughter for six months!?' Right at that
moment, who do I see walk in all bright and cheery? But Tanya!

My heart starts pounding. I am surely witnessing a historical moment.
The repentant daughter has asked for a discreet rendezvous to
negotiate her return to the family. I am witnessing the prelude of the
return of the prodigal child!

But it doesn't look like that. Tanya kisses her mother as if she had seen
her last night. And everyone happily sits down for lunch.

I look at Tanya. She's adorable. When I think she lives in an attic where
she lives in misery, I am moved. What treasures of courage, of
ingenuity, she has had to evoke, to look like she just came out of a
good hairdresser's, to wear such elegant clothes, and to maintain
such delicate and gold-ringed hands, after all the heavy
housecleaning in her attic!

I feel a bit uncomfortable, though. What's bothering me here, in my
pocket? Oh, it's that blasted newspaper! I open it again and read:
'Eddie Constantine borderline insane!' I turn the page and read,
'Scandal at Buckingham... Tony caught in a trap... Liz Taylor dies
of pain...' My God! Such sensational things happen in the world!
Life is so dramatic... in the newspapers!

Although that reporter was convinced that the newspapers were
overdramatizing our situation, his account of our meeting at that drug-
store was actually quite accurate. We did pretend that we had met the

day before, especially whenever we met in public. Saving face was very important to my mother. She felt it was important to uphold an image of the perfect family and couldn't tolerate the idea that people might find out that wasn't the case.

My pregnancy was really beginning to show now. This caused Eddie unbelievable turmoil. First of all, he didn't relish the idea of becoming a grandfather, mostly because he was worried the public would think he was growing old. Of course, he didn't want anything to mar his image of the cool and untouched tough guy. *What? The virile hero is growing older and becoming a grandfather? That's not possible! Heroes don't grow old!*

There was even some talk about my mother being pregnant around that same time, but it turned out to be a false alarm. This spoke to the fact that there was certainly some age rivalry going on. But as always, the primary issue with Eddie was that he despaired over the thought that Lorenzo and I might never ever separate. And to be honest, I couldn't help but also secretly wish that something would happen that would separate us (my father and I) for good. My expecting a child, therefore, was the last thing in the world that he wanted, and he was terribly disturbed about it.

Not long after the wedding and in spite of the tension between us, he invited me—alone, without Lorenzo—to the farm for weekend visits. In those days, Eddie went horseback riding at least once, if not twice a day. He had built a corral in which we could experiment with new techniques and fall into the sawdust as often as we pleased; there wasn't much risk of getting hurt. Now that I was pregnant, however, I didn't go riding as often. It wasn't the safest exercise for a pregnant woman, but I loved to ride horseback so much that sometimes I just couldn't resist.

I noticed that Eddie was having his thoroughbred horses prepared for me to ride, which was something he'd never done before.

Considering that he knew I was pregnant, I found it kind of peculiar that he not watch out for my safety. After all, those horses were known for being fast! When I tried to question him, he always answered with a sort of forced enthusiasm "It's good for you! It's the best exercise there is!"

I looked at him suspiciously and thought, "What is he hoping to accomplish?" But I didn't dare argue and provoke his wrath, so I went along with the program. To be fair, I'm not entirely sure if he was really aware of how dangerous it could have been for me. But I think that in his state of mind, he saw no other solution but to hope that I fall and have a miscarriage! Nonetheless, with all my suspicions and resentment, I still rode a couple of those thoroughbred horses. I didn't fall off, and, unfortunately for Eddie, I never had a miscarriage.

Around that same time, Eddie was hired to do an advertising campaign for Renault. He had to pose for the photographers in front of a cute little French car that they named the 4L Parisienne. It was a small, square black station wagon with a rattan design painted on the side doors. I really liked that car. As partial payment for the ad, Eddie was offered the car for free. He didn't really need another car—what with his Jaguar and the Mercedes-Benz—so he decided to give it to me. I was delighted with this gift, but since I hadn't passed the test for my driver's license yet, it was Lorenzo who ended up driving it! Eddie was not happy about that.

In the meantime, I was actively learning how to drive. My dad was good enough to accompany me along the roads around the farm and give me tips, but he really disliked these jaunts. He hated the way I drove. He said I drove too fast and it made him nervous. That last time he came along with me, just as we had gotten back to the farm, he angrily opened the door and announced, "I'm not going with you ever again! You're too dangerous!"

I felt a bit hurt that my dad was withdrawing his support, particularly in light of the fact that Lorenzo wasn't offering me any assistance at all. He believed women should stay home and take care of the children; they shouldn't go around gallivanting in cars. Lorenzo's favorite motto was: "Beat your wife every day; if you don't know why, she will!"

He never beat me up, but he did bulldoze me with his will. I was weak, and I easily succumbed to his male dominance. What can I say? I was young and inexperienced. I didn't know any better—or rather, I just didn't know any other way to be. I didn't yet feel equipped to fight back and take a stand for myself.

It wasn't until much later that I finally got the courage to take my driving test. In this convenient way, Lorenzo continued to be the sole driver of the Parisienne, while I remained under my husband's thumb. The fact that I still wasn't driving the car led to a terrible fight with my father. Eddie was livid that Lorenzo was driving the car he had given *me*. "What is that gigolo doing driving my car? He's such an opportunist! I can't stand him!"

One time when Lorenzo was dropping me off at the farm, Eddie was in a very bad state of mind. His dark mood encompassed the whole property. The farm hands were walking around with their heads stooped, and Helene had a fixed smile on her face—she had checked out emotionally. I always knew when she had that look on her face that she was trying to pretend everything was fine.

We all knew it was not true. Everything was *not* fine, and Eddie was at his worst that day. As soon as he saw Lorenzo, he became so belligerent that everyone, including the stable boys, ran for cover. "This time," I thought, "we better get out of here before someone gets hurt." I made an eye signal to Lorenzo, and just as Eddie went off to answer a telephone call, we made a dash out to the car and drove off in a cloud of dust. Minutes later, after he'd found out that we left, Eddie's

thundering voice could be heard throughout the entire farm, "Where's that gigolo? I'm gonna kill him! This is gonna drive me to drink!"

Once again, we were back in our studio in the Île Saint-Louis, having run off and cut all communication with my parents. Lorenzo was still working every night of the week at the Chez Régine, coming home at 7 or 8 every morning with his clothes reeking of stale cigarettes and soured wine. He slept until 2 or 3 in the afternoon, while I spent most of my time washing and ironing his shirts, making him his meals, bringing him his coffee, reading French literature, and living my own brand of domestic life. But mostly, I was awaiting my baby's arrival.

Still not on speaking terms with my folks, we didn't let them know when or in what clinic the delivery would take place. Instead, on the day our daughter, Jessica, was born—in December of 1963—Lorenzo sent them a telegram announcing her birth.

The popular Sunday paper, *France Dimanche*, printed a famous quote of Eddie's on the front page: "I WOULD HAVE PREFERRED THAT ONE OF MY MARES HAVE A FOAL THAN MY DAUGHTER HAVE A CHILD!" Needless to say, I wasn't very pleased to read that article. I almost considered retaliating by giving an interview to that same newspaper—at least I'd make some money from it! But then I decided it would only add fuel to the drama, plus it just wasn't my style.

A few days later, having discovered the name of the clinic in the newspapers, my mother came to the clinic for a short social visit. She had brought a little gift for the baby. As was her way, she pretended everything was fine, but the tension between us was still palpable. When she left, I felt even more dissatisfied. As much as I understood my parents' disapproval of Lorenzo, I still couldn't accept their apparent lack of concern for me.

I grew very lonely and depressed as the days went by. Lorenzo had barely come by the hospital to say hello, and when it was time to go, I had to call a friend to help me get a taxi. When I walked into our

studio, Lorenzo was actually upset at having been woken up at 3 in the afternoon! This was too much for me. After all the tension of the last few months, I broke down and fell into a lengthy postpartum depression. I cried almost continuously for two full weeks.

But as always, life went on, and soon an opportunity came up for Lorenzo to run a nightclub in Perpignan. Not that he had any experience running a business. Within weeks, we were on our way, driving to the South of France, in hopes that we'd come into some money. We had a good gig at the club: Lorenzo was the MC, I was the disc jockey and, as an added attraction during the evening, we did a dance routine to help rev up the atmosphere. It was kind of fun for a change, and I liked the attention we got. Everyone would stand in a circle, watching and cheering us on, as we monopolized the dance floor. Our apartment was close by, and at night, I would bring Jessica with me to the club. I kept her in a little room next door, where she slept most of the time. Unfortunately, this whole setup didn't last long. Due to mismanagement, the club never paid us what we were promised. After six months in Perpignan, we returned to Paris empty-handed.

Upon our return, Eddie expressed the desire to meet with his granddaughter, much to my surprise. A photographer happened to be present for this momentous event, and the photos appeared in newspapers the next day. Although Eddie Constantine had accepted his role as grandfather, we continued to go in and out of good terms with him.

That same year, my dad decided to go to Los Angeles to visit his parents. He hadn't seen them in quite a few years. With the news that his mother was ill, he felt the need to go. He knew that I wouldn't accompany him unless Lorenzo came too, and so he invited the three of us to join him.

In those days, the only hotel Eddie ever stayed in was the Beverly Hills Hotel, and this time he brought along the whole family, including my mother, Barbara, Lemmy, and then Lorenzo, Jessica, and me. We rented

*Promo photo of Eddie,
Tony Curtis, and Helene
posing on the movie set
of* The Rat Race

a bungalow, which was the same one Elizabeth Taylor and Richard
Burton always rented when they were in town. The big novelty for us—
coming from France, where television sets were not that common and
had only two channels—was that every room had a TV! We'd walk from
room to room, switching channels to catch as many different programs
as we could. It was exhilarating, and quite a novelty for the time.

During our stay in Los Angeles, we had a number of experiences
with different well-known celebrities of the time. One evening, we went
to Gregory Peck's for dinner, and Tony Curtis and his wife were there
as well. We had ourselves a very wild and boisterous time, cracking all
the jokes we could think of, each one of us trying to top the other. After
dinner, it was decided that we'd go to the Daisy Club for a few drinks.
We climbed into Tony Curtis' Rolls-Royce—all 12 of us—and we drove
through Beverly Hills, singing at the top of our lungs, "There's no
business like show business!" When we arrived in front of the club, the

doorman was absolutely amazed at the endless stream of people climbing out of the car!

Another evening, we went over to Paul Newman's house, who was on a health food kick at the time. That night, he served celery and carrot sticks for dinner. Eddie was so offended! He kept complaining about how poorly Paul Newman treated his guests.

Next, we spent a day at Jane Fonda's house in Malibu, when she was still married to Roger Vadim. I was very impressed with Jane. I loved her self-assurance and just the general way she walked and talked; she seemed to know what she wanted. That really left a mark on me, and ever since then, I always looked up to her as a model, an example of what I'd like to become when I grew up.

At that time, Alain Delon was living in Beverly Hills, and he and his wife, Nathalie, invited us over for dinner at their house. During the meal, Alain said to his son, "Come over here and show Eddie how much you look like your father!"

Later, Eddie commented in his usual caustic tone, "He didn't have to say that, because he and Nathalie looked like twins, so it didn't matter whether the kid looked like one or the other!" Eddie said he thought Alain would gain more character as he grew older. Personally, I thought Alain was the most gorgeous man in the world, and I had an awfully strong crush on him. I loved being around him and secretly wished that I had been married to him rather than to Lorenzo!

Alain invited us to a private showing of a film he had just completed, *Once a Thief*, with Ann-Margret. He was very excited about this film and wanted to see what our response was. I was honored that he had gone through such trouble arranging a showing just for us. I enjoyed every minute of his film—that is, until the end of the movie when Alain is killed. I was so upset to see him die that I started to sob. I cried and cried and cried. I didn't care if I was making a fool out of myself. Alain Delon and Ann-Margret stood there watching me in the viewing room,

Me, Eddie, and Helene
in Courchevel in 1964

waiting for me to calm down. I think they felt encouraged and hoped
that my reaction was a sign the film would do well. (Unfortunately, I
don't think it did.)

My reasons for crying were far more personal. The film had brought
to the surface the deep sorrow I was feeling at the impossibility of life
at that time. It reminded me of my existential belief that nothing ever
works out. And that made me horribly sad; it triggered my dread of life.

At last, when it was time for us to return to Paris, Alain invited
Lorenzo, Jessica, and me to stay at his house for another couple of
weeks. We were flattered and delighted at the opportunity, and of
course, we accepted the invitation. Alain's son was just a little older
than Jessica, who was then just learning how to walk. In fact, she took
her first steps with Alain's help!

Alain Delon was fascinated with guns in those days, and he was very
proud of his collection. Lorenzo already had an interest in weapons
(he always carried a switchblade in his car) and was more than eager

to have something in common with Alain, and so they spent time together playing with their toys.

One afternoon, as the men were fiddling around in the living room, pointing guns at each other like little kids, a shot suddenly went off. Shocked, I looked at both men, wondering what was up. Nathalie came rushing into the room screaming, "What happened?" We all heaved a sigh of relief when we ascertained that no one was hurt. I'd been sitting nearby at the other end of the couch when Alain's gun had gone off, missing Lorenzo's shoulder by a quarter of a millimeter. His shirt was torn, and there was a hole in the sofa right behind him. Alain exclaimed, "That was a close call!" We nervously laughed, which helped to release some of the tension. The guns were then immediately stashed away in a closet, and I don't remember ever seeing them out again.

We had a wonderful time together. Two weeks later, with reluctance, Lorenzo, Jessica, and I returned to Paris. Eddie was enraged when we got back. He let us know in no uncertain terms that he didn't appreciate it one bit that we had stayed on. He screamed, "I spent all that money on your trip to America, and that's how you thank me?"

I think in some ways he was hurt that we hadn't stuck with him. He'd wanted us to stay together like a team. But more than this I think he was jealous of the attention we had given Alain Delon. He would often complain that we only ever raved about other big stars but never about him. He believed that we didn't think he deserved his fame.

Come to think of it, he was actually quite right. I did think he had a fantastic voice when he sang—that was his real talent—but I never actually thought he was that great of an actor. In some of his films, in fact, I thought he was downright bad. Sure, he knew how to walk with a swagger, like John Wayne, but in my opinion, that fake smile of his was hard to swallow. I also didn't think he had much versatility. He seemed kind of one-dimensional, like a cartoon character. There are some performers who are character actors, and they always act that

same type of role. But who am I to judge? To this day, there are still loads of his fans who would argue that he was great.

Not surprisingly, the relationship between Eddie and Lorenzo never got any better. No matter what Lorenzo did, he was always on my dad's shit list; no matter what he said, it was invariably wrong. Eddie was revolted by what he referred to as "Lorenzo's obvious and evident opportunism."

Eddie related to me an experience he had driving into town with Lorenzo in the passenger seat. Lorenzo said to him, "I think it's time you should give me my chance and get me a good job."

He really thought Lorenzo was out of line. "*Your* chance? I worked my way up; no one gave *me* a chance!" Later, as he dropped him off, Eddie asked, "Where are you going?"

"Oh, I'm going for a stroll."

Eddie thought, "A stroll? What about going to look for work or something?" Lorenzo's carefree attitude only worsened my father's feelings of resentment, and it added weight to his belief that Lorenzo was just a gigolo.

Feeling in some way obliged to help me out, Eddie decided to impose Lorenzo in his films as assistant to the director. This began a series of films that they would work on together. Of course, Eddie was very ambiguous about doing it; he felt his integrity was at stake.

Alphaville was the first in the series. Lorenzo was awarded the job of third assistant to Jean-Luc Godard, who was famous for being one of the Nouvelle Vague ("New Wave") directors, with most of his films being big hits, such as *Les 400 Coups* ("*The 400 Blows*"). For Lorenzo, this was a *very* lucky break.

Godard had known about Eddie but he believed he was just too shallow for his taste—that is, until he was invited along with some other friends to come to the farm one Sunday morning for a visit. It had been

the first time that Godard had seen Eddie in his home environment, and he apparently saw something in him that he hadn't seen before. Prior to that, he often made negative comments about Eddie Constantine, claiming that he only made commercial films—and Godard despised commercial films. The visit to the farm gave him the impression that, in fact, Eddie was capable of more genuine acting.

Shortly after that first meeting, he phoned Eddie and asked him if he would like to be in his short, titled "Sloth," which was one of a seven-part series called *The Seven Deadly Sins*. Eddie jumped on the bandwagon and felt it might be a good occasion to let go of the character Lemmy Caution, with which he was becoming tired. This was Eddie's first film with Godard.

A few years later, *Alphaville* went into production. Interestingly enough, Godard wanted Eddie to play, of all things, Lemmy Caution! This really dismayed my dad. It was not at all what he had expected. He had so hoped to be given a different role, one he could really sink his teeth into.

During the entire production of that film, my dad was miserable. He was especially nasty with Lorenzo. He kept complaining that he was an ass-kisser, attentive only to Godard's every need—and not to his! No matter that Lorenzo's job was to serve the director's needs! He thought he could at least show some appreciation for having been offered such a job.

During the shooting—in The Nouvelle Vague's normal *modus operandi*—there was no script to work from. Every scene was improvised. But what bothered Eddie the most about this film was the fact that Godard didn't treat him like a star. He never asked him for advice or what he thought about a scene, unlike most of the other directors.

One time, while doing an improvised love scene with Anna Karina, Eddie smiled. Godard asked, "Why are you smiling, Eddie? You look like Burt Lancaster!"

"Yeah, but Burt Lancaster, when he smiles, he's very successful!"

"Burt Lancaster smiles all the time, even when he makes love. So don't smile!" said Godard.

Another incident occurred when they were shooting a potentially difficult scene, in which Eddie had to slap an actress in the face. Having done films for the past 15 years, Eddie knew how to slap without hurting the person but still make it look like a real hit. In other films where he had to do this, with the sound being added in post-production, it really did seem like the girl's head was being knocked off. He felt confident with his technique.

But Jean-Luc disapproved and said, "No, I don't want a John Wayne slap. I want a real slap."

"If I do it like that, I'll kill the girl!"

"Yeah, just do it."

So my father reluctantly slapped the girl, and she became so paralyzed that she couldn't move. The scene was all screwed up. Godard said, "Oh, you should do it like this!" and he slapped my dad so hard, he thought he was going deaf. "Did I hurt you?" Godard asked.

"Oh, no, not at all!" answered Eddie, gritting his teeth.

Another conflict bubbled up at the beginning of the picture. Eddie made the mistake of telling Godard he preferred that only his right profile be photographed (everybody seemed to have a better side; so did Eddie). Godard's response was: "Oh, then you'll be photographed from the left from now on."

Eddie couldn't believe it. He was shocked! He was beginning to think Godard was sadistic. But yet again, Eddie made the mistake of telling Jean-Luc, "The light can't be from above. It should be from straight in front of me; I look better like that."

"Well then, the light's going to be from above from now on, and never from straight on!"

Eddie shared with me that he found himself to be so ugly in that

picture that he hated the film with a vengeance. It took him years before he started to appreciate it, but he never got over thinking he looked bad in that film.

The next of Eddie's films that Lorenzo assisted on was *I Salute You, Mafia!* Filmed in 1966, this was Raoul Lévy's directorial debut. Previously, he had only been a producer (and quite a few of his films had been successful, such as *"Et Dieu... créa la femme"* (*"...And God Created Woman"*). To play the leads for this film, he cast Henry Silva, Jack Klugman, and Eddie Constantine.

My father encountered more problems during the shooting, and he complained that Raoul Lévy was yet another sadistic director. Eddie even claimed that it was Lévy himself who had killed the actor Montgomery Clift during the shooting of his last movie, *The Defector.* "He had him jump over a bridge and land in the water in the middle of winter. Well, Montgomery Clift came out and had a heart attack and died!"

Eddie was convinced that most directors were in reality frustrated actors. He had a strategy to deal with this belief: He'd tell his directors that he'd do a dangerous scene only if they did it first. Some of them actually did it, but most would say, "Oh, no, you can do it. I've seen your pictures!"

In *I Salute You, Mafia!,* there was a scene in which Eddie had to run out of a burning house with his back in flames. He was to continue running while the camera continued to follow him right behind him. Eddie noticed that Raoul Lévy kept motioning to the prop man to pour more kerosene over his back so it would look realistic. By now, Eddie was fearful that he might really get burned.

As the take progressed, Eddie's back was so drenched with kerosene that he could feel the heat come through his back. He later griped to me, "He put enough kerosene to burn a house down!" Oblivious to any of this, the director didn't yell "Cut!" and just let the scene unfold, Eddie now sprinting down the road with his eyes popping out of his

head. He continued to run, until he felt someone tackle him and roll him to the ground to put the flames out. In fact, it was Lorenzo who had grabbed a blanket and thrown himself onto Eddie's back. Together, they tumbled on the ground. As soon as the flames were squelched, Lorenzo offered a hand to lift him to his feet and helped him take off his clothes. He and Eddie were both shaking—eyes wide, hearts beating fast, and breathing heavy—they attempted to release the tension of the adrenaline rush. Just a few heat blisters on Eddie's back required ointment, but nothing more. Eddie conceded to give Lorenzo a thankful smile.

Later, when the shock was over, Eddie complained to Raoul Lévy, saying that if it hadn't been for Lorenzo, he would have surely burned to death. He proudly declared, "Lorenzo saved my life!" After this episode, everyone thought the relationship between Eddie and Lorenzo would improve considerably, but not even that event would make any real difference.

The next picture Eddie produced was a Spanish co-production, which was set to be filmed in Madrid: *Cartes sur table* (*"Attack of the Robots"*), directed by Jesús Franco. He managed to convince the director that Lorenzo would be his second assistant. However, there was a hitch: Jesús claimed that because of limited funds, he wouldn't be able to pay Lorenzo; all that he could promise him instead was room and board. Being grateful that he still had an opportunity, Lorenzo didn't complain. After all, the more movies he did as assistant director, the closer he would get to creating himself a space in the movie business. He could possibly become a director! That was a prospect that got his attention.

At the last minute, Eddie invited me and the whole family—all seven of us—to come with him to Madrid. There, we all camped out in a tiny little apartment: Eddie and Helene were in one bedroom; my brother and sister were in the other; and Lorenzo, Jessica, and I ended up sleeping in a large closet with a mattress on the floor.

After just two days, Eddie began to regret having gotten Lorenzo involved in this film. With all the pressures of producing a picture, coupled with living in such close quarters, he was becoming increasingly aggressive as the days went by.

In the midst of the turmoil, Lemmy—who was 5 years old at the time—was given his first role in a film. Dressed in a business suit, he played a secret agent who was delivering a message, and he was good! He followed direction really well, and everybody on the set adored him. He was so proud of himself, especially when he got paid for his services! That was special for him, and it made him feel like an adult.

But that was also a big slap in the face to Lorenzo. I suspect that Eddie was, as usual, trying to sabotage my relationship with him. I guess he figured if Lorenzo didn't have any money, it would put a strain on our relationship and then maybe, just maybe, it would come to an end. In that atmosphere, needless to say, I couldn't wait for the film to be over and return to Paris.

In a way, Eddie's plan worked. Due to lack of funds, Lorenzo, Jessica, and I were forced to move to the farm. Lorenzo wasn't bringing in any money for us to live on, and it was becoming more and more difficult for us to pay for the studio in the Île Saint-Louis. Although the tension between Eddie and us was still terribly strong, we didn't have much choice, and so we thought we'd make the best of it and remain at the farm until our finances allowed us to move on.

A week later, we were invited to a costumed ball at the Pavillon d'Armenonville in the Bois de Boulogne, an event they called "The Londonest Day." The theme being England, it was my idea to invite Androutchka to create our costumes. I convinced my parents that he would make us all look fabulous.

I was the ghost of Joan of Arc. I wore tights and silver boots, and Androutchka made me a shield with aluminum foil. My makeup was white to look like a ghost, and I had a white stiff veil that covered me

Eddie, me, and Helene at the Pavillon d'Armenonville party

from head to foot. It looked fantastic, and I got a lot of attention. Lorenzo went dressed as John Lennon, complete with a wig, a Mao jacket, and narrow glasses—a real lookalike. My mother was Robin Hood, and Eddie came as John Wayne, with his cowboy hat. He wanted something easy, something he could take off right away because he hated wearing costumes. When we walked in through the door that evening, we really made a sensation. People oohed and aahed, and our costumes got rave reviews.

A funny incident happened that night. To introduce the story, prior to my mother having essentially given up her career as a ballerina, she was a soloist and sometimes prima ballerina with the Ballets des Champs-Élysées. She had a famous partner named Jean Babilée who was an unbelievably talented ballet dancer, and the two of them often performed "The Bluebird" from *The Sleeping Beauty* by Tchaikovsky. The two of them were astonishingly good together. They both were

short and muscular, which helped them with the speed of their pirou-
ettes and the height of their jumps. They both literally looked like the
bluebirds they were portraying in their *pas de deux*.

So here I was, sipping a drink with friends at the Londonest Day
party, when I felt a tap on my shoulder. And who was the dashing man
getting my attention but Jean Babilée himself. He was much older now.
It had been at least 10 years since he was my mother's dance partner,
but he was still gorgeous—and heterosexual, too! I hadn't seen him
since I was a little girl, and now he was flirting with me. It was flattering,
and I was relieved that Lorenzo wasn't anywhere near, so I could enjoy
myself and not feel guilty.

Meanwhile, Jean Babilée was sharing how much he had had a crush
on my mother all those years ago. He said it was a blast dancing with
her because she was adorable and especially sexy! He went further and
told me that he knew it was mutual, in spite of her marriage to Eddie.
I was shocked and a little embarrassed that he shared this private infor-
mation with me, but the naughty side of me was titillated, and the
champagne was starting to go to my head. It was a side of my mother I
didn't know anything about.

Eddie Barclay was the one who had put the event together, and he
and Eddie were laughing and drinking together, making a ruckus all
night. My dad kept raving about the fine wine glasses that Barclay's wife
had set out for people to use. He was going around, showing everyone
who would listen to him how fine the glass was. He would squeeze it to
the point that you could literally see the glass bend. Eventually, he went
too far and pressed so hard that the glass shattered, breaking into tiny
fine pieces. Standing right there to witness it all, my mother was furi-
ous. She was embarrassed and very worried that all these people would
think badly of him. Photographers were milling around, flashing their
bulbs relentlessly, catching humorous moments all through the wild
evening, but surprisingly, they never caught that shot!

Back at the farm, time was flying by. Jessica was growing, and I was now expecting my second child. Although he entirely disapproved of my pregnancy, Eddie seemed to have a soft spot for me at times. He mentioned a few times his plan of building a house on the piece of property he owned across the road from the estate. He told me the house would be mine. Very excited at the idea, we both talked endlessly about how it should be done, what it should look like, what shape it should have. Eddie hired an architect for me to work with, and we started on the plans. It was exhilarating to create a home from scratch!

I had imagined it being in the shape of a cross, with a kitchen in the center. The second floor would be for extra bedrooms, and the bathroom would have a tub in the center with marble all around, in the style of ancient Roman baths. I wanted an enormous fireplace in the open, with copper pots and pans hanging from the large beams, like in the Early American style. I wanted very thick walls, in the way they made them in the 17th century, with a wide space for air in between the two layers of bricks. I had pretty firm ideas of what I wanted, and the architect incorporated all of them in his plans.

Construction began, and slowly, the house took shape. As they were laying the foundations, Eddie dropped a bunch of coins in the cement before it hardened; he claimed it was for good luck. At some point, I had the thought that if Eddie were planning on giving me this house, surely he would have the papers signed over to me sometime soon. But I dismissed the concern after realizing that maybe he'd rather keep it in his name just to make sure Lorenzo wouldn't end up owning it. And I understood that.

Another film was in the making around this time. It was another of Eddie's films being shot in Spain, with Lorenzo working as second assistant to the director. The rest of the family left for Madrid, leaving Jessica and me at the farm. With my delivery approaching, I was really hoping the bottom floor of the house would be completed before the

baby's arrival; the second floor could be done later. And so I set to work making a patchwork cover and overseeing the staining of the wood floors, as well as the waxing and the painting. There was still much to do, and I was as busy as a bee.

The day my parents were due back, my excitement was at its peak. Vincent drove to the airport to pick up the family, and I was impatiently awaiting their arrival. The horn of Eddie's car played a tune, and as soon as I heard it resound throughout the courtyard, I came running out to greet my folks. Lorenzo had been gone for over six weeks, so I was eager to see him too.

"Welcome home!" I screeched. After giving each one a warm hug— with an extra tight one for Lorenzo—I said, "Come see the house! It's impressive!"

Leaving the bags for Vincent to carry in, Eddie, Helene, and Lorenzo agreed to walk the 500 feet over to the new house. As we strolled over, Eddie and Helene talked about their return flight. I noticed Eddie glancing at my large belly with a disapproving air. It made me feel a bit uncomfortable, but I was kind of used to it by then.

As we entered the house, I mentioned that I had bought a cradle for the new baby. I also explained that I had just moved into the ground floor. I noticed Eddie cringe, but he continued his tour anyway. I proudly showed him the patchwork cover I had just completed, point- ing out that I had sewn it entirely by hand. In a disdainful tone, he said, "It's not very well made!"

I felt a little hurt at this comment, but I decided not to reply. Then he began complaining about how much of an expense this house was going to be for him. "I can't afford to pay for two telephones and two gas bills and two electric bills. I just can't afford it!"

Surprised that he might have had a change of heart without telling me, I continued showing him around, pretending I hadn't heard a thing. I thought to myself, "Doesn't he know we're building this house

for me and my family to live in? *What is going on here?*"

Lorenzo and Helene started walking back to the farm, leaving us alone to deal with the matter. As Eddie went through the house, speaking in his caustic tone, he kept reiterating, "Who do you think I am, J. Paul Getty or something?"

He started to scream throughout the house, yelling at me with incredible venom and bitterness. The fear was gripping me, the adrenaline surging through my body. Eddie completely lost his cool and hollered, "Who's gonna pay for all this, huh? Me? Are you crazy? You must be out of your mind!"

And he chased me out of the house.

In shock, I ran back to the farm feeling utterly destroyed. All my plans had crumbled. My hopes and desires for a better future had just vanished into thin air.

That same afternoon, Lorenzo, Jessica, and I packed our bags and returned to our studio in Paris. Within the next couple of months, the unfinished house was sold to some friends of ours, the Laskys—and the dream was over.

It had all been an illusion. My mother later confessed that she knew he had been planning on selling that property from the very start. She said he'd never had any intention of giving it to me; he couldn't afford to give it away. He had had a series of flops with his latest film productions and was losing his shirt.

I was devastated. It just didn't make any sense to me. It looked like I didn't deserve to get what I wanted. And at that time, the way I dealt with that pain inside my chest—that feeling of utter disempowerment, of being up against the wall— was to shut it out of my mind and not think about it anymore, as if it had never happened. That was a great survival mechanism I'd learned from my mother, and it seemed to work; or at least it propelled me through the hard times.

In August of 1966, my second daughter was born in a Paris clinic. Lorenzo had been expecting a boy, and he was sure that's what it would be. He'd actually arranged with my doctor to induce the birth so that the baby would be born by the 21st and thus be a Leo instead of a Virgo. He was insistent that boys should not be Virgos, because in his mind, Virgos were wimps. Being the weak and inexperienced young woman that I was, I meekly did what my husband wanted.

I wasn't aware that inducing the birth, particularly when it was elective, could be dangerous. Having previously had a relatively painless childbirth with Jessica, I was not prepared for what was to come. Inducing the birth made for intolerable pain, and I went out of my mind screaming with all my might. I could be heard throughout the clinic. The nurse announced, "She's completely out of control," and they had no choice but to anesthetize me.

When I woke up from the fog of the anesthesia, I remember hearing Lorenzo talking on the phone, "It's a girl!" I thought, "Oh, but he wanted a boy! I didn't give him what he wanted! He's not going to love me anymore!" Lorenzo was talking to my mother, who had gone up north to Deauville for the week. "She had the umbilical cord wrapped around her neck three times, so they had to put Tanya to sleep and use forceps! But I'm not too disappointed it's not a boy, because she's so cute."

Helene: "Oh, how dear! Who does she look like?

Lorenzo: "She looks just like Eddie! Do you know of any girl's name that sounds like Edward?"

Helene: "Edwina."

Lorenzo: "Edwina? That's a good name! Let's call her Edwina!"

I thought Eddie would be happy, but when we told him the news, he didn't seem impressed that his granddaughter was named after him. In fact, his only comment was "Another girl? Is that all Lorenzo knows how to make?" As a second name, we called her Bella after Eddie's

mother. Interestingly enough, we found out later that Grandma Bella had died exactly nine months before Edwina's birth, which I thought was kind of symbolic.

Life continued at its petty pace, with high unemployment rates and both students and workers protesting the disparity of wealth, capitalism, consumerism, and American imperialism. A volatile period of civil unrest soon began, and demonstrations and protests were escalating furiously. Being a flower child, I was exhilarated to know that people were standing up for their rights at rallies and union meetings all over the country.

In May of 1968, the whole situation exploded, and the entire economy of France came to a halt. For two weeks, the entire country was on strike: school teachers, students, workers, unions—11 million people went on strike. The Métro stood still, and the buses, the taxis, the trains, the gas and electric utilities, television—everything went dark. It was the largest general strike ever to take place in France.

During this period, Lorenzo had made friends with a group of demonstrators and had gotten himself embroiled with supporting the riots. He ended up being one of the organizers at the Sorbonne protests. For days on end, he would disappear with his friends, leaving me to wonder where he went when he came home exhausted at 4 in the morning. Some days, he held meetings in the middle of the night in our apartment, but only when he felt it was safe enough to do so without alerting the neighbors. He volunteered to work on building one of the barricades. He had me go out and buy some red fabric to tie on his arm, along with the rest of his gang, to distinguish them from the other protestors in the chaotic Parisian streets.

It was a deliriously hopeful time for some of us. I was elated that there might be some resolution to the problems facing the nation, and where total strangers walking down the streets of Paris would share their views with people they didn't know! The air itself was filled with

hope! But the very day the strike ended and a settlement was reached, everything went back to the status quo. So long, great ideas of reform. So long, warm hugs from strangers. Essentially, in my opinion, it had all been for much too little, and the ultimate goal was lost.

Meanwhile, I was becoming more and more dissatisfied in my marriage. We had so little communication going on between us. There were times Lorenzo would withdraw to such an extent that he wouldn't talk to me for three days straight. I never knew what it was that triggered him, because he didn't talk about his feelings… ever. In fact, he never even told me that he loved me. When I asked him if he did, he would always say, "You know I do, so why ask?" He would ignore all my pleas to have a meaningful conversation; I wanted him to know how I felt about things. It seemed that there was absolutely no possibility of any real exchange of ideas and I never had a chance to be honest with him. Invariably, he wanted to have the upper hand.

To boot, his playing around with other women was becoming more blatant, and although I'd never caught him in the act, I had strong suspicions. By leaving my father's house, I had unintentionally jumped out of the fire and into the frying pan. At this point, I just wanted out. I was no longer willing to perpetuate the illusion that we had a marriage. I mean, in the name of what? For the children? That was an absurd notion. The hurt was too painful, and he was clearly unwilling to work it out.

There were several options as to what to do, but what most attracted me was the thought of moving to California where my aunt and uncle lived. Initially, the plan was to fly there ahead of time with the children, find a house and get a job, and then Lorenzo could join me later. When I told Eddie about my idea, he immediately pounced on the opportunity. He said, "What a great idea! You should do it! It'll be good for you! Maybe you'll get rid of that husband of yours! I'll even pay for your trip!" He knew I was on the right track, and his hope was that

Lorenzo would never make it to the United States. He was sure it was just a question of time now.

Helene, on the other hand, was very upset at hearing about this plan. She feared that I would never return and that we'd never see each other again. Although she acknowledged that I was determined, she pleaded with me to stay—but I just couldn't. I *had* to go!

She never forgave my father for facilitating that trip, which left another sore spot in their already precarious marriage. Whenever I would visit the farm in those days, I'd often hear their screaming matches. They had even begun to sleep in separate bedrooms. This was really hard on Helene. To her, that was the sign their marriage was coming to an end. In spite of Helene's attempts to hold us back, Jessica, Edwina, and I flew to California in October of 1968.

At first, following the original plan, we stayed with my aunt and uncle in Los Angeles for a couple of months. But soon, I was able to move out and rent a house. I found a job in a clothing store in Beverly Hills, which was a big deal for me. I had never worked at a 9-to-5 job before and knew nothing about sales, but I did just fine.

My dad would call once in a while to check on my progress. He was happy to hear I was taking driving lessons. They soon paid off, and I was able to get my license. That was *the* milestone for me, and soon after, Eddie very generously sent me some money to buy a secondhand car. I thought that was such a nice gesture, and I was very appreciative.

Eventually, to my father's dismay, Lorenzo did make it to America, albeit accompanied by a family of four: our friend Ann, who was pregnant at the time, and her three children. We all looked at it as an adventure, and we did our best to settle in as one big happy family—as if that were possible!

Meanwhile, I was enjoying my job. I sold clothes at Jax, a boutique in Beverly Hills, and I excelled at it so much that I ended up being

their top salesperson. I especially enjoyed rubbing elbows with the famous people who came in, such as Raquel Welch (whom I was delighted to learn was the same height as me!).

In order for Lorenzo and Ann to be able to take the kids to the beach in the car, I rode the bus to work. But after a year of this, I was starting to feel resentful. I was thinking, "These guys are on a perpetual vacation, while I have to go to work every day! Do I ever get to go to the beach? Never!" Something about this didn't sit quite right with me.

One evening after work, Lorenzo and I had decided to go out. As we were walking out the door, Lorenzo called out to Ann, letting her know we were going to the movies. I heard her door slam and an inaudible muttering of some complaint. Walking out the entrance, I asked Lorenzo, "What's she in a bad mood for?"

He shrugged his shoulders and said, "I have no idea." I could tell he was trying to avoid facing me. Suddenly, I felt a rush of anger run through my body. In a flash, I saw the whole situation clearly. I realized then that Ann was *jealous* we were going out. Without a doubt, this signaled to me that she was having an affair with Lorenzo. It all became clear in that split second.

Filled with rage, I stormed back into the house and yelled out, "If you want to have a jealousy scene with Lorenzo, go right ahead! Don't let me stop you!" and I slammed the door behind me. On the way to the movies, I confronted Lorenzo, but he wouldn't answer. He had gone into his silent treatment. I was so infuriated that I hollered I wanted a divorce.

He acted real macho and threatened me. "Just try. You'll see. I'll take the kids away from you. You'll never see them again."

The next morning, resolved to move forward on my decision, I called my aunt and asked her to find me an attorney. I had made up my mind: I was filing for divorce. Some months later, we were on our

way back to France. Eddie's wish had finally come true—Lorenzo and I were divorcing.

He boasted, "I knew it! You should have listened to me! I knew all along! He was just a gigolo!" Now my father was happy. He had finally gotten his way.

Well, so, you must be wondering, what happened to Ann and Lorenzo? Believe it or not, they got married and had a child together!

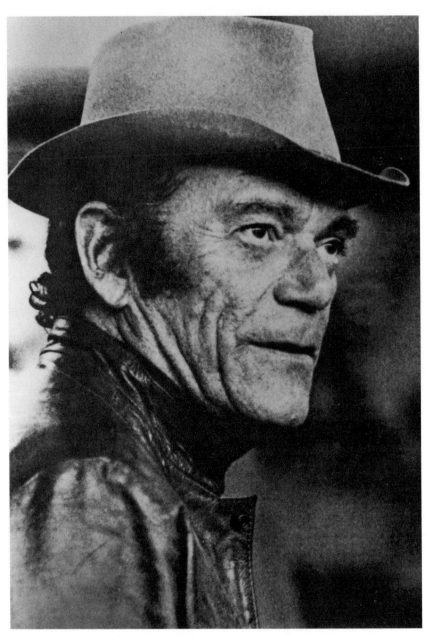

Eddie in 1973; I love this photo of him.

8. ALPHAVILLE

IN AUGUST OF 1969, my daughters and I arrived back in Paris. I felt like the prodigal daughter returning from exile. After a year of being away, it was refreshing to hear French being spoken again. My folks were in Deauville in northwestern France for the horseracing season, and they had made arrangements for us to fly up there immediately— without even a night's rest in Paris. Eddie was eager to see me right away. And he also wanted me to share in the experience of watching his horse run in an important race.

We hopped on the next plane headed for Deauville and landed at the little airport, where a chauffeur was waiting to pick us up. On our way to the racetrack, where Eddie and Helene were spending the day, I couldn't help feeling a bit apprehensive about seeing my parents again. All the unpleasant memories came rushing to my mind, and I was anticipating difficulties with my dad.

As soon as he saw me, he screamed loudly, "You look wonderful!" He gave me a big bear hug and praised me for looking so thin (coming from him, that was quite the compliment!). It was a long-awaited reunion; we were all very excited to see each other. Everyone looked marvelous! Barbara and Lemmy had grown so much: Barbara was now 14, and Lemmy was 12. I quickly forgot about all my worries. Sure, I

still harbored fears about what I was going to do with the rest of my life, but it was important for me to focus on the now. I was in Deauville, and my parents were opening their arms wide—that's all I wanted to deal with at the moment.

No longer married, I was feeling as free as a bird. It was such a new experience for me, not having someone I had to kowtow to all the time. Every night, Eddie would take me out to all the clubs in town and introduce me to his friends and acquaintances, showing me off to everyone he met. I liked the attention, and he and I were having a good time together. We would joke around and make fun of people, and sometimes Eddie made fun of me by mirroring my high-energy excitement, looking at me all cross-eyed. He looked so silly that we'd both burst out laughing.

In Deauville, life entailed spending the days at the racetrack and the nights at Le Régine's, where most of the jockeys, trainers, and owners would hang out. One jockey in particular stood out to me, a good-looking, charming young man. For several days, we exchanged flirtatious glances from across the room. Finally, he walked over and boldly asked, "How would you like to come with me?"

His audacity left me feeling a bit embarrassed. But I was amused and it sounded like fun. I looked over at Eddie and thought, "I'm emancipated now: I'm divorced, I'm free, and I can do what I want." Without saying a word, I picked up my coat and followed the guy out the door—the coat dragging along the floor behind me just like in a Jean Harlow movie.

Eddie was furious over this incident and later accused me of acting like a whore. He screamed, "I'm discouraged! I don't know what to do with you! You still haven't learned how to act in public!"

Although I didn't appreciate the reprimand, I had to admit he was right. Even after 10 years with Lorenzo, I was only at the young age of 26, still acting like a rebellious little girl. I apologized for my behavior

and instead decided that I would keep my eyes open for a potential relationship, one that would lead to a good and stable marriage.

A few weeks after we returned to Paris, my father bought me a car—a red Austin Mini Cooper—and took me to Emanuel Ungaro to buy me some clothes. I was delighted with his generosity and loved the *haute couture* outfits he bought me. For the past 10 years, I'd gotten used to accepting scarcity as a way of life, but right then, I was taking full advantage of my circumstances, grateful to have the opportunity to experience wealth again—at least for the time being!

Soon after, my dad was invited to the German Film Awards in Berlin, where the picture he starred in, *Malatesta*, won the grand prize. Eddie played the role of Errico Malatesta, the famous Italian anarchist and atheist of the 19th century. It was a great role for him to play, and he was elated that the film was nominated. Always happy to have a companion, Eddie whisked me off to the airport one day and we flew to Berlin, leaving my daughters with my mother at the farm.

The awards ceremony was exciting. Not only did *Malatesta* win best feature film, but it also received the prize for best production design and for best cinematography. As my dad and I entered the gigantic reception hall, set up to accommodate hundreds of people at a dinner buffet as lavish as a king's banquet—with enormous bouquets of flowers on all the tables—I couldn't help but feel a twinge of sadness that he hadn't received the prize for best actor. He'd done so well in that film (and I was usually so critical of his acting!).

That evening, it so happened that I fell into the arms of another handsome, blond-haired, blue-eyed man. He had received the award for best production design. I was totally electrified by him, once again swept off my feet. After the awards ceremony, I ran off with him and stayed the night at his home in Berlin.

My father was irate when I called him the next day and told him I wasn't going back to Paris with him. He was sure I'd gone mad. Was I

being a rebellious girl again? Maybe, but this love affair didn't last very long. Our lives were so different, and we soon went our separate ways.

Next, Eddie received an invitation from Grace Kelly requesting his presence in Monte Carlo for a glamorous, all-expenses-paid, three-day birthday party for Scorpios. All the famous Scorpios were going to be attending: Richard Burton, accompanied by his wife Elizabeth Taylor, Rock Hudson, and hundreds more. Eddie was also a Scorpio, and it was an offer he couldn't refuse, and so he made arrangements for himself, Helene, and me to fly to the South of France. For the occasion, he took me to Yves Saint-Laurent and bought me a black tuxedo that looked sensational on me.

We stayed at the magnificent Hôtel de Paris Monte-Carlo. Even though we were in separate rooms, I caught my parents fooling around in bed one morning and jokingly called them "sexual perverts." (They didn't appreciate that.) We spent three days continuously partying, and it was an absolute ball! Even at breakfast time around the swimming pool, we were still partying. I remember Elizabeth Taylor was walking along the edge of the pool, when she tripped and lost her balance. Eddie happened to be right there, so he quickly caught her, held her in his arms, and gallantly said, before setting her down on her feet, "See? All the women fall for me!"

Back in Paris, Helene wanted to support me in doing something for myself. She was disturbed that I'd failed at my last audition. She knew I was perfectly capable of singing, and so she convinced Eddie to pay for a studio session so that I could record a few songs. The idea was that I could use these tracks as a demo to present to a record company. I worked on four songs, one of which was "These Boots Are Made for Walking."

Eddie didn't seem enthusiastic about this venture and didn't lift a finger to help me prepare for it. He had his own problems to deal with

and had no incentive to introduce me to any of the right people. I resented his careless attitude because if he would've tried, it certainly would have increased my chances of making it.

Helene came to the recording session and offered bits of advice here and there, which I greatly needed. One of the artistic directors from Barclay Records came by as well and listened to me sing. He seemed interested, but he suggested I continue working for a while. My voice was good, he said, but mentioned that I still needed some training. At the end, he said that he'd gladly get together with me again to see how I'd progressed.

I was disappointed. All I needed was a bit of encouragement, but what I got instead was: "Go back to the drawing board." I lost what little drive I had left and never called the guy back. My attempt at recording fell by the wayside.

Around this time, Eddie met John Wayne at the Hotel George V. Because John Wayne didn't speak a word of French, he asked Eddie to be the translator at the presentation of his film *Genghis Khan*. Before going onstage, he handed Eddie a few pages of dialogue and a pair of glasses. Eddie boasted, "I don't need glasses."

Surprised, John Wayne exclaimed, "But everybody needs glasses!"

My dad proudly said, "Well, not me!" as if it were a great accomplishment. (In fact, he *did* wear glasses but not for reading; he was far-sighted.)

During the presentation, Eddie said, "I don't know what I'm doing here. I've got a picture playing across the street. I should be plugging my own film!"

The audience laughed heartily.

After the presentation that evening, they got to joking around, and John Wayne commented on one of Eddie's films: "Eddie, you do those fight scenes so well!"

"It's easy. I'll show you," Eddie replied, and he pretended he was

going to give John a punch. Protecting his face with his hands, John yelled, "No! No!" This was really cute because here was *the* John Wayne—a guy who was taller than anyone around, including my dad, known in his films for winning the big fights—and *he* was afraid of Eddie's punch! Eddie loved it and joked about that interaction for years.

With my dad being a movie star, there was a very fine line between reality and fiction in our family. Sometimes, there was no line at all. I remember on one occasion, we were all watching one of Eddie's films on television in the living room. Edwina was about 4 years old at that time. As the film progressed, Edwina was getting more and more uneasy about the fight scenes. She was convinced that they were real, despite Eddie being in the room with us. At one point in the film, he gets scrunched between two cars and has a terrible accident. Well, she was so upset that she began to cry inconsolably. My father went over to her, took her in his arms, and whispered in a comforting tone, "It's okay. I'm right here. It's just a movie!"

Jessica's relationship to Eddie was just as unusual. From day one, she was starstruck, and she'd convinced herself that *he* was really her father. In fact, she called him Daddy. Helene, too, was Mommy; she called me Tanya. Jessica used to watch all of John Wayne's films and had come to believe that John Wayne and Eddie were one and the same—to the point that she actually claimed that John Wayne was her grandfather!

Once she found out that Eddie was in touch with John Wayne, she asked him to get her an autograph. She must have only been about 6 years old. Eddie had never asked anyone for an autograph in his whole life, but Jessica was so adamant about it that he went ahead and did it. A few weeks later, he received an envelope in the mail with two signed photos: one for her and one for Eddie!

In spite of Jessica's and Edwina's attachment to him, Eddie still had

his moods around his grandchildren. When he wasn't working, he'd spend his time sipping his whiskey and being generally very negative. At times like this, he'd get irritated with my daughters if they happened to be close by. One gloomy day, he announced, "I can't stand having them around anymore! Put them in school somewhere! They're costing me too much money!"

In retrospect, I'm sure now that he was more upset with me than with them. That was his way of lashing out at me. Hurt by his sudden change of attitude, I became very anxious. Having no money—nor any place to live—I saw no alternative but to enroll my girls in a free Catholic boarding school, which was 10 minutes away from the farm.

I was extremely upset at having to do this, but I made the arrangements anyway, in spite of my reluctance, and drove them to the school. At the gate, Jessica refused to get out of the car and put up a terrible fight, holding onto the car door for dear life and shrieking at the top of her lungs. After several attempts to pull her out, I walked away horribly agitated. Edwina didn't react as badly. She watched Jessica freak out and didn't really understand what her problem was; for me, on the other hand, it was a nightmare.

When we finally made it into the courtyard, Jessica continued to scream. As I drove away, I could still hear her calling out to me. Later, when I called the school, they said she was still sobbing. It continued like this for a whole week until I decided I couldn't bear it any longer. I went to the school and picked them up, vowing never to return them there. It had been far too traumatic an experience for us to endure any longer.

In spite of Eddie's bad attitude, we returned to the farm. For many years, I blamed Eddie for that whole ordeal—it was his idea, after all. I felt awful that I had put my children through such a trauma, and I kept looking for ways to get out of this predicament and find a way to leave my parents permanently.

Meanwhile, Eddie received an invitation to play one of the leads in Rainer Werner Fassbinder's film *Beware of a Holy Whore*, which was set to be shot in Munich and Sorrento. Eddie invited me to come along. Regardless of the bad blood between my dad and me—and since I had no other plans—I accepted the offer. We'd arranged for Helene to babysit my daughters while we were away.

When we arrived in Sorrento, we were driven to the hotel where the entire film crew was staying. Eddie and I were offered one large bright and sunny room with beds at opposite ends. A bit shocked to be put in the same room as my father, I stiffened up, but I didn't dare make a scene. Eddie noticed my reaction, and the tension between us mounted instantly. I quickly went out to explore the area to escape the bad atmosphere.

That first day, Fassbinder had no script to work from—no story line, not even a synopsis. He simply had the crew come down and meet in the hotel lobby. Everyone just sat there, waiting for him to come up with an idea for the first shot. After a while, we'd lose patience and go have lunch on the terrace. But even after we'd come back, we'd resume waiting.

This whole time, Fassbinder was locked up in the hotel room with his boyfriend, busy coming up with an idea. It seemed that he was in a strange and dark mood. People have said that he had problems with his sexual partners—he had relationships with both men and women—and was very tormented by this. He also smoked marijuana and hashish all day long—in fact, everyone in the crew smoked marijuana. For me, it was a brand-new thing. I wasn't quite sure whether I liked the effects or not; I tended to get paranoid, and I hated that. But when the joint was passed around, I did like everyone else just to fit in.

This aspect of the set shocked Eddie at first, to see that everyone was getting stoned: the cameraman, the technicians—even me! From the moment they woke up to the time they went to bed, they were smoking

pot. My dad held strong and resisted the joint that was being passed around. It's true that he was the eternal whiskey drinker—of a different generation, with a different set of behavior patterns. This was a classic example of the generation gap. We were now in 1971, the age of the flower child, and these "New Wave" filmmakers were a bit too far out for Eddie's taste!

Finally, Fassbinder deigned to come down from his hotel room, much to everyone's relief. He looked like he'd been through the wringer and didn't appear as though he was in any state to shoot a scene. Nevertheless, he got it together and had the actors improvise in front of the camera. No one really knew what they were doing, but it didn't matter: Fassbinder was the director, and this was his picture.

He was a short, burly man with dark hair, a mustache, and eyes so narrow that his pupils were barely visible. He looked swollen, as one would when drinking too much beer. It goes without saying that he was no average movie director. His films were like clay that he molded the way he wanted. He was really a genius at what he did.

Having seen me around the set, Fassbinder decided to give me a small bit part in the film. He spoke very little English, but I could speak some German, although it didn't really matter because he hardly said anything to me. He didn't have much of an idea in mind for my scene. Arbitrarily, he directed me to stand here or walk there, letting me improvise as we went along. Yet as the camera was rolling, and with total silence on the set, everyone's full attention was fixed on the scene. It was riveting. Suddenly, there was magic in the air, and something happened that was indescribable. It was like a very intense meditation. To catch the right mood, he'd leave the camera rolling long after the scene was over, and then he'd whisper, "Hold it there. Just stay with it." It was unbelievably creative, and I had never seen a director work that way before. But it wasn't just him; everything about that film was unique.

The first time I'd seen Hannes Fuchs—one of the lead actors in the picture—I was immediately drawn to him. He was different from all the other people on the set. He moved slowly and consciously, rarely doing anything in a hurry, and he thought about what he said before he spoke. The man was a law unto himself, and I had the distinct feeling that he knew things that others didn't. A handsome man, he was tall and lean with black hair down to his shoulders. His dark eyes were large and penetrating, and he dressed always in black. And he spoke English quite well.

A few others recognized him as a very special person, but most didn't have a clue. With the movie set being in a continuous state of emergency, people frenetically running around doing very important things, it was a relief that in the midst of all the chaos, here was this presence, this oasis of awareness appearing in the middle of the tornado. It was pretty extraordinary, though I think it was only visible to those who could see it. And as much as I was drawn to him, he never made the slightest romantic gesture toward me, choosing instead to remain his own person—centered within himself.

As Eddie, Hannes, and I were strolling down the streets of Sorrento one day, a fight broke out nearby between some men. Eddie started to walk over toward the scene of the fight to see what was going on, but Hannes gently grabbed his arm and pulled him the other way. He led us both across the street, away from the tumult, and said in a very serious tone, "This is not your reality. All you have to do is walk away."

Surprised at the authoritative manner in which he had said that, I contemplated his words in silence as we continued our walk. My father whispered to me, "This guy is weird!"

One night when Eddie and I were getting ready to go to bed, Eddie was in another of his nasty moods and started to pick on me. We ended up having a fight and I went into despair, sobbing and sobbing. It was around 2 o'clock in the morning, and everyone had gone off to bed. I

was utterly dismayed, feeling like my life was too hard to bear, that there was no end to the pain I was feeling. In my gloom, suddenly a light bulb turned on in my mind and I thought, "Hannes! He will surely have the answer! Where is he?" I knew he was staying in another hotel, but I really didn't know where, although I had vaguely remembered the name. I dashed out in the dark through the streets of Sorrento, tears running down my face, with one thought in mind: "Hannes will relieve me of my pain." I ran and ran, and have no idea how I found his hotel in the dark, but I did.

I didn't even have to knock. He had intuited me approaching and opened his door wide. Without saying a word, he gently put his arms around me and held me for the longest time. I cried and cried and cried. I didn't have to explain; there was nothing to say. All I had to do was allow the well to empty. I let the tears pour out until there was nothing left. He waited patiently until my catharsis was over, and then he handed me a box of Kleenex. I looked around the room. I must have looked insecure because he said, "This is not the first time you've been here. When you come into a room, don't assume you don't know where you are. You do know. You have already been here before. You already know."

He slowly walked me back to my hotel. In that moment, I felt all my problems and difficulties vanish and a great peace came over me. We exchanged a warm hug, and Hannes walked away into the night. After that film, I never saw Hannes again. I sometimes think of him, wondering what has become of him.

My dad, on the other hand, had found a friend in the actress and singer Hanna Schygulla, who was also in the cast. She showed him proper respect and made him feel like an important person, always trying to appease him when he was upset. Eddie liked working with her. The first day they'd met, they had to take off all their clothes and get into bed together to do a love scene. That was kind of an awkward way

of being introduced to one another, but he loved it!

Hanna told Eddie that Fassbinder was really happy to work with him and even wrote in scenes for himself so he could be in the same shot with him. Eddie sadly recalled, "But Fassbinder had his bitchy side and could suddenly turn against you. That happened before he died. He didn't know me anymore."

During the shooting of *L'empire de la nuit* (*"Empire of the Night"*), François Truffaut came to the set to pay a visit to his good friend, Pierre Grimblat, who was the director of the film. Eddie was doing a scene, having some difficulties with one of his lines. He kept saying them over and over, and each time he'd stumble over the words and have to start over again. Normally, he would have said, "Look, let me change this line so I can say it," but with Truffaut standing right there, he didn't want to do that. He wanted to impress him and show him how well he could recite a difficult dialogue.

Frustrated, Eddie kept trying until he just couldn't take it anymore. He blurted out, "Fuck you!" and stormed off the set, stomping off to his trailer nearby, and violently slammed the door. Once inside, he was banging and kicking the walls with his fists and feet, so the whole trailer rocking and shaking dangerously. Truffaut later commented, "That was great! What a scene! That should have been in the picture!"

A similar outburst occurred during the shooting of John Berry's *À tout casser* (*"The Great Chase"*), involving a speech coach who was working with all the actors in the film. Eddie complained, "She was an American dialogue coach, coaching in French—can you imagine that? She didn't even know what was being said! I was always known for saying my lines in a certain way with a lot of humor and simplicity, so it would come out easy. But she said, 'Oh, no! You've got to say it the way it's written!' Well, I was so upset about this that I wanted to walk out of the picture, except that it wasn't possible for me to do that. Usually,

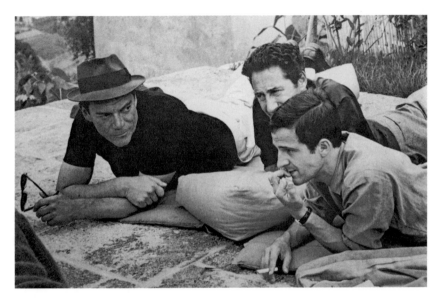

Eddie and Truffaut planning a scene

when I complain about a line, the director will say, 'Oh, don't worry about it, we'll change it.' But this woman was a real dragon! I was so hurt! You have no idea! I could have killed her!"

Eddie and I continued having our difficulties, but it was a different situation now. Before, he would have Lorenzo to blame for everything going wrong, but now he only complained about *me* and the way I did things. In response, I tended to be self-derogatory, insisting that I was just a misfit and a lost cause—almost convincing myself!

One evening after a very bad altercation, I decided it was once again time to leave. I packed all my belongings—and those of Jessica's and Edwina's—into three pieces of luggage, put them in the Austin Mini Cooper, and drove the three of us into Paris to my friend Minouche's apartment. I found a parking spot right in front of her apartment on the Rue du Bac.

As I arrived, I was considering what to do with all the heavy luggage. It was one of those buildings with no elevator, and the prospect of

carrying those heavy things up five flights was daunting. I made a quick decision to leave the bags, and so I locked the car and we clambered up the staircase. Happy to have us over, Minouche pulled out a couple of folding beds, turning her living room into a dormitory. We had a fun sleepover that night.

The next morning, we parted with hope in our hearts and promises to stay in touch, and the girls and I walked down the staircase. Climbing into the car, I commented, "It feels different in here. What do you think has changed?" I kept looking around inside the car, and then I realized, "Our bags are gone!" Flabbergasted, the three of us looked at each other with big eyes, our hearts pumping rapidly. It got very quiet in the car. "We've been robbed!"

The back windows in the Austin didn't lock—they slid open—so the robbers were easily able to help themselves. We lost everything: All my outfits my father bought me from Emanuel Ungaro and Yves Saint-Laurent, many pieces of memorabilia (that I wish I had today, like my letters from Sir Laurence Olivier), all my daughters' clothes, and more. It was all gone!

After brooding for a few minutes, I said lightly, "Well girls, now we have nothing to weigh us down. We're completely free. Let's just be flower children and go with the flow!"

Jessica looked at me as if I were crazy. She did not share my views and felt that my response was totally inappropriate. She bitterly resented that comment. But whether she liked it or not, we had just switched into the new era—from upper class to poor hippies.

9. CET HOMMES EST DANGEREUX

("This Man Is Dangerous")

THE SCHISM BETWEEN my parents had grown so wide that they were now sleeping in separate bedrooms, as I said earlier. For 15 years, the threat of divorce was always present, but it was only ever a ploy to make contact. They were never actually earnest about going through with it. Helene was not satisfied with the way she was living her life; all she wanted to do was dance. For years, Eddie had promised to get her a ballet company—as soon as he had the money—but it never happened. Helene realized that if she were ever going to have her own company, she would have to be the one to get it together. Like a good Christian Scientist would, she just assumed the money would be there when she needed it. With this faith behind her, she began to make plans.

The first thing she needed was a good dance partner. She'd been taking lessons with Franchetti, who was the "in" ballet teacher in Paris at the time. The Studios Wacker on Place de Clichy where he taught was where all the best dancers in the world came to study.

At one of her classes one day, she happened to take notice of a young Japanese male dancer. She was very taken by this husky, handsome man. He was in his 30s, about 5'10", 180 pounds, with an unusual Eurasian flair to his movements. Helene was fascinated with his unique style; she thought he danced like a god.

Hearing him speak French, she approached him at the end of class, asking shyly, "Your lines are so beautiful. Where have you studied?"

Flattered, he answered, "I just arrived from Tokyo."

They then went into a long conversation about ballet techniques. His name was Yasuhiro Okamoto, and as they spoke, she was thinking that he'd be the perfect partner for her. "I'd like you to join my company!" she told him.

He jumped at the opportunity, adding, "I'm also a choreographer, you know?"

"How convenient!" Helene thought.

Now all they needed was money. Helene made numerous attempts to raise the necessary funds, calling on her wealthy acquaintances, but she kept hitting brick walls and was never met with any success.

Meanwhile she was getting closer to Okamoto, spending a lot of time together: planning new dances, talking about ballet, and dreaming about the company. Although their relationship was kept strictly platonic, there was no doubt that they were becoming romantically attached. Eddie had always been jealous of Helene's partners, and Okamoto was no exception.

Every occasion he had, Eddie would throw jabs at her: "What are you doing spending so much time together? What is there so much to talk about?" But Helene shrugged his comments off.

Because he knew she was struggling to raise money, Eddie would make occasional donations, but never enough to grow a business. Okamoto offered a suggestion: "Why don't we line up some performances with our own money and reimburse ourselves once we're paid—just like other ballet companies do? I think it would work."

Helene thought it was a good idea, confident that Okamoto knew what he was talking about. They got to work right away on finding a location for the rehearsals and hiring the best dancers out there. She felt strongly that, once the company was performing, they would be

making a big splash in the ballet world.

In spite of his growing irritation with Okamoto, Eddie still came to watch the rehearsals. But by witnessing Helene's obvious adoration of him, Eddie was becoming terribly jealous. In the mornings, whenever she would be enthusiastic about running off to work for the day, Eddie would always have a comment—usually complaining that she was never around anymore. The first time he ever came to a rehearsal, he growled in front of everyone, "What's this Japanese music? You're doing a Japanese dance? Why don't you marry the guy while you're at it?" This put a real damper in the studio's atmosphere that day, and Helene was furious with him. Needless to say, they had a big argument that night when they returned home.

The next time Eddie came to visit, he walked in on a photography session—with Helene and Okamoto posing in full costume. Furious, he snapped, "What's this all about? You haven't even done any performances, and you're already spending all this money on photos? You must be crazy!" He stormed around the studio, griping about how much money he was going to lose with this ballet company of hers. Helene was embarrassed, not really knowing how to deal with the situation. Nevertheless, she was persistent, certain that this was what she wanted to do. She wasn't going to let Eddie intimidate her and jeopardize the project, and so she made light of his outburst in front of the photographer.

The problem was, however, that what little money Eddie was giving her was in fact going out the window, and it seemed the finances would continue to drain in that same way. There was just no way that any funds from performances would even come near the amount they'd already spent, and Eddie felt he needed to put his foot down or else they'd be totally ruined. Already, he'd had to let go of Vincent and his family—since there wasn't enough to pay for their wages anymore—and they all went back to Spain. And one by one, the horses were being

sold off as well—not just due to Helene's dance company, but because Eddie's latest film productions were financial fiascos.

Okamoto then doubled his efforts to help find funding in a most curious way: He enrolled Helene in the Nichiren Shōshū branch of Buddhism, to which he also belonged. Central to this branch of the religion is the practice of spending hours on end chanting the mantra "Nam Myōhō Renge Kyō." He was convinced this would bring the fulfillment of all their wishes. Although her Christian Science beliefs didn't conform in the least to those of Japanese Buddhism, she thought she'd give it a try. She began to chant every morning and evening in her bedroom and also at meetings she'd attend with Okamoto—all, of course, adding to Eddie's aggravation. Sarcastically, he'd say, "This is your new religion? Praying for money?" but Helene ignored these nasty comments and went about her business.

In the next couple of months, she and Okamoto were able to line up a string of engagements. Hopeful, the group of six dancers embarked on a short tour, but the amount they were paid didn't end up covering their expenses. After returning home, they got together for a brainstorming session: Helene came up with the idea of inviting a famous jazz choreographer, Peter Goss, to create a new dance for the company. She figured having a big name on board would enable her to get gigs that she otherwise could not.

For the next choreography, I was invited to participate along with two other jazz dancers. It was decided that we would use the song "In-A-Gadda-Da-Vida" by Iron Butterfly. We rehearsed in the studio, utilizing everyone's best assets—jazz, modern, and ballet movements—and it seemed that the piece was really starting to shape up. Eddie came to watch so that he could keep an eye on things. He especially liked that Okamoto wasn't included in this dance.

This particular production was requiring much more work. Money continued to flow steadily out, and barely a trickle was coming in.

Meanwhile, Helene was persisting in spending more time with Okamoto. After months of arguments and attempts at blocking the continuous drain of money, Eddie finally decided to put a halt to it, making a big scene in front of the whole company by firing everyone. It was over—the whole project was cancelled. All of Helene's efforts wasted. And that was the end of her dream of having a ballet company of her own.

Woefully, she mused, "I was a pretty good dancer. What happened to me? All the other ballet dancers I worked with have had books written about them and films made about them, like Margot Fonteyn, Yvette Chauviré, Zizi Jeanmaire—so why not me? There was no room for two stars in a family, so I lost my identity and hid behind my husband!"

She had developed so much bitterness over the years, what with all of Eddie's philandering, and this incident of broken promises with her ballet company was just one too many. At the end of her rope, she finally realized that she'd be better off on her own. She reflected, "I'm disappointed. Eddie loved his wife, but he didn't see me. He didn't notice my needs or my desires. People walked all over me. I always refused to be diplomatic, so I never got what I wanted."

Eddie had a different view. He claimed, "I always said I was untrue to Helene, but I never betrayed her—if you get the nuance. 'Untrue' means to sleep with a girl, but I never promised the girl that I was going to leave Helene and marry her! I never said that. Helene was probably humiliated that I was flaunting myself all over Paris and everyone knew about it. I'd been built up as a ladykiller, but I really wasn't! So when it did happen, it was a big thrill for me. But I never wanted to divorce Helene for that. She should have understood the unusualness of our relationship. We could have had a special kind of marriage, a unique kind of thing. But she didn't understand, and she got even with me."

Under Helene's repeated pressure, Eddie finally gave in and agreed

to grant her an "amicable" divorce. Since both were willing, he suggested she meet with his lawyer and find out how to go about it the best way. But Eddie's lawyer advised otherwise. "Knowing Eddie, you'd better get two separate lawyers!"

She took his advice and hired her own attorney. During their first meeting, Eddie magnanimously declared that Helene should take all their possessions. Since he was the only one working and generating income, he wanted nothing—just enough money to live on.

When it came time for Eddie to sign the papers, however, his mood had completely changed. He refused, saying simply, "Not today." He was intent on stalling—just to get even.

He kept changing lawyers, further delaying the procedures, which of course only increased divorce fees. The whole matter ended up costing a fortune, dragging on for another six years!

Helene's lawyer worked hard on the case, and one of the difficulties was getting the evidence. Well, one day, he stumbled on just the piece of evidence he needed. Eddie was doing a television interview, and he'd brought along a young girl to the studio. She was a school friend of Barbara's, just 16 years old, and she'd really wanted to see a live television show. Eddie was delighted to have company, so he'd invited her to come along. During the show, when the interviewer asked who she was, Eddie thought he'd make a joke—on live television of all places—announcing, "This is my fiancée." Of course, it was a shocking statement, considering the difference in age. The next day, the lawyer got a copy of that show, and that was the evidence needed to win the divorce suit.

Helene then withdrew what money was left in their bank account, packed up her things, and moved to Paris. There, she rented a two-bedroom apartment, sharing it with Barbara, Lemmy, and me and my daughters—leaving Eddie with the whole farm to himself.

The apartment wasn't very big, and we all had to live in pretty close

quarters, but at least there wasn't the anxiety we'd experienced at the farm. This isn't to say that everything was perfect ever after; far from it. Helene had her financial problems, and I had mine too, trying to find work and take care of my daughters all at once.

I went through a lot of ups and downs at that time. It was a heavy burden, to carry the load of raising my daughters by myself. I cried bitter tears and would pray for help on a daily basis. My dad came over a few times, but he and Helene would end up having terrible fights— always about money. Now that they were separated, Eddie had hoped that the tension would subside, but the house was now unusually, uncomfortably quiet. The friction had only seemed to keep the fire going. He was feeling very lonely, and he had to fill that gap any way he could.

One evening, he invited my mother out to dinner at the Chinese restaurant he co-owned with a restaurateur on Rue Marbeuf in Paris. Seated in a private room (Eddie's usual spot), they were having a pleasant meal until Eddie started to tell her about his dalliances with his latest girlfriend. Helene was getting upset, but still he kept elaborating and embellishing his experiences, seemingly unaware of her reaction. He kept rambling, "She's so attentive to me! She listens to what I say! And she's so tender, it makes me feel good!"

Impassively, Helene continued eating her dinner, somehow managing to contain her rage by pretending she wasn't really interested. When she was done eating, she composed herself and looked at him straight in the eye. Then she grabbed the pepper shaker from the table and threw it in his face. Astonished at her explosion, Eddie was livid. "What got into you?"

She screamed, "How dare you tell me about your girlfriends? How can you do that to me?"

Grabbing onto the side of the table, she abruptly tipped it over, and everything went flying and crashing on the floor. She lunged at him,

attacking him with no holds barred. Soy sauce shot all the way up to the ceiling; the lace curtains were grabbed and torn; the customers couldn't help but overhear the commotion in the room next door. In her fury, Helene realized she was putting herself in a precarious position and that she'd better get out of there right away. Sailing through the restaurant, the patrons' perplexed eyes following her, she ran out the door. Eddie was left behind to deal with the damages.

The next day, I was visiting him at the farm. I heard him singing in the shower, happy as a lark. Sure, he had a big black eye, but it didn't matter. Her anger was a sign that she still loved him. He couldn't have been more thrilled!

That Christmas—my first one without Eddie—my mother was basking in her newfound independence, busy getting ready for the holidays. She went out and bought a tree like she always did, and we all spent the evening decorating it at our apartment, setting our gifts beneath it and preparing for the festivities. None of us said a word about Eddie. We chose instead not to broach the subject.

Two days later, Helene, Barbara, Lemmy, Jessica, Edwina, and I all hopped into my mother's car and drove to the farm to pick up some things we'd left behind. Helene wanted the set of porcelain dishes and the clothes in the back closet, and I'd come to get my collection of books. As we walked into the entrance hall, Eddie greeted us sadly. "Where have you been? I've been waiting for you for Christmas!"

Walking past the large living room, he pointed to an enormous Christmas tree that almost touched the ceiling. He said, "I decorated it all by myself!" Although he was trying to sound nonchalant, we could all sense his hurt and disappointment. He really did do a beautiful job of decorating that tree. He even put gifts underneath it for each one of us. My heart broke at the thought of him being all alone in his gigantic house, with absolutely no one around. I felt bad that we hadn't

had the sensitivity to break through our past resentments and reach out to him for the holidays. Driving back to Paris that day, we were all very quiet in the car. My heart was heavy, and I could tell my mother wasn't too happy either.

Things for my father would soon get worse. In the midst of serious financial difficulties—essentially due to Eddie's film productions flopping at the box office—the farm went up for sale and long-term payments were arranged. Helene received her share of the sale and, at Okamoto's instigation, put a large portion of it into opening a Japanese restaurant in the city. Out of all her options, nothing else seemed quite as able to produce consistent income as a Japanese restaurant. It was agreed that Okamoto would contribute a share of his own and also find the necessary help in order to get it rolling.

It seemed to be working out well and Helene was pleased. But then one day, he flew back to Tokyo and was never heard from again. Helene was overwhelmed, now saddled with a Japanese restaurant, the operation of which she knew nothing about.

During these hard times, Lemmy was growing older. Early on in his life, Helene tried to instill in him the love of music. He did study the violin for a while, but his interest eventually waned and he ended up letting it go. Later, she enrolled him in the Paris Opera, where he entered at the age of 11 to study ballet as a *petit rat* ("little rat").

But pursuing ballet was not really his choice. He had a very rebellious streak and kept getting into trouble. When he was 13, he started hanging out with a gang of teenagers who were up to no good. My mother was at a loss as to how to handle the situation. She didn't have a clue. She'd get all bent out of shape and bitterly complain to Eddie, "You better do something! Because you always say you're gonna do something and you never do!"

Under Helene's pressure—and in need of a way to vent his rage—Eddie gave my brother a few severe whippings. Of course, this didn't

have much effect, and the situation went from bad to worse. Lemmy and his friends started stealing motorcycles and selling the parts, guys were pulling knives on him, he was getting himself into more and more trouble—until one day he was arrested. He took the blame for the whole gang, ending up in juvenile hall for an entire year. His counselor said, "With the kind of life he's had, Lemmy has had an axe driven into his personality." Yet judging by his self-confidence, no one would have ever guessed that he had something to work out!

Music didn't completely fade from Lemmy's interest. Years later, he produced his own record, and there was a song he sang called "Looking for Trouble" that really fit him perfectly. To this day, he works in the music business.

It's not easy being the child of a superstar, and Barbara has had her problems, too. Like me, she ran away from home as a teenager. She hopped on a train headed for Spain, where she stayed with Vincent's family in Valencia for some time. Eventually, though, she decided it was time to return to Paris. Now she is an accomplished French author, with six books to her name—two of which have been bestsellers.

While talking about his children, Eddie reminisced, "I never felt as though I had anything to do with bringing them up. They were Helene's children and I had nothing to say. I feel they don't care about me. They never thought I deserved the fame I had. Barbara didn't think I was any good as an actor, so my reaction to that is to not care about them!"

"He added, 'I don't think I was a good father because I always wanted my children to do what I wanted. I wanted them to go to a good school, have the best clothes, the best of everything, to marry, to have a house, to know the most erudite people, to be more complete. I wanted them to have what I never had. But that's where I went wrong.'"

Meanwhile, in the midst of all the money problems Eddie was facing, he was presented with an offer to play the lead in a stage play called *Hold Up!* at the Théâtre des Capucines in Paris. His role was a Lemmy Caution-type character in a cops-and-robbers plot in which he, rather typically, smoked cigarettes, drank whiskey, fended for all the women, and beat up the bad guys. Even his costume was the same; he wore his famous fedora and Burberry trench coat, just like in most of his films as Lemmy Caution.

But to Eddie, this was just more of the same. He wasn't excited about the project because it didn't afford him the opportunity to play a new character. He also had terrible stage fright, and that really drove him up the wall (or to drink!). But the play was a way of keeping himself busy, and so he decided to go for it anyway.

Memorizing the two-and-a-half-hour dialogue was a feat. He was just as afraid of forgetting lines as I ever was! He still managed to get through the four-week run, despite the fact that he didn't enjoy himself. He complained, "It was awful! I was so scared! I put glasses of scotch all over the décor, and every time I got really frightened, I'd drink it down. It was part of the character, fortunately!"

Although I thought he was great in this play—and I'd told him so when I went to see it—he wasn't proud of his performance. In fact, he was very relieved by the end of the run. He never mentioned that play again, and it seemed as if he wanted to erase the event from his memory altogether.

During this time, I'd landed a two-week contract in a variety show at Olympia Hall. There were to be six weeks of rehearsals, and I'd be dancing in a troupe of six dancers. One of the numbers was called "*ménage* à *trois,*" wherein three performers danced in the background (stage right), while the other three of us sang in a trio at the front (stage left). The décor was simple—plain black curtains and a blue

spotlight pointed directly at us. The choreography was superb, as was the accompanying music. The way our melodies harmonized was extremely inspiring to me. Up until that moment, I don't think I'd ever done anything as uplifting in my life as that five-minute act.

The night of the opening, I was elated to hear the audience's response at the end of our number, and the record producer who'd auditioned me years before came backstage to see me after the show. He was enthusiastic about what I was doing: "That was sensational! And you're good! When you're ready to go for it, just call me. I'll sign you up!" He handed me his business card. I thought, "Wow! After all this time, he's still interested?" I was flattered and terribly excited. Hearing this meant so much to me, and it felt like coming full circle. The option was still open—how validating!

I called Eddie to tell him about the proposition. I don't know why I sought his encouragement; I knew perfectly well he wouldn't give it to me. His response was cool and disinterested, and it sounded like he thought it would never amount to anything.

I instantly got cold feet. A master at the art of self-sabotage, I shucked the whole thing off and never called the guy back. Whether it was destiny or not, another golden opportunity was missed.

Struggling to make ends meet, I was beginning to think that it was just too hard for me to survive in Paris. I really wanted to find a community that would help me raise my daughters so I wouldn't feel so alone. I thought, "Where in the world would it be easier to live? In a sunshiney place, all year round?" Having good weather was a very important element in my decision. I thought of inquiring with the State of Israel to find out if I could join a kibbutz. After all, I was part Jewish. Wouldn't they be happy to welcome an enthusiastic and hard-working woman? I fantasized how nice it would be to live communally: learning a new language, sharing all our meals, working as one big family, doing everything together—it sounded like heaven! I put in

a call to the Embassy of Israel and made my request, but I soon received a call back with a polite refusal. Their reason had to do with a particular quota. It turns out that a single mother with two children was not their ideal kibbutz member.

With that plan being a dead end, it was time to go back to the drawing board. After brainstorming with friends about the various possibilities, it occurred to me that I was better off going back to California. I could stay with my aunt and uncle, at least until I was able to find a job. Lorenzo was also still there, and by this point, he had become a chief aid and confidant to a prominent California statesman in Los Angeles—which was a brand-new thing for him! I thought he might be able to help as well. Maybe.

I informed Eddie of my plan, which he supported unconditionally—except for the part about Lorenzo, of course. He was still reactive even to the mention of him. He said to me once, "Lorenzo took away what was most dear to us, and we reacted like animals react. I feel no shame from our attitude. I wouldn't react to him today the way I did years ago, and believe me, it's not that indifference has set in!" Well, as they say, what you resist persists.

In spite of Helene's reluctance to see us leave Paris, I made reservations to fly to Los Angeles with my daughters. Aunt Fay and Uncle Harry were happy to greet us and help in any way they could. They ended up hosting us for the next three months, and to this day, I am grateful for that.

Naturally, Lorenzo didn't lift a finger to help. I received no support from him whatsoever. With tears streaming down my face, I read the want ads in the papers every morning, desperate to find something I could do. Looking for a job felt like the most hopeless thing in the world, since I lacked skills. This made me feel like a misfit, like I didn't fit in with the norm, like a square peg trying to fit into a round hole. In those days, I was confronted to the core, my sense of self-worth tak-

ing a nosedive in the process.

After a few months of vacillating, however, I resolved to join the human race. There was no alternative but to take the bull by the horns. Within a couple of months, I was hired by Patrick Terrail, the owner of a new restaurant called Ma Maison on Melrose Avenue. It turned out that he knew my father, which was the main reason I got the job. He also liked me and thought his new space could use an enthusiastic, French-speaking hostess to attract his legendary clientele, which included all the movie stars of the day. He also needed an administrative assistant, and apparently, it was okay that I had no experience. But it turned out that Patrick actually needed an experienced bookkeeper, and so I didn't last very long, but I left on good terms. In fact, some years later, Lemmy also worked at that restaurant for a while.

Back to the drawing board, I decided I needed to learn a skill. Typists were a dime a dozen back then, but I thought I'd give it a shot. So I borrowed a typewriter, purchased a how-to book, and taught myself how to type. I learned relatively quickly, and as time went by, my skills had developed to a point where I was typing 105 words per minute. This enabled me to branch out into the legal world, first working as a legal secretary for California lawyers and then eventually doing some paralegal work.

Eddie phoned me from New York where he was filming a B-rate Italian detective movie. They'd only given him a secondary role, and he was feeling badly about it. He said he was lonely and asked if I could join him for a week, and so I did. When I arrived at the hotel on 6th Avenue, I brought along a newspaper clipping with a photo of me dancing with my dance partner. It was from a show I'd recently worked on, and it had gotten some publicity. I thought he'd be pleased to see that I was still dancing, but he only showed a mild interest and threw the paper aside.

That day, on our way to a friend's house after the day's shooting, we

flagged a taxi down the street. Getting into the cab, the driver gave Eddie a wide-eyed look and asked, "Are you Eddie Constantine?"

Surprised, Eddie said, "Yes."

All excited, the driver exclaimed, "I don't believe it! That's fantastic! I've seen all your films! Every one of them! I'm honored to drive you!" Eddie was used to having people recognize him in Europe; that's where everyone knew him. He couldn't even walk down the street without someone accosting him. But in the United States, it was unexpected! This made him very happy. After a long day of shooting on location, we ended up in an Italian restaurant, spending hours chatting, joking around, and singing Neapolitan songs.

As the shooting progressed, Eddie was reacting to the fact that he wasn't getting the respect he deserved from the producers and the director. After a couple violent outbursts, the producers realized that he needed to be appeased or else he was going to make life miserable for everyone on the set. They did their best to accommodate him—making sure he had the food he wanted, that the chauffeur was there on time to pick him up. They even took him to the best restaurants in town, hoping this would pacify him, but nothing really worked. Eddie simply hated the film and wanted it to be over. It didn't help either that it was a low-budget film, which meant that there were not enough hired hands. In this setting, things could get quite chaotic.

Sure enough, he made an awful scene in the hotel lobby. We'd been sitting there idly waiting for the crew to get going, when Eddie started to get antsy. He kept going up to his room to take a swig of whiskey, only increasing his dark mood. Eventually, his voice began to thunder throughout the lobby: "Is this the way you people treat a star? You need to learn a little respect!"

Cringing, I thought, "Oh, my gosh, there he goes again!" The crew looked at him quizzically, the Italians especially. They didn't understand a word of English and just looked at him with expressionless

faces, perplexed as to what his problem was but never daring to ask. I overheard an American actress say under her breath: "Who does he think he is? If he's such a big star, why is he doing a picture like this?" Boy, was I embarrassed!

The next day, I was given a job as an extra. We were scheduled to shoot in a boxing ring in the Bronx. Eddie was in yet another one of his moods because the chauffeur—who looked like a Mafioso—had arrived late to pick us up. To make matters worse, nothing was ready when we arrived on location. The director hadn't shown up yet, and we had to wait even longer. Eddie was getting hungry, so we walked over to Woolworth's across the street to get a candy bar to kill some time, but when we returned, still nothing had moved. It looked like we were going to be there for days!

Eddie's mood was getting worse as the hours passed by, and by lunchtime, he was frightening everyone around him. In an effort to suppress the tension, the producers offered to take him out to lunch; Eddie gladly accepted their invitation. At least by the time we returned to the set, I thought for sure that the director would have gotten the show on the road—but that was only wishful thinking. Instead, we had to wait another two hours. I tried to keep Eddie engaged in conversation, but I wasn't doing a very great job. To be fair, his state of mind made it nearly impossible.

Finally, Eddie was placed in front of the camera, and he got to do his scene. All day, he'd been going off to drink a glass of whiskey, and so by then, he was pretty loaded. Nevertheless, he perked up for the scene, and no one could have guessed that he wasn't completely sober. But after that shot, there were even more delays, and around 9 p.m. I watched my dad lay down on three chairs to take a snooze. The director realized he wasn't going to get much else out of Eddie that night, and he sent us all home.

The next morning, I bumped into Melinda, the producer's

girlfriend, in the lobby of the hotel. She was rushing out to find a replacement for the young actress who hadn't shown up that day. She enrolled me in helping her search throughout the New York City streets for a specific type: a 16-year-old girl with long brown hair, about 5'4" with an innocent look.

Barging into shops and accosting young girls, we tried our darnedest to invite them to come and do a day's work in front of the cameras. Some thought it was a joke, while others thought that we were madams looking for hookers, but most just looked at us as if we were crazy. After a couple unsuccessful attempts, we grew discouraged and returned to the hotel.

Meanwhile, the original actress had shown up and was already in front of the cameras rehearsing the next shot. Our wild goose chase had been for naught! Eddie roared laughing when I told him what we'd done.

All of Eddie's scenes were soon wrapped up, and he and I were packing our bags to get ready to leave. I went to my dad's room to say goodbye. Out of the corner of my eye, I happened to glance in the wastebasket next to his bed, and what was in there but the newspaper clipping with my photo! I gently nudged, "Don't you want to keep that?"

Grimacing, he said, "What for? Who do you want me to show it to?" Shrugging my shoulders, I realized he just didn't have the interest. I felt the hurt inside me and swallowed it as best I could.

On Eddie's return flight to Paris, as he was going through Customs, they'd opened his bags and looked through everything. Searching through his toiletries, the handler discovered a syringe. At that time, before doing a picture, Eddie was in the habit of taking shots of vitamin B12. Searching deeper still, the agent found a spoon left over from another trip. It's hard to imagine a worse combination of paraphernalia—a syringe and a spoon. It was looking awfully bad for Eddie, but he

kept protesting, "I don't have anything! I'm a drinker! I don't do drugs!"

They looked at him suspiciously and forced him to undress for a body search, looking closely at his boots to see if the heels were hollow. After about an hour of not finding anything, they finally said, "You're free to go!"

That whole New York trip had gone from worse to catastrophic, and this was definitely the culmination. But it was just the beginning of the gloomiest period in Eddie's life. During this time, he accepted an offer to star in a horror film produced in Los Angeles titled *It Lives Again*, which was a sequel to *It's Alive*. He played the role of a demented surgeon, and this made him absolutely miserable. He was ashamed that he'd had to stoop so low as to work in such a revolting picture.

While shooting, he met an attorney from Los Angeles named Dorothea. She had already been married five times before, and Eddie was the sixth. Not surprisingly, they had a very brief and stormy marriage. Eddie realized he'd made a terrible mistake, and just 90 days after their wedding, he filed for divorce. I never even had the chance to meet her.

But the final blow came when he returned to Paris. He'd rented an apartment near Notre Dame, on the Île de la Cité, and he lived there for a while, nursing his breakdowns. Then one day, the electrical wiring short-circuited and his place went up in flames. The whole building burned down, and everything he had was destroyed in that fire. He was devastated.

It was terribly hard for him to face the fact that his life was different now. Everything was letting him down: his fame, his friends, his family. He maintained that his only friend was his bottle of whiskey. He felt lonely and unnoticed, with no hobbies or interests to distract him from the emptiness he felt.

He described his feelings to me later: "I have no more friends.

Everyone has betrayed me. But I think to have friends, you have to *be* a friend. Maybe I wasn't a good friend. It reminds me of the tragic story about two actors who meet. One says to the other, 'What are you doing lately?' The first actor answers, 'Well, I'm making a picture with Visconti, and then afterwards, I'm doing a picture with Fellini, and then I'm going to New York to do a film with John Huston, and then another with Louis Malle...' and he adds, 'By the way, what are *you* doing?' And the guy replies, 'Me? I don't give a damn!'"

I understood why he liked that joke so much. I know it was humiliating for him to have to accept secondary roles and even bit parts. He always wondered, "What happened? Where did all the fame go? Where is everybody? Why am I all by myself, waiting for the phone to ring to give me something to do?"

On some level, though, he did continue to get recognition. One particular instance stands out: He was at the Beverly Wilshire Hotel, waiting at the curb for the bellhop to bring his car around, when a very good-looking young man came up to him and said, "I want to congratulate you. I think you're great. I love your pictures!"

Not recognizing the man, Eddie asked, "What's your name?"

"Bertolucci."

"*Bernardo Bertolucci?*"

"Yes!"

Bernardo Bertolucci was the Italian movie director who had directed *Last Tango in Paris*. Eddie was thrilled!

There were aspects of my father that I had to admire, like his strong resilience and immense resourcefulness. It seemed he was never at a loss for creative ideas. He reminded me of a prizefighter. And although he would wallow in misery for a while, he'd soon get back up and keep on going.

For example, having been involved in the horseracing for over 20 years, he knew all the dirt and intrigue of the milieu. This knowledge

and experience proved to be an asset—right in the palm of his hand—
and he came up with the idea of writing a novel about it. He approached
a publisher with the idea and got a hefty advance. Working with a ghost-
writer, his book, *Le Propriétaire* ("*The God Player*"), was published in 1975,
and with that, his new career was launched.

The book did quite well. Eddie went on tour promoting it through-
out the United States, and he also appeared on television and radio
talk shows. He even produced *The God Player* T-shirts! The book was on
bestseller lists and was translated into many different languages. His
publisher urged him to write more, and over time, he came up with
three other novels: *The Odds, The Countess,* and *Thunder-Man.*

The success of his books allowed Eddie some space to adjust to the
fact that, in his acting career, he'd made a transition from leading man
to character actor. Although this was tough to adapt to at first, he'd
eventually come to accept it. Besides, anyone at that time could still see
him in films, on stage, or in television programs throughout Europe.
And believe it or not, he was soon married again.

10. LUCKY JO

"If you live long enough, even good things can happen to you!"
—Eddie Constantine

I T WAS 1979, E DDIE WAS 66 and still kicking, eagerly waiting for the next interesting opportunity to show up. He kept himself in shape, eating spoonfuls of peanut butter to ensure there was enough vitamin E to—as he said—keep the lead in his pencil. He watched his diet, sticking to steaks and salads, rather than indulging in his favorite mashed potatoes and corn. He'd gained a little bit of weight, but he was aging well. He still had great sex appeal.

Meanwhile, I'd met and married my second husband, John, a tall, handsome man of Polish descent with blue eyes and blond hair. We were married in March of 1974. He's been my best friend ever since. He gave me the acceptance that Eddie never did, and in him I found an equal. Together, we've braved life's difficulties, delving into the depths of pain and suffering, flying to the heights of bliss and exultation.

When Eddie met him, all he had to say about him was, "He's so laid-back, he's liable to fall over!"

He certainly didn't understand John's gentle nature. During one of Eddie's visits, John said to him, "Eddie, you're just like Picasso!"

"You mean I'm old?"

John had meant it as a compliment. Like Eddie, Picasso was a virile man having children at a ripe old age, still painting masterpieces. But Eddie was prone to feeling sorry for himself when he wasn't busy, and he missed the compliment.

During this period, I wasn't much in contact with my dad. I'd call him every once in a while, just to keep the connection, but it was never very satisfying. He was such a temperamental man, often indulging in brooding states of mind. I called him one day when he was in one of those moods. As I dialed his number, I felt tension in the pit of my stomach, thinking, "Would I gain his acceptance this time?" The slow flow of adrenaline, radiating through my chest and down my legs, reminded me of how I used to react in the past. I thought, "Even after all these years of psychotherapy, I still have that same fear? How dreadful!" I wondered if I'd ever get over it.

After three rings, his wife, Maya, answered the call. She sounded delighted to hear my voice and asked where I was calling from, thinking I might have been in Paris. I said, "No, I'm in San Francisco, and I'm calling because after five years, I felt it was high time I spoke with my father."

She agreed and asked in an enthusiastic tone how I was doing. It sounded like she was genuinely excited to hear from me. I asked how Eddie was. She said, "Oh, he's fine. He's right here, I'll pass him to you."

Strengthened by her enthusiasm, I anticipated that we might actually have a healing moment together. As my father grabbed the receiver, I chimed in, "Hi, Dad! How ya doin'?"

He mumbled something inaudible, so I continued, "It's been a while since we've spoken!"

He muttered something else that I didn't understand, and instead

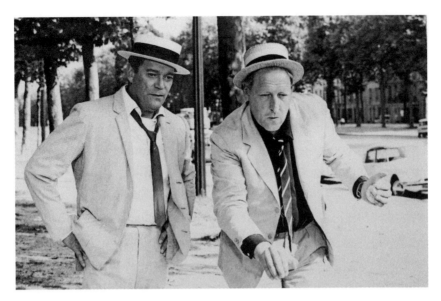

Eddie and Georges Wilson playing petanque on set of Lucky Jo

of asking him to repeat himself, I kept up the cheerful questioning. "Aren't you happy to hear from me?"

In a chilling metallic tone that reminded me of Darth Vader, he declared, "Actually, no. I really don't have anything to say to you."

Taken aback, I thought, "Oh, no! I called at the wrong time. He's in a very bad mood!" I wondered for an instant what I should do, what I should say. I replied incredulously, "Really?"

Encouraged that he might have struck hard enough to stun me, he blurted out in one long breath, "Yes. You've ruined my life. You've ruined your mother's life, too, but I don't care about her anymore. You ran away with Lorenzo and ruined my career!"

In utter disbelief, I emitted a nervous laugh, attempting to hide the sensation of having just been hit in the knees with a baseball bat. I could feel his uncaring and frigid inflection freezing me to my very bones. I thought, "Why in the world is he freaking out about this now? That was 35 years ago! His acting career wasn't ruined because of me!"

This was totally uncalled for.

Striving to maintain some clarity within myself, I thought I'd let him know that I understood he was hurting. In as compassionate a tone as I was able to muster, I said, "You sound really hurt!"

He jumped on that comment right away, as if it were fodder. Discharging some of his rage, he bellowed defensively, "Don't you psychoanalyze me! I don't need any psychoanalysis!"

Astonished at the intensity of the flare-up, I thought I'd point out to him as innocuously as I could: "You're so vengeful!"

Indignant, he hollered, "Not at all!" And then he went on a tirade that seemed almost rehearsed, dramatically emphasizing certain words. "But *you* are the *stupidest* person that ever *lived*! Everything you *ever* did was a *mistake*! You get the prize for the *stupidest*! And you never did *anything* we wanted you to do! *Nothing*!"

I couldn't help but laugh. I'd heard this so many times before, and here it was again. It was just too preposterous; he couldn't be serious. I sensed that he wanted to impress upon me how bad it was for him. He was waiting to see if he had done some damage, hoping to see blood streaming out of the open wound.

Parodying one of his favorite sentences, I managed to articulate as humorously as I could: "If this is friendship, who needs enemies?"

He savagely retorted, "*I'm not your friend*! Who ever said I was your *friend*?"

"No! You're my father!" I said sarcastically. I thought of the time he yelled, "I want a divorce!" at me during one of our last violent arguments. There was no doubt he thought of himself as my husband; that always made me feel uncomfortable.

He mumbled something I couldn't understand. I thought, "This is stupid. I don't need this kind of abuse," and so I said calmly, "You know, I'm a grown woman now. I'm 48 years old, and I really don't need to listen to this."

"Yeah, you don't need to be spending so much *money* on this *phone* call. Especially when you don't *have* any!"

Wow, was he hitting low! I thought, "He's pulling out all the stops; I better sign off before it's too late!"

Just as I was about to hang up, he started again, confident that this time he was going to strike hard: "One good thing is that your children are wonderful. I got a card from Jessica. She's great! And Edwina is fantastic! She's a good person. She wouldn't hurt a fly! So you see?"

I guess he was trying to say that my children had come out okay *in spite of me*. He knew just how to get to me. But I felt I had received enough hits for one day, and so I said decisively, "I guess we don't have anything more to say right now."

Not at all ready to end it there, he went for the throat. "I don't think we need to see each other. Yehudi Menuhin doesn't see *his* children. And he's a *good* man! When his kids call him and ask him if they can come over, he says, 'No, I don't want to see you.' I should be able to do the same thing."

Registering the hurt within myself, I noticed my solar plexus was terribly sore. I was just barely breathing. It occurred to me then that my father and I may never come to a resolution in this lifetime. We had grown too far apart. And in that moment, I felt the immensity of my disillusionment. I wondered if he had put my brother and sister in the same boat as me. Out of curiosity I asked, "Do you feel the same way about Lemmy and Barbara?"

He took a moment to think about it and replied, "Yeah, a little bit. Barbara, yes. Lemmy, no. But *you*? You take the *jackpot*! You win the *prize*!"

"Dad, if you want to be abusive, go right ahead, but I don't need to hear it. Not at my age."

"Yeah." His voice trailed off. It seemed that he was losing ground. He was flailing about, searching for a hidden weapon to deliver one

more whack. I don't think he'd counted on the fact that I wouldn't give him the satisfaction of knowing how deeply I was wounded.

Aware that this would be his final strike, he jumped in one last time before I could say goodbye, and in the most disdainful tone he could possibly invoke, he mockingly said, "I heard you're taking *acting* lessons!"

"How do you know?" I asked.

"Aunt Fay told me."

In an attempt to protect myself, I thought I'd try to be funny. I protested, "I deny it. In fact, I deny everything in this conversation!"

Deeming my comment irrelevant, he ignored me and said scathingly, "At 48? To try to become an actor at 48? That's *absolutely ridiculous!*"

How did he know exactly what target to hit? My knees ached as if I'd just run a marathon. I could sense that he had achieved his goal—to punish me for how he felt. But now I'd reached my limits.

I announced, "I think that's all we have to say."

"Yeah. Let's go our own ways. I'll go mine, you go yours."

"I'm sorry you feel that way." And I quickly added in a whisper, "I love you, Dad."

"Have a good life!" were his final gloating words as he hung up.

I waited to hear the click before I put the receiver down. I wanted to make sure I got the full impact of the last conversation I would ever have with him. Then it was all over. There was nothing but deep silence in the room. I sat on the edge of my white rattan armchair, shoulders slightly slumped, eyes vacant and tearless. In the depth of the emptiness that filled the space, I felt nothing. Absolutely nothing. Emptiness.

After a while, I noticed the sunlight shining on my navy-blue Chinese rug. I could see the fraying along the edges, and I had a passing thought that I should have it mended before it gets any worse. The branches of a tree right outside my window caught my attention. I

watched the tiny green leaves ripple in the gentle breeze. My chest welled up and I heaved a long, heavy sigh.

While Jessica was in Paris, visiting from California in the summer of 1981, Eddie came by Helene's apartment one afternoon. He'd just been booked to sing "L'homme et l'enfant" on a live television show called *Le Grand Échiquier* (*"The Great Chess Board"*) and asked Jessica if she wanted to do it with him. She was barely 16 at the time and looked even younger still. But he thought it would be a great gimmick to sing the song with his granddaughter.

Jessica didn't hide her excitement. Right away, she said she'd be happy to do it, especially because she knew the lyrics by heart. She was jumping up and down, ecstatic at the opportunity. But suddenly, she grew worried about her ability, asking with trepidation: "But are you sure I'm good enough to do it?" He maintained that she had nothing to worry about.

That evening, Jessica phoned to tell me the news and to ask me if I could go over the lyrics with her. Although I was delighted that Jessica could have this experience, I felt a twinge of protectiveness toward her. After my experience with him in the studio, I was just hoping Eddie would be in a good mood and not give her a hard time like he did with me. She promised to call right after the show, and I hung up praying that all would go well.

The next day, Eddie and Jessica rehearsed with the band. They went through the song twice. The first time wasn't so hot, but the second time was perfect. Jessica was so nervous that night, she could hardly sleep.

The following day, Eddie came by to pick her up, and Helene, who was supposed to accompany them, wasn't ready. He got very irritated and, as usual, started yelling at her. "I hate people who are late. Why are you late?" Helene ended up taking a cab later, almost missing the

entire show.

Jessica claimed she wasn't nervous. Instead, she said she felt nothing, as if she were on autopilot. I think she just didn't want to let anyone know how tense she was. Later, she claimed that any nervousness she did have only stemmed from her fear of making Eddie look like a fool—having a granddaughter who might freeze in front of the cameras!

Eddie himself was tense, but he was in a good mood, ready to get rolling. Having arrived at the studio, they went directly to the makeup room, where Eddie started to tell the lady how to do her job. He had very specific ideas about how he wanted his makeup done, and, as he most often did, he got his way. As they were getting dressed, Jessica noticed the tattoo on his upper arm: a large bluebird surrounded with the printed names of each of his children and grandchildren. She thought that was special. When their makeup was finished, they walked gallantly around the studio arm in arm, staying close to each other the whole time, which made her feel comfortable.

Their moment had come. The assistant seated them around the piano and gave Jessica her cue. With the lyrics in front of her, she began the song, hesitantly at first, but then rapidly growing more confident as she went along. Her childlike innocence came forth perfectly, and she sang the song just the way Eddie had always wanted. At the end, he was so happy with her, he gave her a kiss. She was feeling absolutely wonderful.

Eddie was asked to sing another song, "Ah! Les Femmes!" ("Ah! Women!"), and in a nonchalant way, he said, "I don't remember the lyrics to that song. It was a long time ago. I don't sing anymore. I'm only doing it here because I'm with my granddaughter!" And so he got up anyway and sang a few choruses, but then he stopped in the middle of the song and said, in a charming and relaxed tone, "That's all I remember!" and got a lot of applause.

The show was a big success, but for me, there was a peculiar ring of déjà vu to it. I had tears in my eyes when Jessica gave me her moment-to-moment account of the show.

Years later, after *a lot* of therapy in learning how to deal with my wounded self, delving into my tendency toward self-sabotage, I finally came to a place of forgiveness. There was no big drama about it. I just came to that place of inner quietness and allowed myself to forgive my father, on a profound level. I was struck by a strong urge to communicate this state, and I wrote my dad a short letter:

Dear Dad:

There are some things I want to say. First of all, I have to say that I want your approval. That's one thing. Then another thing is that I don't want you to know that I'm not okay, that sometimes I even feel bad. I'd like you to think that I'm perfect all the time, that I have no problems, and yet, I can't keep pretending that everything is okay because I feel that I'm not okay. I think I'm a failure. I feel that I have missed many opportunities out of fear, fear of not being good enough, fear of failing. So that's just what I did, because I was afraid to try. At this point I'm tired of this failure, and I want to let go of this attitude. Dad, I know you know what I'm talking about. I want you to know that this is not the easiest thing in the world for me to tell you, because I don't want to reveal my dark side. I don't want to let you down. I really hate to let you down, and yet I know I have. Maybe by revealing this to you, I may have a chance to break the pattern, and this leaves me feeling kind of vulnerable. I also want to tell you that I love you.

Love,
Tanya

I soon got a response:

Dear Tanya,

*Your letter came yesterday, and I read it immediately and wept.
Communication with you is so rare, and you speak from your heart, and
you haven't found all the answers to your searching. Who ever does? So
you are like all of us! If anyone ever tells you they know the so-called
answers, we will build a pedestal for him or her. There will be no
pedestal!*

*You are not a failure; perish that thought. You are a dear human
being who tries to be better, especially for yourself and to your family.
Never for one moment must you think of failure. Actually, what does
failure mean? Success or failure, what are they? Nothing! I have known
both.*

*When people ask, "What ever happened to that daughter of yours who
sang with you?" I am always pleased to say you are a successful lawyer
living in San Francisco with your own family, and they are pleased to
hear that. It is the truth. You are certainly not resigned to mediocrity. It
is not in your nature or character. That's why you ask yourself so many
questions. Emotions, sentiment, and insecurity—that is basic man. You
are not different from anybody else. YOU HAVE A GOOD DESTINY.
NEVER FORGET IT. You will always know the highest and the lowest,
so be sure that's the way it is.*

*You have much love for your immediate family and your parental
one. That seems to disturb you. I find that very human and
commendable. I wished for you things that you couldn't understand and
you rebelled. That's good! I was wrong. But there is nothing to feel bad
about. Parents always mean well, but that's their point of view, and they
are not always right. That's part of the game.*

*I was always disturbed when you would say, "I know you." You really
didn't. No one ever does. I learn and am trying to learn more.*

You have done no wrong and have hurt no one. So live and take the good with the bad. One moment of good is worth a year of boredom and resignation. I am happy with Maya. She has a certain magic that exalts me. So you see, it will happen to you, if you reason well and never resign!

Write again,
Dad

Needless to say, this was the message I'd always hoped to receive from him. It was the healing I'd longed for, and now here it was. I must admit, however, that he was wrong about me being a successful lawyer (I was making a living instead as a legal secretary). But it didn't matter anymore that he wasn't willing to accept me as I was—that was just his conditioning. He couldn't help it. What mattered to me was that, with this letter, he proved he could be compassionate. This letter had major significance in my life. This was what I'd needed all along, and it seemed like the fight was finally over. For me, it was the dawn of a new day. A new life was just about to begin. Sure, I still had to deal with remnants of the wound on a daily basis, but now there was hope.

A few years later, on February 25th of 1993, Eddie died of kidney and heart failure in Wiesbaden, Germany, at the young age of 79. Curiously enough, my mother died exactly nine months later.

Acknowledgments

OH, MY GOODNESS! I am infinitely grateful for getting so much support for getting this manuscript out. It moves me to no end to think of each and every one who had some influence in the handling of this book. You have to understand—I wrote this memoir over 30 years ago. Every once in a while, I would pull it out from a box that I kept under my bed, and see if it was worth putting energy into. But soon, I would lose hope that it had any value and it would go right back under the bed.

So right off the bat, I am incredibly thankful to my publishers Adam and Jessica Parfrey of Feral House, who so graciously jumped on the bandwagon and decided to publish my manuscript. Then there's Tim Lucas. Without him, this manuscript would still be sitting under that bed. He knows more about the details of my father's life and movies than anyone else on the whole planet (as you can see in his introduction) so I can't even begin to express my gratitude to him. Ken Reed is another one I have to thank for attempting to get the book out in the early 1980s. Ken was the publisher of Wisdom Garden Books who had offered to help. However, I was not yet prepared for a win and I sabotaged his efforts. I am so very sorry I put you through that, Ken! Do you forgive me?

I want to thank my daughter Edwina Barzaghi for her unwavering support; my brother Lemmy Constantine for adjusting some of the dates I had wrong; my cousin Stash Wagner (the composer of the song "Don't Bogart That Joint" featured in the movie Easy Rider) for believing in the project; my writing group at Rancho Grande who gave me confidence in my writing abilities—Denise Briand, Carolyn Allen and Charlene DeCosta; my friend Christie Nelson; and last but not least, my wonderful husband John Krajewski whom I adore—you just knew this story would be published one day, and you were right. I love that you are always there for me! Thank you, dear friends and family! I'm grateful!!

The DESPAIR of MONKEYS
and Other Trifles

A MEMOIR BY

FRANÇOISE HARDY

TRANSLATED INTO ENGLISH BY
JON E. GRAHAM

She embodies the word "iconic."

Famously private, Francoise Hardy carries the burden of desire and expectation of perfection of millions of fans. Teenage pop chanteuse. Style trendsetter. Actress. Mother. Astrologer. Françoise Hardy is the consummate French artist— unknowable in her chic reserve. Until now.

Ms. Hardy is the inspiration and animating spirit of the early 1960's "yé-yé" pop music sensation. Her striking beauty offsets her sublime and often melancholy songs. Her early recordings (recently remastered and released by Light in the Attic Records) vaulted her to European superstardom. American tastemakers Sofia Coppola and Wes Anderson have claimed her as muse. More than a "pop singer," Hardy is an accomplished lyricist whose collaborations with artists ranging from Serge Gainsbourg and Michel Berger to Damon Albarn and Iggy Pop have kept her recordings vibrant.

Sharing unvarnished truths of her childhood as well as the celebrity-filled anecdotes, Ms. Hardy is no coy narrator as she recounts her fears and triumphs, friends and lovers, and her unconventional marriage to fellow French singer Jacques Dutronc. Rare personal photos from Ms. Hardy complete the book.

We invite you to join us in celebrating the life and art of Francoise Hardy.

A Feral House fh Publication

Out of My Father's Shadow:
Sinatra of the Seine, My Dad,
Eddie Constantine

©Tanya Constantine 2019
All rights reserved

ISBN: 978-1627310666

Designed by John Hubbard/emks.fi

Published by Feral House
1240 W Sims Way #124
Port Townsend WA 98368

www.feralhouse.com

10 9 8 7 6 5 4 3 2 1

PHOTO CREDITS
FRONT COVER: Eddie and me on the
 cover of Paris Match
 WILLY RIZZO
BACK COVER: My headshot in 2017,
 San Francisco
 EDWINA BARZAGHI
TITLE PAGE: Eddie and me at Grand
 Central Station in New York in 1947

UNCREDITED IMAGES ARE FROM
 THE FAMILY ARCHIVE.